Contents

For their inspiring passions, to:

Avril, for art
Farn, for Africa
Dolly, for reading
Philip, for learning
Kai-Julian, for play
Carl, for persuasion
Roger, for adventure
and
Lisa, for life

Acknowledgments

To the hundreds of people who shared their homes with me and, through me, with all those who read this: *Ke a leboha!* My thanks also to Lisa Brittan, Roger van Wyk, Molly Nesbit, and Vanessa Solomon, who shared the rigors of field trips, and to Professor the Reverend Gabriel Setiloane, Taole Sesele, and Masepeke Sekhukhune for their valuable perspectives on the research.

The Ph.D. dissertation on which this book is based was submitted to the Department of Art History and Archaeology, Columbia University. For academic support during my studies there, I am indebted to my dissertation supervisor, Professor Suzanne Preston-Blier (currently Department of Fine Arts, Harvard University), Professor David Rosand, who encouraged me to prepare an exhibition of the photographs contained in this book, and professors David Freedberg, Keith Moxey, and Margaret Nesbit.

For fruitful discussion, thanks to Dr. Sandra Klopper (Department of Art History, University of Cape Town), Stephen Gill (Morija Museum and Archives), Professor Z. A. Matsela and Dr. David Ambrose (University of Lesotho), Karel Schoeman (South African Library), and Dr. Andrew Spiegel and Dr. David Coplan (Department of Social Anthropology, University of Cape Town).

Thanks to the Morija Museum and Archives, South African Library, South African Museum, and South African National Gallery for black-and-white archival illustrations.

Financial support was provided by the Fulbright program (1989–91), the Rockefeller Foundation African Dissertation Award (1991–92), and Columbia University's President Fellowships (1992–94).

6

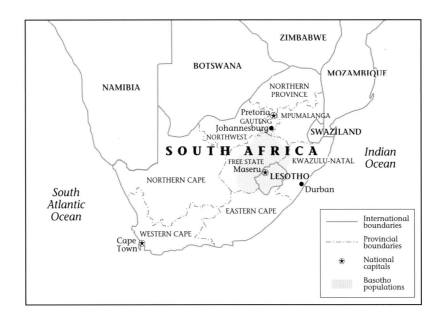

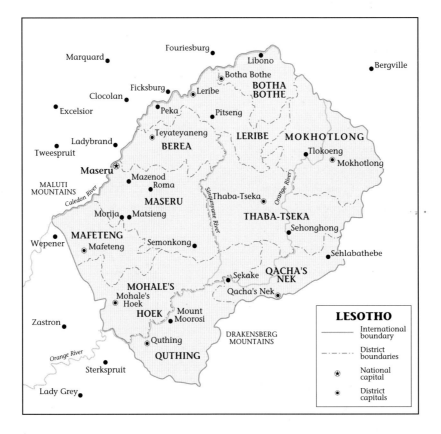

Introduction

At the heart of South Africa is a high plateau called the Highveld. It stretches for 200 miles south of Johannesburg to the dramatic escarpment of the Drakensberg Mountains, whose spires stand like a barrier of spears along the southern edge of the Highveld. The peaks, ragged as the points on the back of a dragon (which give them their name), plunge down toward the subtropical lowlands and beaches along the Indian Ocean coast. These inhospitable Drakensberg Mountains, together with the Maluti Mountains, which merge into them, and the Highveld, are the home of the Basotho (pronounced buh-SOO-too) people.

For me as a child, en route to and from beach holidays with my family, the Highveld's rolling plains and fields were a bleak and monotonous torture that had to be endured. The landscape is hypnotic in its uniformity. The highway unravels in a shining black ribbon of tar over a succession of low hills. It vanishes over one hump and reappears, slightly narrower, to climb the next rise. As a family game, we tried to estimate how far it was to the next visible landmark, and, speeding, how long it would take. The arcs of electric wires, strung between the poles that marched beside the road, rose and fell as regularly as a sleeper's chest. Occasionally, brightly painted mud houses flashed past outside the window, like surreal visions in a dream. These were the houses built and painted by Basotho farm workers living on white-owned farms. Their bold patterns pulsated just beyond the power and telephone poles, whose wires never stooped to connect these humble settlements. We never stopped to appreciate these houses up close.

My aesthetic interest in the paintings and my curiosity about their meaning later became the central focus of my life. I came to realize that the murals are a form of religious art. They honor and please the ancestors to whom the Basotho pray for peace, rain, and plenty. If the prayers are successful, the rains arrive and wash away the paintings, but the fields, the herds and the families of the land all flourish, fertility and abundance abound. The murals, I later learned, are filled with symbolism related to these beliefs.

The mud walls of the houses are likened to the fields, and the designs incised into the walls and painted on them are signs of cultivation, equivalent to the furrows hoed into the earth. Many mural designs refer to flowers and to the plant world, and are signs of fertility. Houses themselves are metaphors for the womb and Creation, when humans emerged from a cave deep in the earth. The symbolism of the houses and the murals are thus intimately related in many ways to the realm of women. These symbolic links are also emphasized during women's initiation ceremonies.

The earth is the source of genesis, a metaphor for the womb, the platform for all life, and the

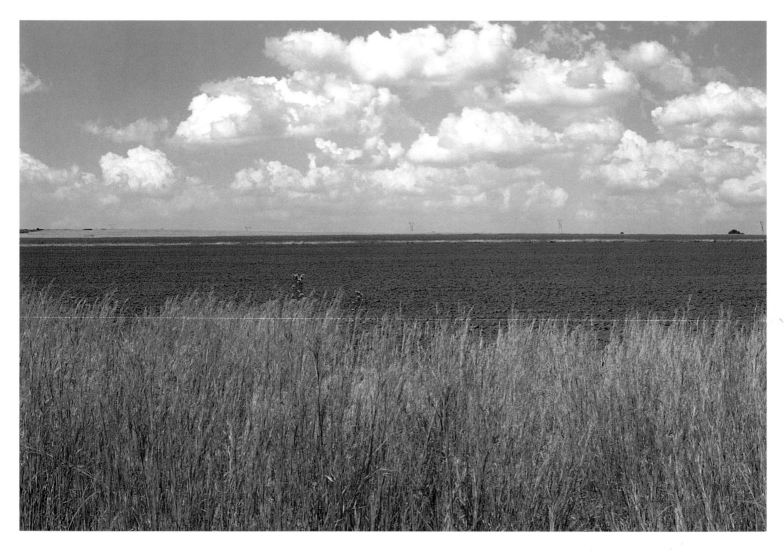

For Basotho the earth is possessed of spirits—it is the home of their ancestors. Much of the Free State province of South Africa is ancestral Basotho territory of which they have been dispossessed by whites in the course of South Africa's bloody history of racial conflict. Violence intensified in the years leading up to South Africa's first democratic elections in 1994, when control of the country was at stake. At the same time a crippling drought struck. Basotho saw this is a punishment from the ancestors for the bloodshed that was defiling the earth. Only if there is peace will the ancestors bring the rain that makes the earth bountiful.

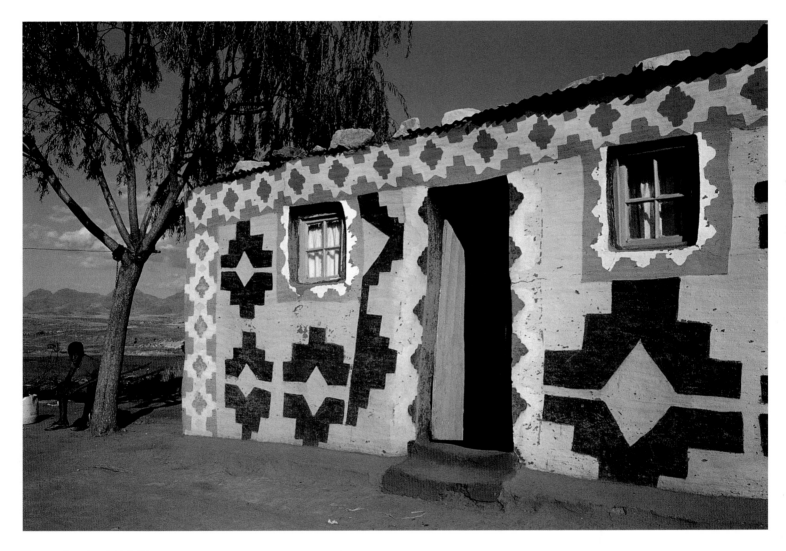

The central portion of this bold design by Ester Mofokeng features the party colors—black, yellow, and green—of the African National Congress (ANC) that led South Africa to democracy in 1994. The mural also employs the symbolic colors of red and black. In the background are the Maluti mountains that, together with the Caledon River, mark South Africa's international boundary with Lesotho.

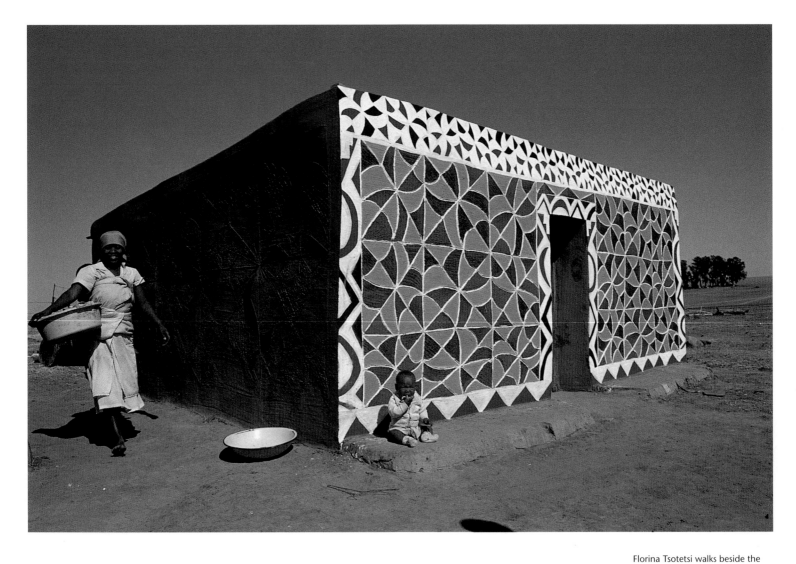

Florina Tsotetsi walks beside the side wall of her house, which she has decorated by incising the mud plaster while wet with designs that are like plowed fields. They refer to ideas of fertility, as does the complex floral pattern on the facade, which is symbolic of the womb and Creation. The symbolic colors of red ocher, black, and white are employed throughout the design, together with a soft pink mixed from red ocher and whitewash. 1992.

This bold design by Sana Mabaso combines a black, radiant cross (right) with a gray, curvilinear, floral motif on either side of the window. The window is skillfully integrated into the composition by the decorative panels above and below it. The black cross design is also employed to integrate the perpendicular surface of the side wall on the left, becoming three-dimensional. The top frieze, sometimes termed the "headband," continues across all three wall surfaces, while the base frieze is a miniature variation of the pattern segment seen at the extreme bottom left of the photograph.

Opposite is a very different but equally bold design emphasing simplicity. Maria Mokhethi, 1992.

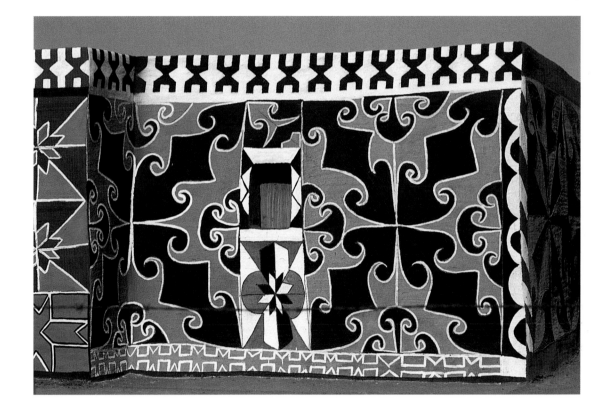

sacred resting place of the ancestors. Earth, which is the building material for the house and the medium of the murals, is thus loaded with meaning: it is meaningful matter.

Red, black, and white are important symbolic colors used in various combinations in most murals. Red ocher symbolizes both the blood of animals offered to the ancestors in sacrifice, and menstrual blood that suggests that a woman is fertile. Red thus implies both rain and fertility. Black is the color of the ancestors and the dark rain clouds they bring. White is the color of purity, transitional states, and enlightenment. To this ancient religious palette is added a spectrum of modern colors, which lend new shades

to old prayers and transport tradition into contemporaneity.

The powerful, dazzling effects of many patterns prove the skill of Basotho women artists in handling color, form, and composition. These achievements are all the more remarkable when one considers that the paintings can also be regarded as symbolic and religious works, as feminist statements, as ritual or performance art, and even as earth works composed of the very sacred earth that is so integral to the murals' meaning. These stylistic labels, however, are of little or no relevance to the artists themselves. Their motivations are moral and religious: to show they keep a proper traditional

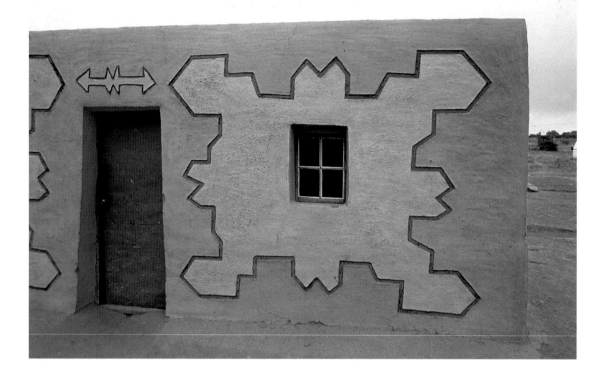

Captions for images appearing on pages 16–31:

Pages 16–17
Ntswaki Khangile's striking end-wall design in black, red, and white employs overlapping squares to create a bold floral motif. The black brackets at the left and right of the mural steady the composition. Viewed in isolation, the powerful contemporary compositions painted on end walls are like canvasses propped up in the landscape. 1990.

Page 18
Mapialo Moloi, 1992.

Page 19
Maria Msiya, 1992.

Page 20
Anna Mofokeng, 1992.

Page 21
Arena Mahlaba, 1988.

Pages 22–23
This family cannot afford window frames—signs of status—but the facade of their home has been beautifully decorated. In houses of this type the corrugated metal roof is hidden behind the parapet, which is marked by the "headband" frieze. Water drains to the rear of the house. The thatched building on the far right is the kitchen; smoke filters easily through the roof. Weie Minah Motaung, 1992.

Page 24
Jermina Ngozo, 1992.

Page 25
Maria Mokheti, 1992.

Page 26
Mamozwake Kwaaiman, 1992.

Page 27
An antenna stands in front of the door, which is emblazoned with the name of the household head and surrounded by white lines in raised relief. Ester and Emily Nguni, 1992.

Page 28
Sanna Motaung, 1992.

Page 29
Titi Nyembe, 1992.

Page 30–31
Miriam Motaung, 1990.

Basotho home that respects the ancestors. For Basotho women artists, beauty is not merely a matter of aesthetics, it is a branch of ethics.

I also came to realize the murals had a deeper and more general significance. They functioned as flags that proudly asserted the Basotho identity of the women who painted them by signaling their creators' participation in a rich culture and an ancient art-making tradition. The murals flew in the face of the oppressive apartheid regime that used every conceivable strategy to demean black existence—past and present. To understand how the paintings asserted Basotho identity, I explored both the quite remarkable history of the Basotho nation and the socioeconomic situation of the Basotho families living in the Highveld at the end of the apartheid era.

The more I researched, the deeper, more poignant, and more dynamic became the message of the murals. The structure of this book parallels my own process of discovery, as I examined the political and historical context of the Basotho, and then explored the aesthetic and symbolic values encoded in their architectural arts.

(Text continues on page 32)

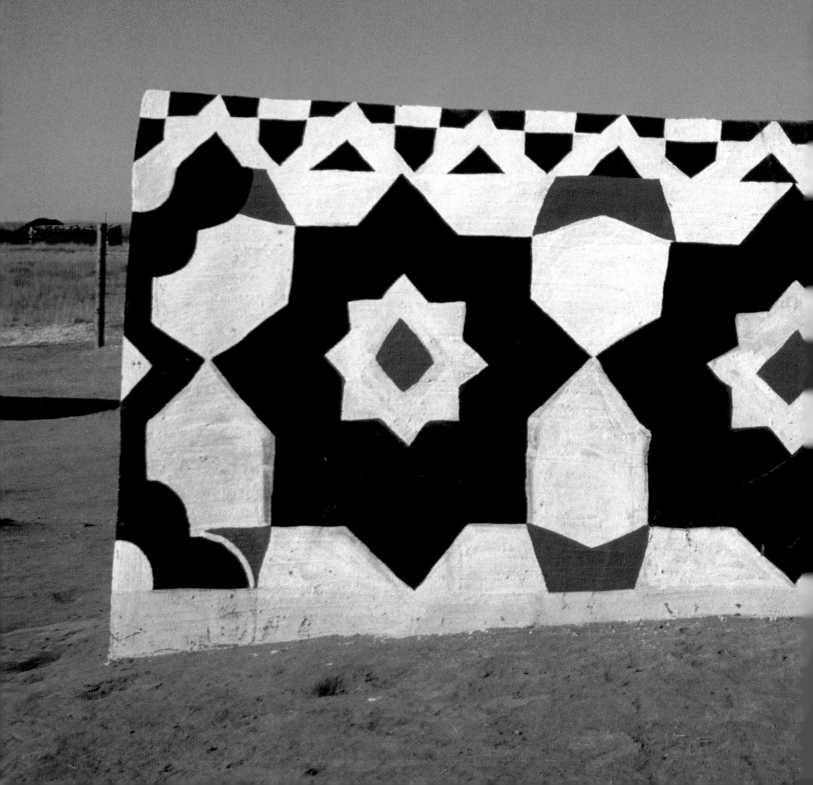

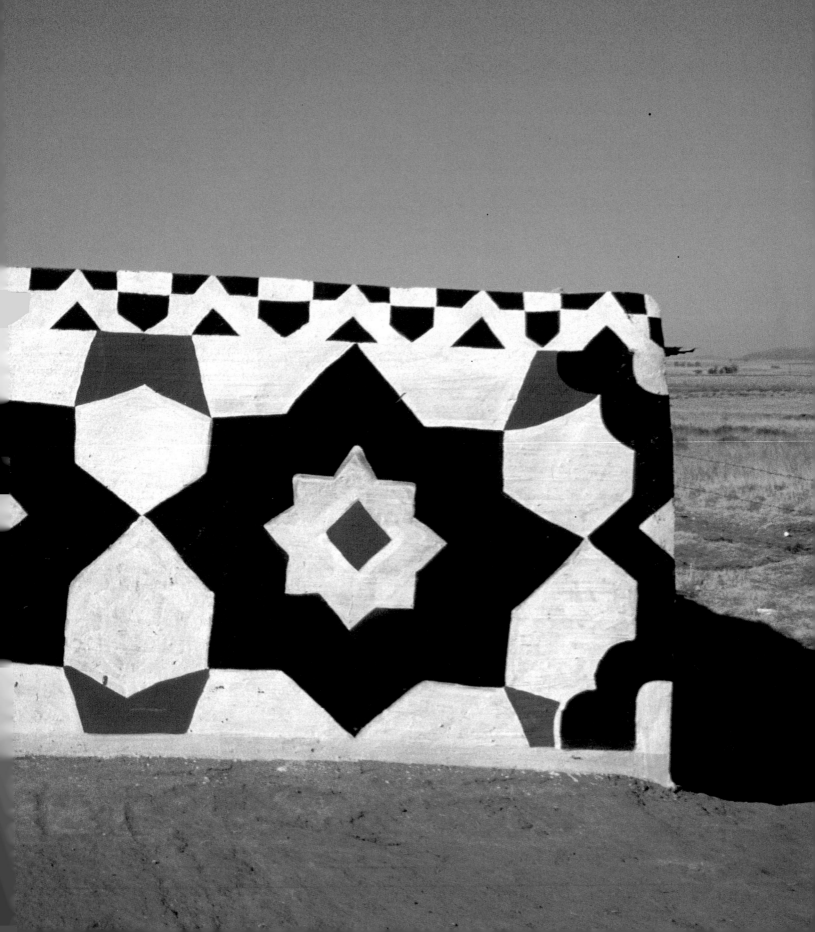

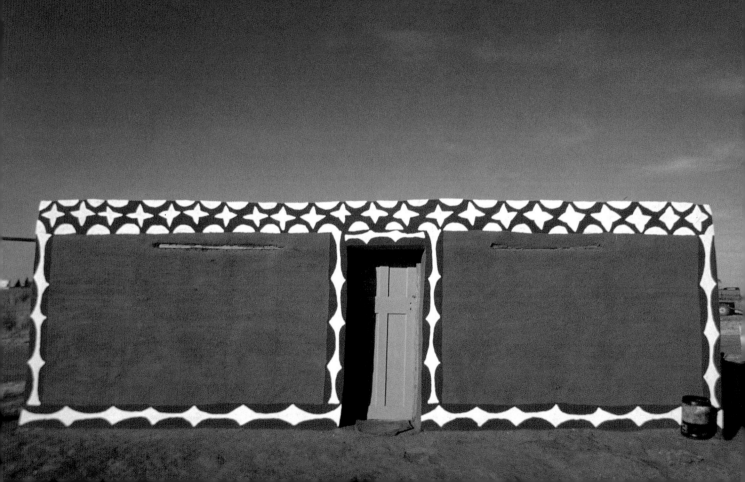

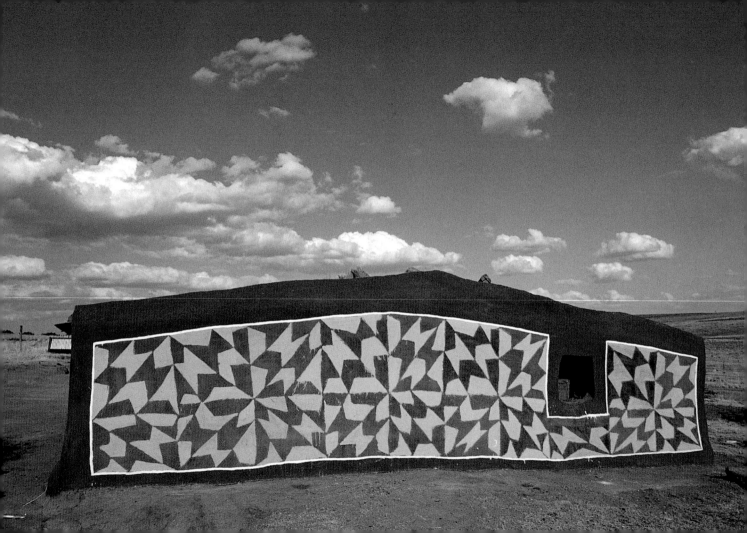

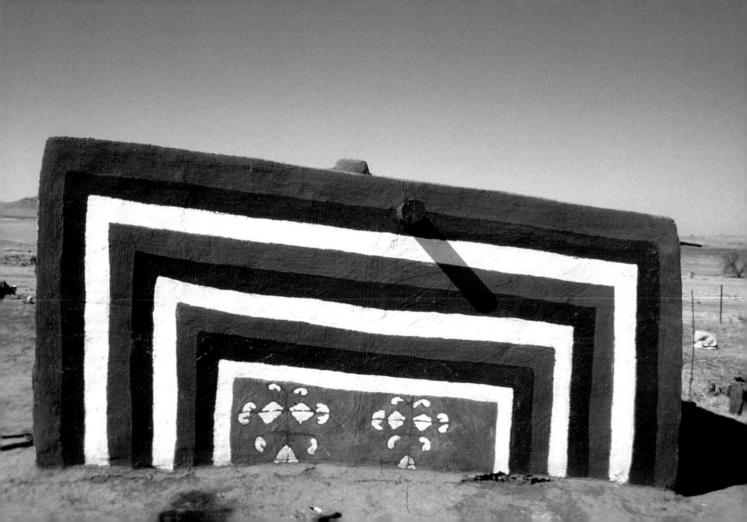

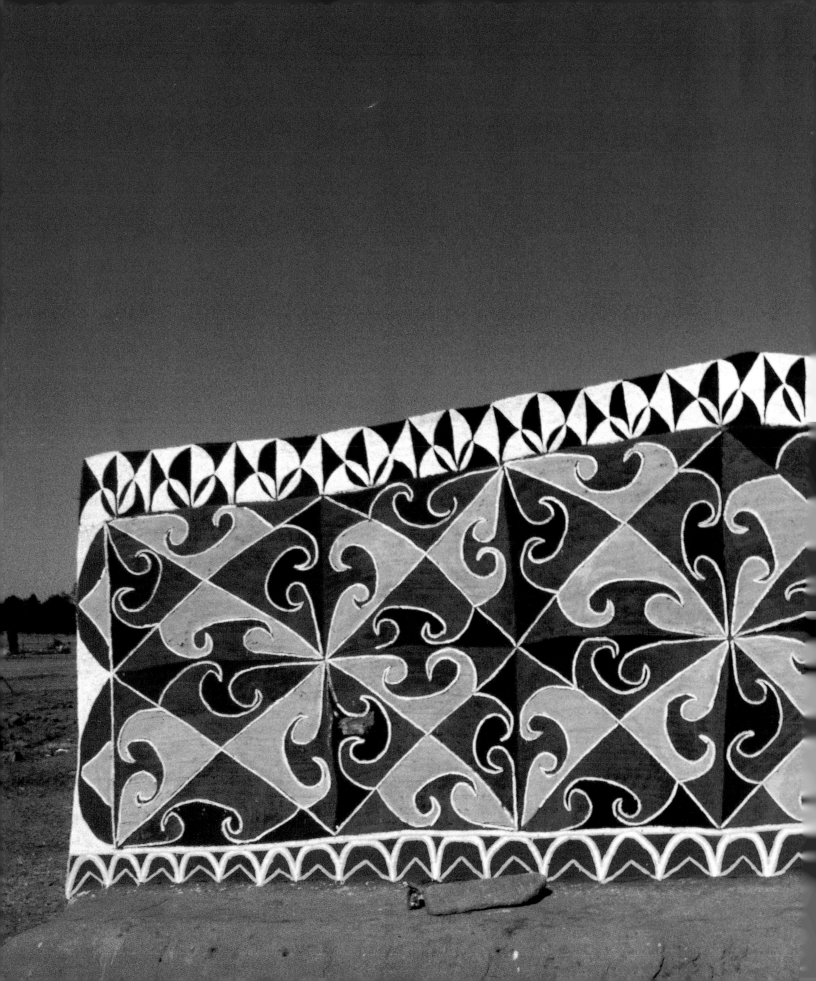

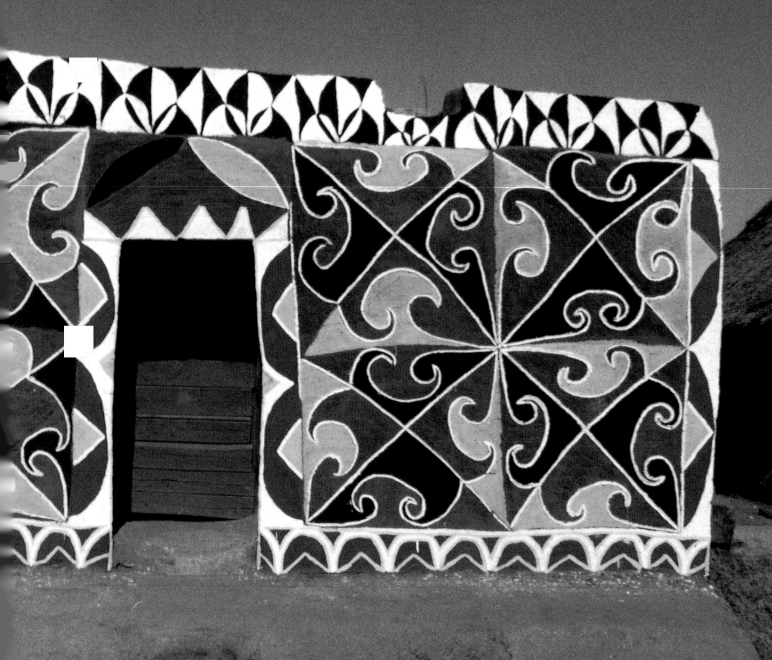

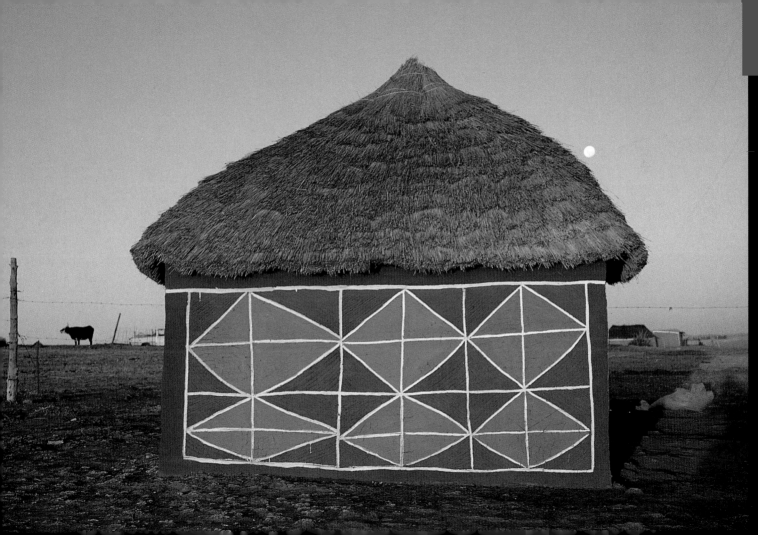

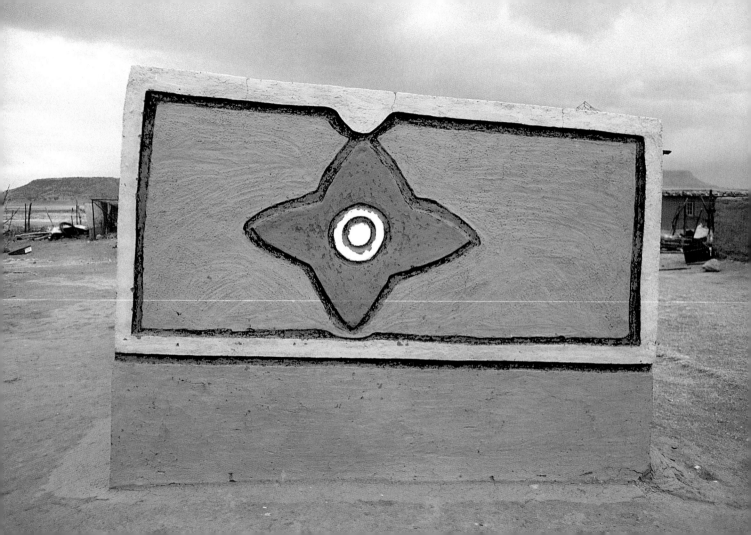

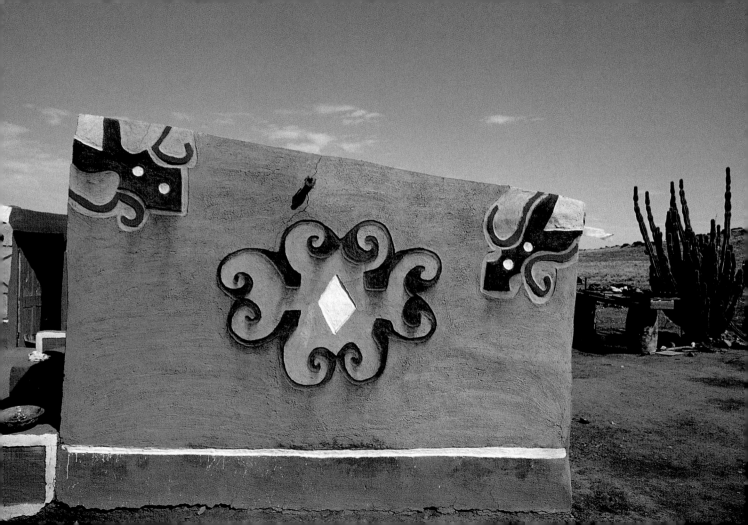

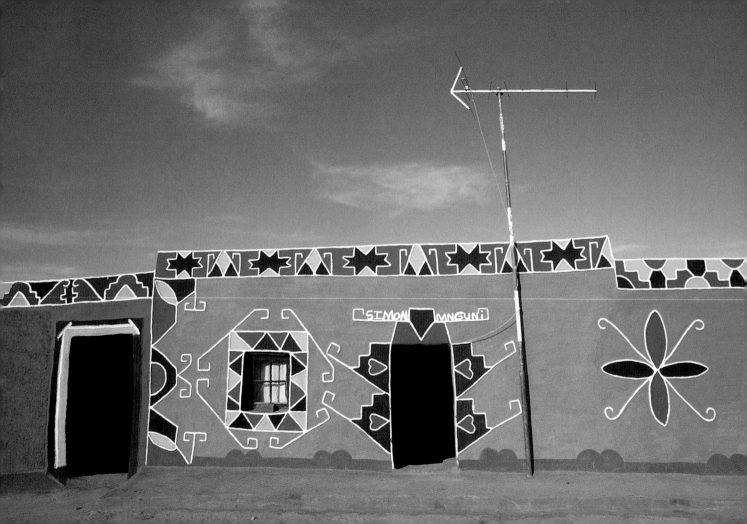

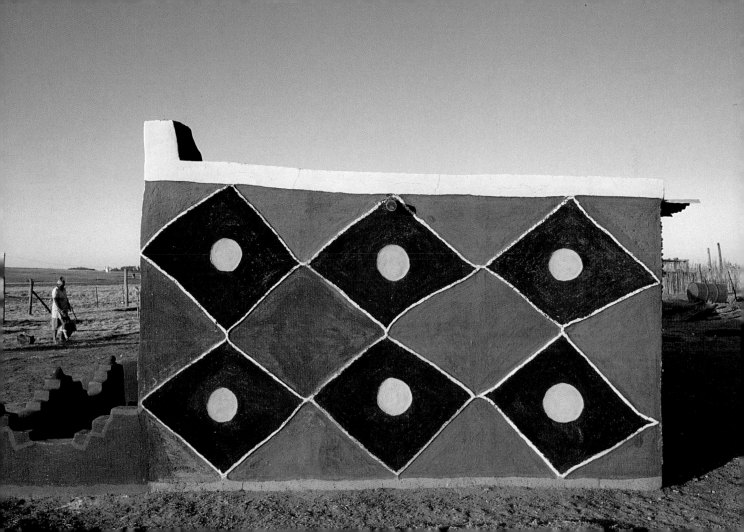

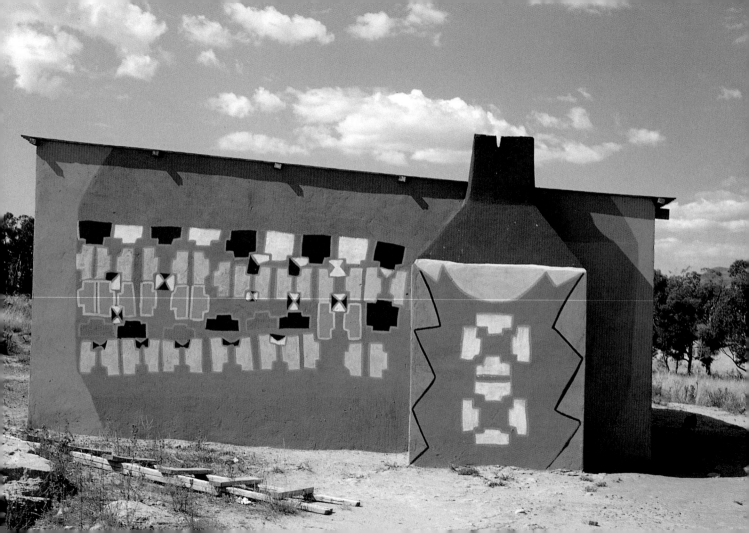

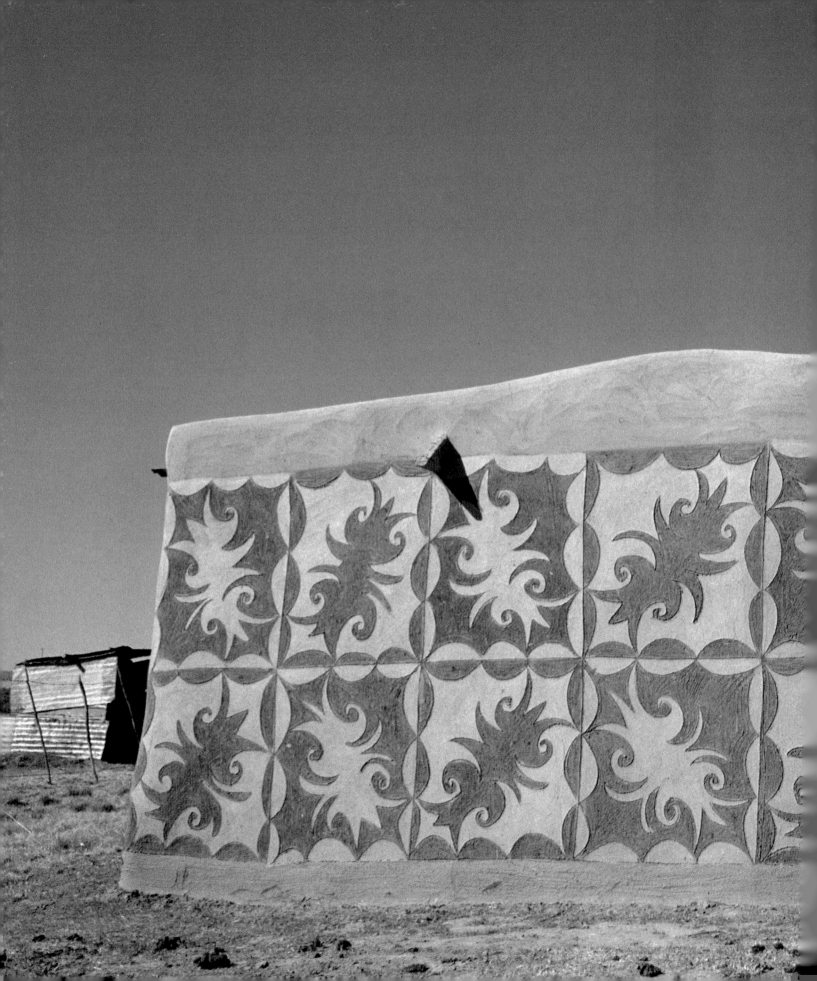

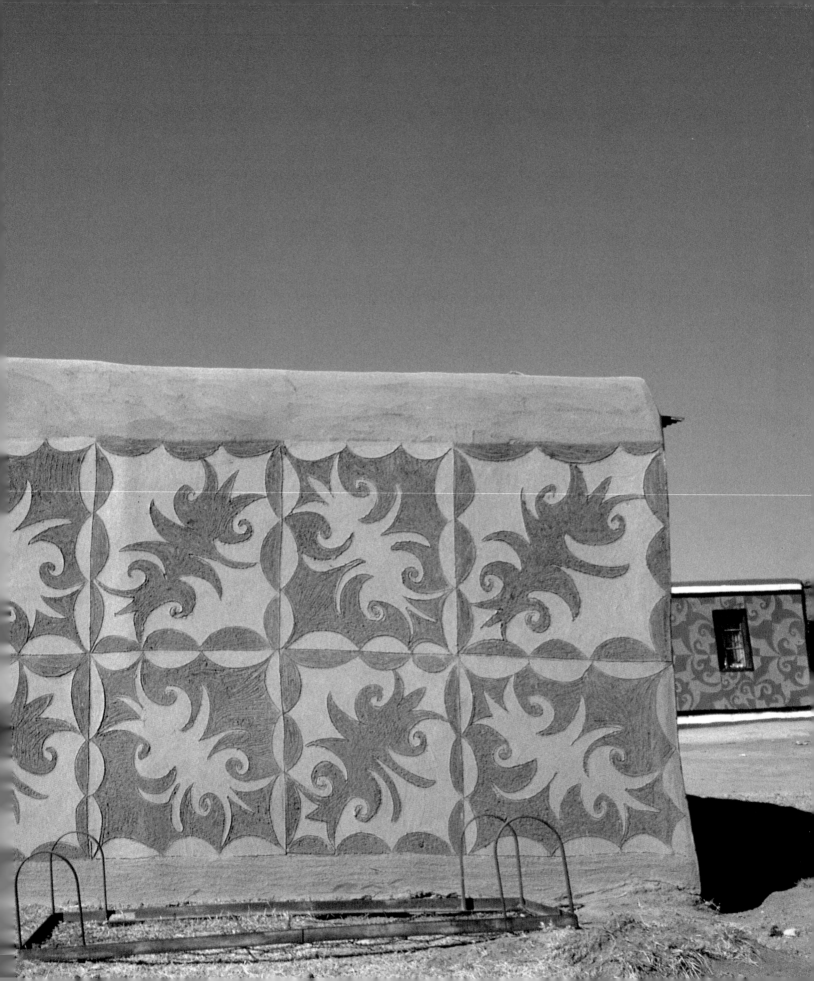

The situations and environments of Basotho in Lesotho and South Africa differ in several ways. In the Free State the security of tenure of Basotho laborers such as Galone Sotetsi (top) is dependent on the goodwill of the farm owners. At any time workers can be forced to leave their houses, which crumble back into the very earth from which they were built. In Lesotho many homesteads continue to survive by farming and herding (opposite) on land that is not privately owned but held in trust by Basotho chiefs, who allocate it to their followers' use. The mountainous country of Lesotho is so cramped that many Basotho live permanently in South Africa or work there as migrants. They might maintain only a tiny room in Lesotho such as this dwelling (bottom) on the outskirts of Molimo Ntusi—a name that means "God help me."

Most of the Highveld falls in South Africa's Free State province, which was called the Orange Free State before South Africa's apartheid regime finally yielded to democracy in 1994. Until then, the province was not free by any stretch of the imagination. The white, right-wing Afrikaner farmers who dominated the region made it one of the most tense and racist portions of the country. Their wealth was built on exploitative labor conditions sanctioned by the state and propped up by generous government subsidies. Over the course of less than a century, first by conquest in the mid-1800s and later by repressive legislation, Afrikaners stole much of this land from its original Basotho inhabitants.

Through extraordinary tenacity, skillful diplomacy, and British protection from 1869 onward, Basotho managed to preserve the least desirable portion of their territory—the Maluti mountains and the Drakensberg. Their country was known as the British protectorate of Basutoland. In 1966, Basutoland became the independent country of Lesotho. It is the world's only landlocked state that is surrounded on all sides by one neighbor: South Africa. Today, because work is there, more Basotho live permanently in South Africa than in Lesotho, and about half of Lesotho's own population consists of migrant workers who spend most of their time in South Africa.

The Basotho laborers on the white-owned farms of the Free State make up 77 percent of the province's population. Their small villages, consisting of families who work on a single farm, range from only a couple of homesteads to as many as twenty. Many of these laborers feel alienated from the center of Basotho culture, which they believe to be in Lesotho, which most of them have never visited. Yet in fact they preserve Basotho tradition and extend it with remarkable artistic innovations. This became

Both: Street mural project, 1985.

crush mounting resistance. The violence and barbarity of the crackdown shocked the world; more than a decade later South Africa's Peace and Reconciliation Commission, headed by Archbishop Desmond Tutu, heard the shocking confessions of those responsible for the massacres, assassinations, and other abuses. During the emergency, the state censored newspapers and passed a law that equated the publication or creation of any photograph, drawing, or other representation of conflict with terrorism, which carried the death penalty in South Africa. The press responded by publishing blank spaces to indicate banned pictures and reports, until that, too, became illegal. Never had the power of art and photography in South Africa seemed so political.

In 1985, I began to paint the violence we lived with but were forbidden to see. In the middle of the night, my collaborators and I covered billboards and city walls with bold murals. Numerous sheets of poster paper had to be hurriedly glued up in the correct order to form the full design. It was terrifying work. I recall one instance when we feared that a passing police patrol had spotted me sticking down the last few pieces of a billboard painting. I yelled at my wife, Lisa Brittan, to hold the ladder still, and she shouted "I am—it's your knees that are shaking." Compared to what other activists risked and suffered, our actions were minor, but they took on disproportionate significance as newspapers printed photographs of the anonymous art on their front pages and in color features. They also published graffiti-watch columns that encouraged people to visit the latest mural before it was torn down. Documenting these short-lived works was the key to their effectiveness. Extending this documentary mission, I began to photograph graffiti and

clear to me during extended periods of travel and research in both the Free State and Lesotho between 1988 and 1994, when the photographs in this book were taken.

I first became actively interested in Basotho murals in my final year of art school in Johannesburg in 1985, at the height of South Africa's most repressive era. The apartheid government had declared a state of emergency to

other subversive ephemera, and became interested in all forms of mural art.

I was astounded to discover that away from Johannesburg some Basotho women in the Free State were painting their houses in the colors of Nelson Mandela's outlawed political party, the African National Congress (ANC). At this time, showing the black, green, and gold of the party colors was illegal. A farm worker whose tattoo included the initials ANC was forced to have it removed and was jailed for three years; a coffee mug with the same initials earned its owner a four-year sentence. In the face of such state paranoia, resistance was forced to find subtle outlets. While a T-shirt with a liberation slogan or ANC colors invited trouble, it would have seemed too absurd for the police to arrest a woman who signaled defiance simply by wearing a green dress, black shoes, and gold earrings. And it was impossible to seize a Basotho house whose facade might, in fact, have been flying a flag of resistance. Several houses subtly occupied this slippery threshold of signification. Some combined the forbidden three colors with the neutral brown of the mud walls, others used only two of the colors. My favorite example used the windows and doorway, which show the dark interior, to provide the black that complemented the green and yellow facade.

The state of emergency effectively slowed overt resistance, but it also strengthened political unity among South Africans of all races and backgrounds who were opposed to the state. Academics, intellectuals, and artists, among others, set out with a new determination to bridge the boundaries between their differences and shatter the racial and ethnic barriers that were the cornerstone of apartheid.

As for my own involvement in battling apartheid, I discovered in art history, which all

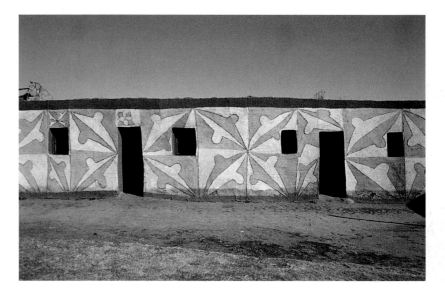

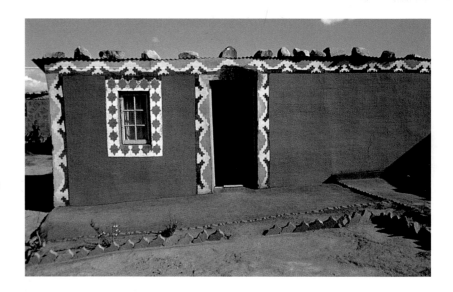

These mural treatments by Maria Sekasa (top) and Puseletso Mohlabai (bottom) use the ANC colors of black, green, and yellow.

art students were obliged to study, a powerful tool for undermining apartheid ideology. The history of African art reveals that works of extraordinary aesthetic power, richly layered with meaning, are intimately tied to the religious, moral, and philosophical values of African societies. On the one hand, this suggested the kind of nexus between art and society that seemed worth striving for as an artist in South Africa at that moment. On the other hand, it countered the denigration of African culture that was the result of apartheid, although not its expressed intention.

In an apparent contradiction of their repressive ideology, the Afrikaner architects of apartheid argued that every ethnic group should be free to preserve its own language and culture. This stemmed from their own historic desire to be free of English domination. The subtext of their rationale for ethnic autonomy, however, was that the Bible stipulates that black people are inferior: Job's descendants shall evermore be the hewers of wood and the carriers of water. The abolition of slavery throughout the British Empire in 1833 was deeply resented by Britain's Afrikaner subjects in the Cape Colony, who saw it as an abomination against both their Calvinist beliefs and their economic interests. These early Afrikaners decided to leave the Cape and trek into the uncharted hinterland to escape British control. They likened their exodus to the biblical flight from Egypt. Before long the Afrikaner trekkers saw themselves as a kind of chosen people, beloved of God and sanctioned by him. For more than one hundred years the history of the subcontinent was dominated by the struggle for control of the subcontinent between the British and the Afrikaners, in the course of which both sought to smash, or at least limit, the power of black states.

The Afrikaner Nationalist Party finally came to power in South Africa in 1948, and implemented the philosophy of apartheid. The world understands that apartheid separated the races. In practice, its philosophy, deeply rooted in Afrikaners' historic antipathy toward both the British and blacks, was to separate *all* ethnic groups. The rationalization behind apartheid was that all ethnic groups should express their own unique character—language, culture, customs—through their own institutions. For blacks, this also meant being sequestered in their own distinct territories.

The Nationalist Party set out to advance the power of Afrikaners in every sphere. The Nationalist government sharply separated English-speakers and Afrikaans-speakers, creating a deeply divided white community over which they entrenched their hegemony. Apartheid fragmented blacks into numerous "tribes" that were each given an ethnic "homeland," or reservation, where they could exercise their own uniqueness, but from which they could lay no claim to the economic and political power of white-ruled South Africa. This policy conveniently restricted blacks, more than 77 percent of the population, to 13 percent of the land. It also sharpened ethnic boundaries between them that have always been far more fluid than apartheid ideologues would admit. Among Basotho, for example, intermarriage with other groups was common, and even today many of the families of farm workers in the Free State are products of mixed marriages. This goes to show that ethnic identity is a far more complex issue than apartheid purists imagined.

One of the ironies of apartheid was that it threw into crisis the sense of identity of those black traditionalists who did take a restrictive view of their own ethnic identities. Increasingly,

it became clear to blacks that the road to freedom lay in uniting across the ethnic boundaries that apartheid emphasized and continually reinforced. The route to democracy necessitated transcending ethnic differences and forging a new national identity across racial and ethnic lines. Those blacks who treasured their ethnic identities and traditions risked playing into the hands of the apartheid state and being seen as its puppets. Tradition was thrown into crisis.

The price of unity and resistance seemed to be the rejection of ethnic heritage—a situation not unlike that of Hans Christian Andersen's Little Mermaid, who makes a pact with a witch to acquire the legs she needs to chase her handsome human prince. The price of every step she takes as a fish out of water is the stabbing sensation of a hot knife in her foot. With great fortitude, wan with pain, she dances with delicacy and flair at the prince's ball. It seemed to me that the Basotho women of the Free State, who used their traditional painting to signal their support of the ANC, showed similar strength as they trod the line between their tradition and their resistance.

Even as a child, I knew Basotho had a proud history. Though the history books employed in our all-white, all-English schools contained almost nothing about black South Africans, I had read on my own about the wise Basotho king Moshoeshoe (pronounced Moh-SHWEH-SHWEH). Later, as I explored Basotho life and researched their history, I understood how their morality and identity, rooted in the past, informed their present. They drew on their cultural outlook, as I drew on mine, and our political perspectives arrived at a similar place of resistance. Nonetheless, our environments were very different in many ways. For one, the car-

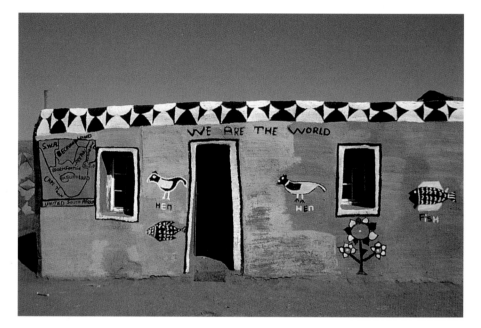

nage and flames in the cities seemed a million miles away from the tense emptiness of the Free State, lying open to the eye of the sun set in its azure sky.

The state of emergency that existed in Johannesburg in the mid-1980s was a dark and depressing period. One memory that I have, vivid because of its symbolic dimensions, is from an incident on our university campus when Lisa and I were part of a demonstration that was attacked by armed police. With us was a friend who had been hiding in our apartment. Occasionally, he slipped out at night, dressed in elaborate disguises and careful not to be noticed by white tenants who might report the illegality. Eventually he could bear the frustration of hiding no longer, and joined a campus protest. As the police charged, Lisa and I fled into the campus theater. Watching the riot through the

Elsina Matlaba's mural incorporates English words and cartography to assert messages of unity and identity. Her map omits all the territorial boundaries of apartheid South Africa's ethnic "homelands," which promoted ethnic and racial separation. Instead it recalls the names of the British protectorates of Basutoland and Bechuanaland that were proclaimed in the nineteenth century to prevent Afrikaners from usurping the land of the Basotho and Batswana peoples. The mural is pointedly political in resurrecting these names and spelling out its messages in English, recalling the historic antipathies between Briton and Boer and the alliance between the Basotho and British against Boer ambitions. But the choice of English also carries a more contemporary sting. In the apartheid era English was the shared language of resistance; Afrikaans—the *lingua franca* in which farm owners in the Free State communicated with their workers—was the language of the oppressor. The English message, "United South Africa," both dismisses the divisiveness of apartheid South Africa and snubs Afrikaans. 1988.

At the entrance to the Skosana homestead, a sign warns visitors to beware of the dog. Free State, 1992.

Opposite top and bottom:
Elisa Mofokeng, 1992.

Page 40:
top to bottom:
Elsie Nhlapo, 1992.
Matobiso Moloi, 1990.
Ntsie Moloi, 1990.
Mamoya Mokwena, 1990.

Page 41
top to bottom:
Sarah Makhalemele, 1992.
Maphalla Magunye, 1990.
Lisbeth Msanyana Sotetsi, 1992.
Mathabo Twala, 1990.

huge, one-way glass windows, we witnessed our friend being seized and savagely beaten right in front of us. Helpless and horrified, we stood there frozen, like useless mannequins.

This movielike scene of a man's capture added to my own desperate sense of the state closing in on me. My most immediate threat was military service in the apartheid army, compulsory for all white men. Called up for January 1986, I lied to authorities to obtain a permit to exit South Africa on the false pretext of a family emergency, and fled into exile in neighboring Zimbabwe, where I had the good fortune to be born and was a citizen. We started a new life. In spare time, I continued to paint mural-size works on canvas. The paintings and my photographs of the poster mural project gained wider audiences through publication and exhibitions in Africa and Europe, yet I felt increasingly cramped and cut off in Zimbabwe.

I enrolled to study by correspondence for a graduate degree in African art history, and nervously returned to South Africa several times on a new passport, declaring myself to officials as a vacationing foreigner.

On one visit to Johannesburg, I was invited by a fellow mural enthusiast, Annette Loubser, to curate a photographic exhibition that celebrated mural arts in South Africa. Combining our own photographs along with those of many other contributors, we assembled a large show that covered every aspect of mural art in southern Africa, from prehistoric rock art to contemporary expressions of political resistance, deliberately ignoring all historic and ethnic barriers. Critics felt that this nonracial view of South African art was radically new, and that it spoke to the desire many felt to express a unitary sense of South African identity. One review called the exhibition "one of the most significant events of the decade for the local art scene."

Preparing the exhibition, I photographed murals on the homes of several African groups, and was again profoundly impressed by Basotho women's dramatic handling of color and mastery of sophisticated pattern. At the Guggenheim Museum in New York, I once watched a friend standing in front of a Mark Rothko canvas enter the aesthetic ecstasy that paintings sometimes can provoke. An engineer with little interest in art, he was overwhelmed by the intense fields of juxtaposed color, and he later described the moment as a mystical and transformative experience. Rothko and other Abstract Expressionist painters were conscious of this power and often spoke of their religious intentions as painters. Only after many years of involvement with Basotho communities did I come to understand that their art is indeed religious, intended to call the spirits of the

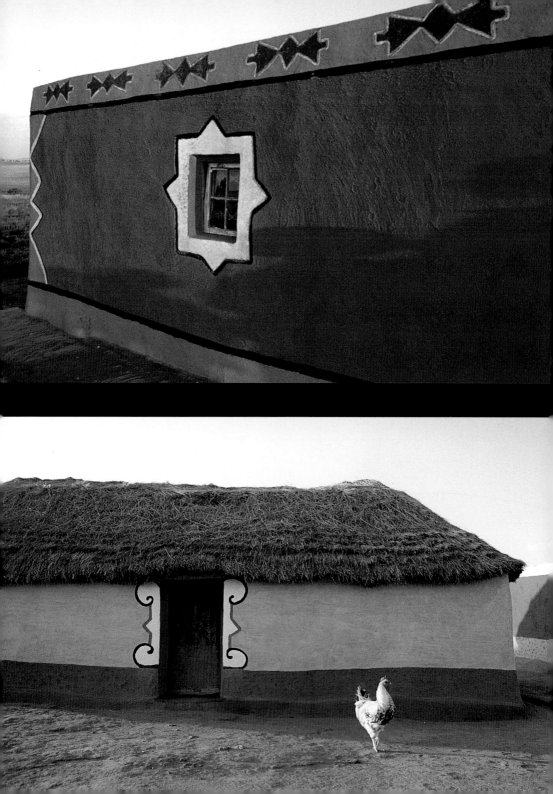

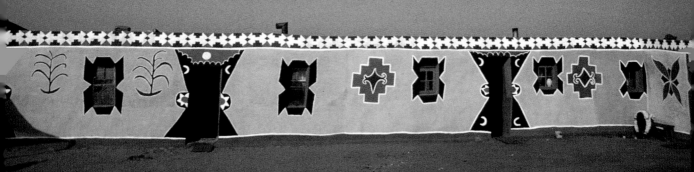
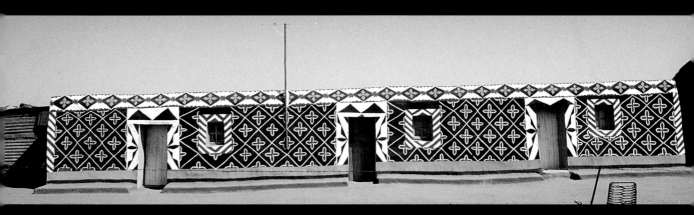
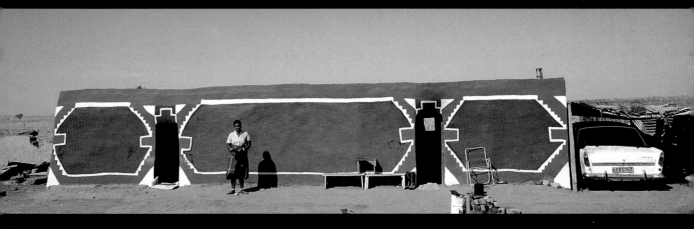
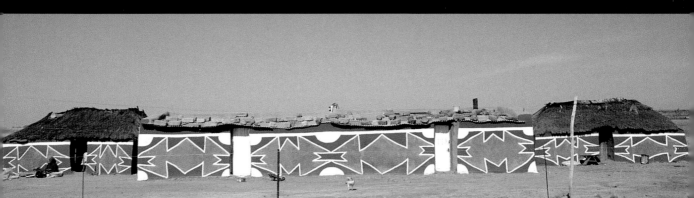

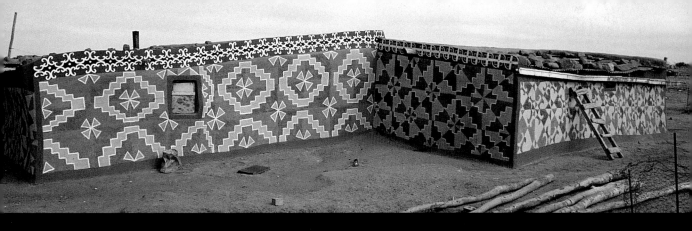

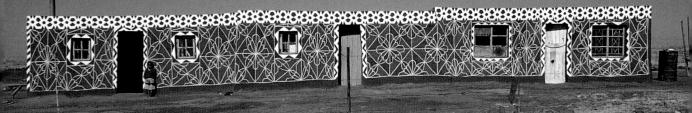

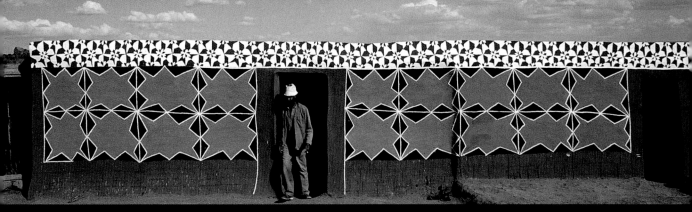

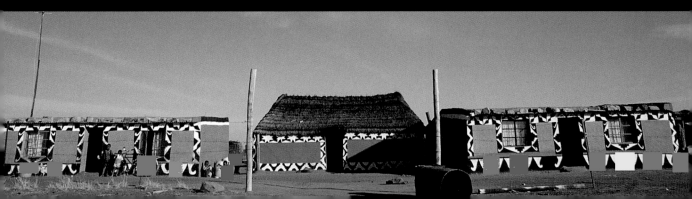

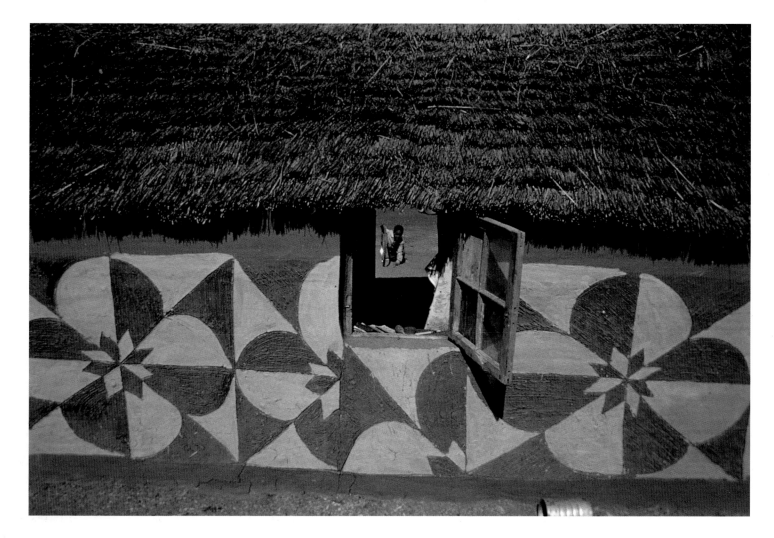

Most Basotho have a strong sense of the continual presence of the spirits of their family ancestors, who reside in the earth and are strongly associated with the house. The house and its precinct are, in this sense, possessed. In this photograph, Alina Tsotesi's son pauses in a game to peer through the house. 1992.

ancestors. But from the outset I always felt that their homesteads were filled with a peace, calm, and religiosity that makes one move through them with the soft and respectful tread reserved for temples, tombs, mausoleums, and, perhaps, museums.

After receiving a Fulbright Scholarship to the Ph.D. program in Art History and Archaeology at Columbia University in New York, this sense of sacredness in Basotho art led me to focus my study of the religious underpinnings of African art on Basotho murals. My

This skeleton of an abandoned homestead reveals the internal structure of a farm worker's house. The evicted occupants have taken with them the valuable doors, windows, and sheets of metal roof to build another house on another white-owned farm, where they might once again be just as easily dispossessed. 1991.

dissertation, *Patterns of Possession: The Art of Sotho Habitation,* set out to explore the ways in which the murals and ceremonies of Basotho were possessed, filled with the presence of the ancestral spirits. I contrasted this with the far less abstract interpretation of the word *posses-sion* as "ownership," charting how the Basotho had lost control of the land of their ancestors. What connects these senses of possession is the fact that religion and tradition have been deployed by the Basotho in artful ways, both to strengthen their own sense of identity and to

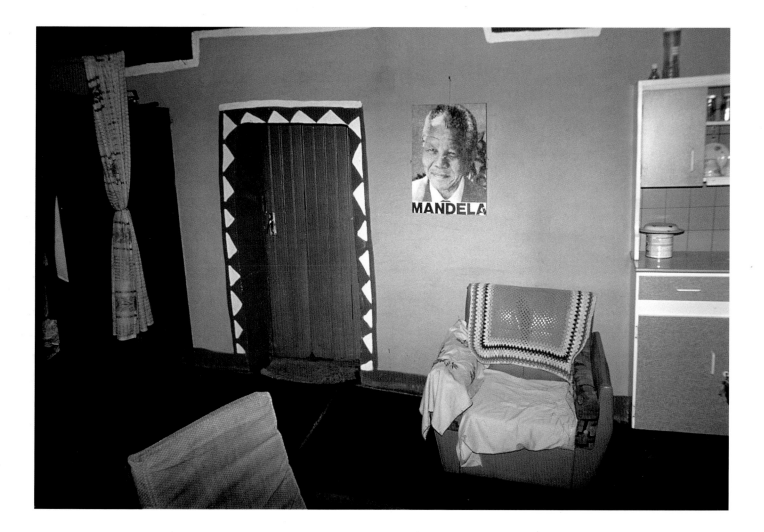

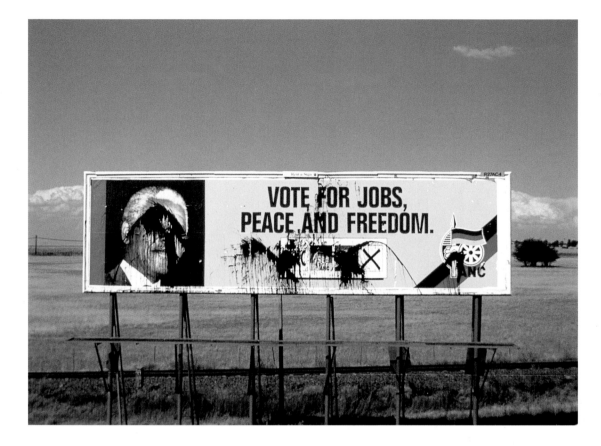

Left and opposite:
All pictures of Nelson Mandela were illegal until after the ANC was unbanned at the end of 1989. Thereafter his face was everywhere. In the homes of Basotho farm workers such as Frans and Christina Moloi it testified to their strong support of the ANC. As elections neared in 1994, whites in the Free State—among the most right-wing communities in South Africa—defaced billboards and posters bearing the face of the man who was soon to become their president and who was already one of the most respected and celebrated leaders of the twentieth century.

resist the dispossession that they had suffered in the past, and with which they were continually threatened in apartheid South Africa.

While studying in New York in February 1990, I watched on television as Nelson Mandela walked out of prison. The ANC was unbanned. The long period of transition that led up to South Africa's first democratic election in 1994 had begun. I was able to return to South Africa in late 1991, and I lived there while researching and writing my dissertation on Basotho arts and documenting the historic changes taking place. My photographic work took on a new

focus as I assembled an exhibition entitled *Fields of Vision: The Art of Basotho Habitation* for the Miriam and Ira D. Wallach Art Gallery, under the auspices of Columbia University. While I photographed, Lisa filmed.

In the early 1990s the Free State was tense and polarized. The Afrikaner right wing was in a violent mood. They threatened war as they sat over strong drinks in their whites-only bars draped with swastikas. Sometimes they made it clear that they did not welcome me talking to the Basotho workers on their farms. They carried guns and set off bombs. Everyone else could

Mr. Mokoena of Forest Creek Farm.

Opposite:
A vista between two buildings
at the homestead of Mmaoupa
Shabangu. 1988.

smell freedom in the air. While we stood in those well-reported voter lines on election day, the Free State turned in its vote: 77 percent for the ANC, exactly the Basotho population of the province. No coincidence.

My interpretation of Basotho art and life presented here evolved slowly. The Basotho family with whom I spent the most time, the Mokoenas of Forest Creek Farm, quickly taught me that personal involvement and experience, rather than asking direct questions, would lead me far more quickly to the deep understanding of their art and outlook that I sought. They took me into their lives and invited me to important ceremonies. The less I thought and questioned like an anthropologist, the more things opened up and fell into place. The more I concentrated my research on the historic background of Basotho, the more the foreground took shape before my eyes.

The photographs in this book have little to do with the requirements of scholarly research. I see them as direct responses to the imminent presence I sensed in Basotho painting, ceremonies, and everyday life. They were taken during brief field trips in 1988 and 1990 and during intense fieldwork in South Africa and Lesotho between 1991 and 1994. There is nothing tricky about them: no color filters, no props, no staging. Wherever possible, I explained beforehand my intentions in taking the photographs. Everywhere I went, the Basotho people with whom I spent time were delighted and proud to share their art and experience with me, and through me, with you.

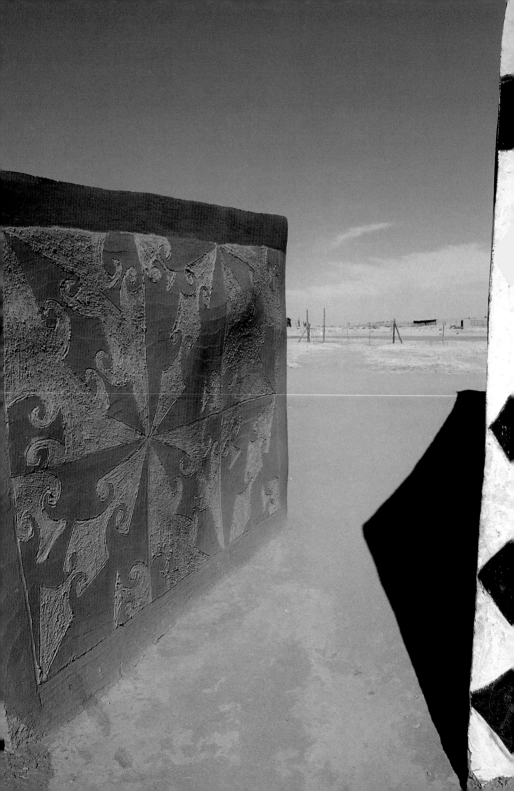

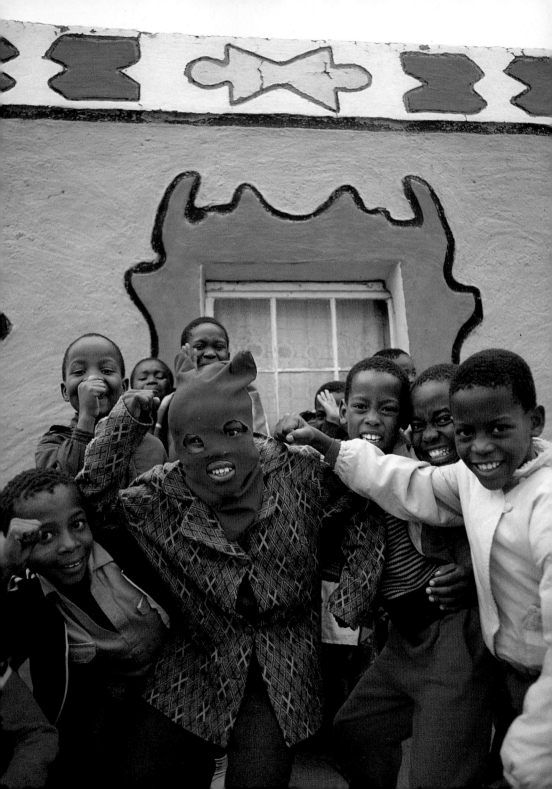

Children enjoyed being photographed and performing for the camera.

Opposite:
A boy staged an impromptu masquerade, his blue balaklava echoing the design of the window surround painted by Maria Mokhethi and his arm raised in a black power salute. 1992.

Left:
An excited dog dashes through the foreground; a wintry wind blows from the mountains of Lesotho in the background; the children of the house strike poses as they warm themselves in the sun. 1992.

Below:
At the Mohapi household a girl poses with mismatched socks that echo the colors of the frieze her mother has painted at the base of the house. 1992.

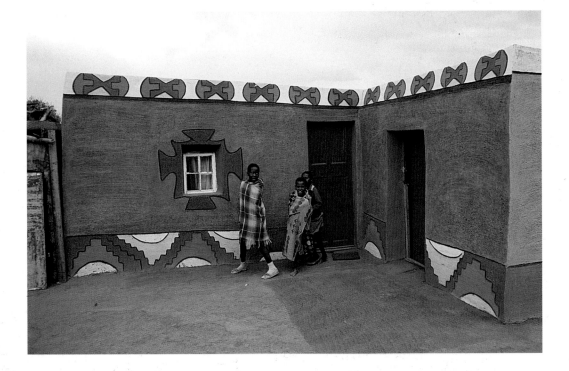

Right:
Children at the house of Nomkubelo Radebe play at traveling in a bus. 1990.

Below:
The poses of these children at the home of Alina Mokgomong echo the strong diagonals of the mural design. 1992.

Opposite above:
In the home of Martha Mokoena (left).

Opposite below:
Girls with dolls.

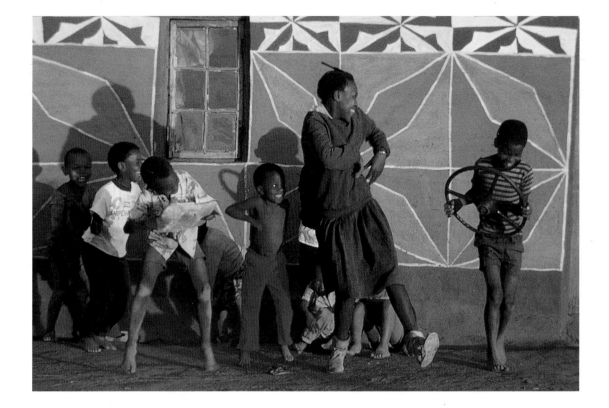

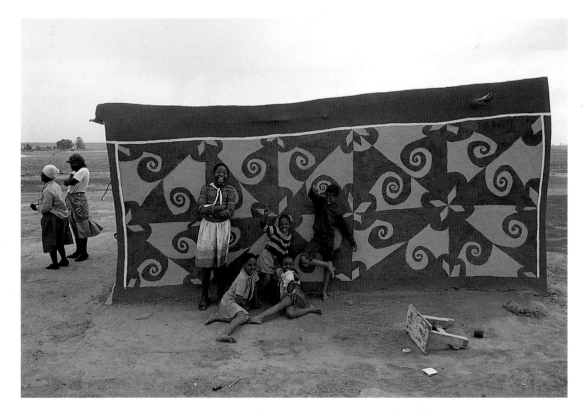

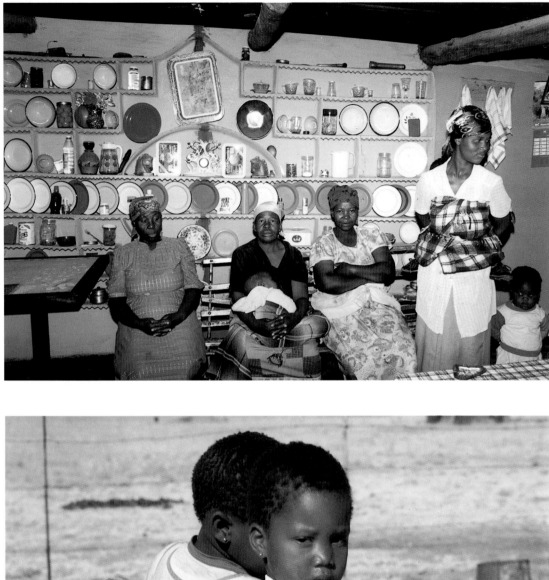

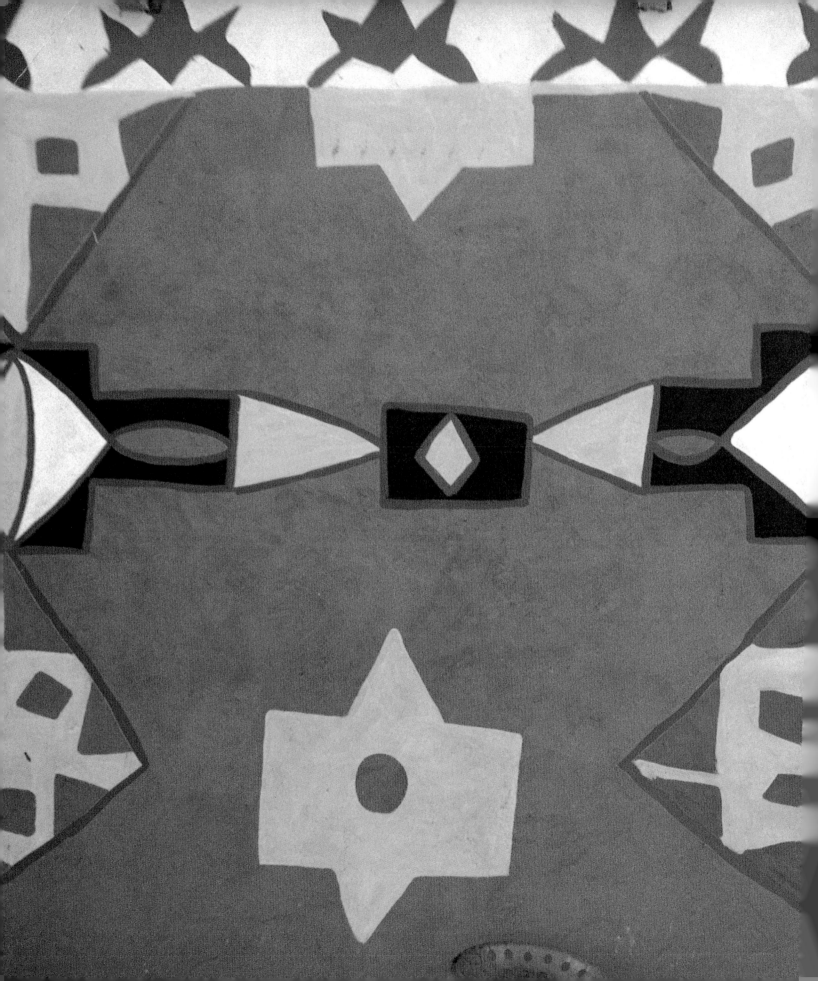

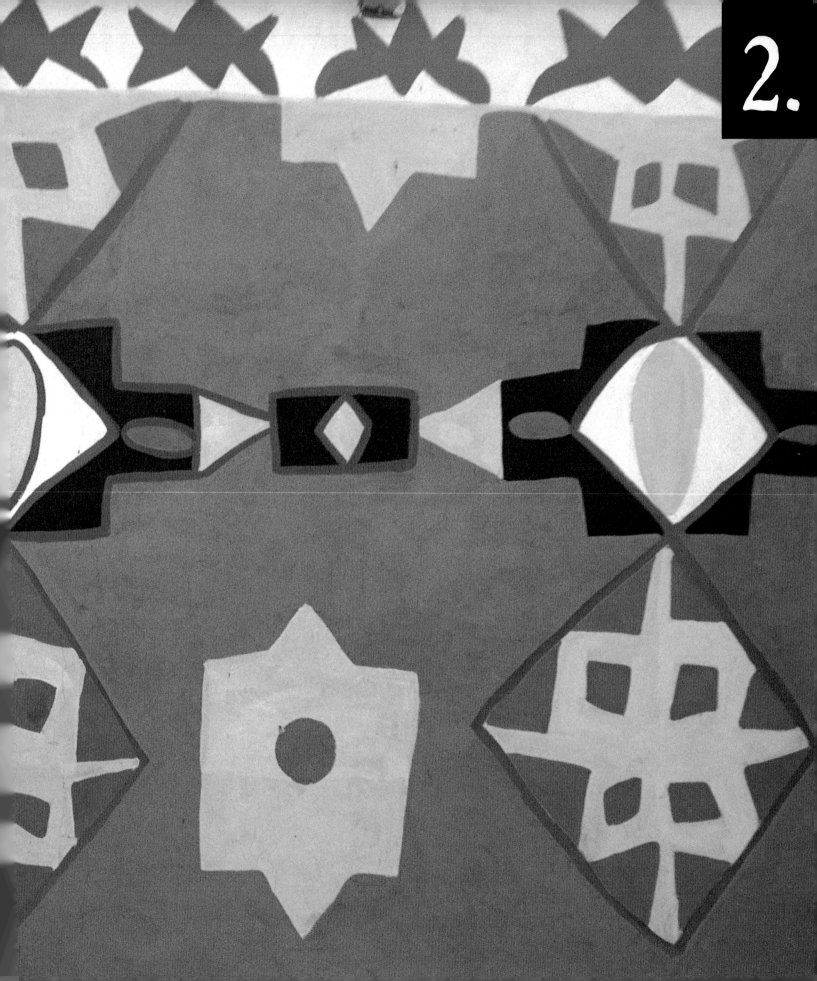

2.

Basotho

The crocodile is the totem animal of the Koena people, or Bakoena, who gave rise to the Basotho nation. The crocodile is found on such nineteenth-century Basotho objects as this spoon, and it remains a national symbol in Lesotho today.

Right:
Of all the Sotho peoples, the Basotho of Lesotho occupy the coldest environment.

Opposite:
Boys and young men in Lesotho are traditionally responsible for herding their family's animals. To find winter fodder, they often spend long periods at very high elevations with only rough shelters and blankets to shield them from the cold. These young men from the Botha-Bothe district of Lesotho sport miner's gumboots—a sign of status and masculinity. One has a heavily beaded hat; the other a decorated skirt.

In the 1820s the Basotho formed into a nation through the leadership of their first king, Moshoeshoe, who remains a role model today. To understand his achievement, however, it is helpful to sketch the history from which he emerged to play such a crucial role. Sotho peoples dominated the interior of southern Africa until the arrival of whites. Speaking similar languages and sharing many cultural features, the various Sotho peoples are today divided into western, northern, and southern groups. The Western Sotho, more commonly known as the Tswana, or Batswana, speak Setswana and live mainly in the northwestern portions of South Africa and in the northerly neighboring country of Botswana. The North Sotho live mainly in the northeastern portion of South Africa; they are often called the Pedi, or Bapedi, after the Sepedi language of their dominant subgroup. The South Sotho, or Basotho, occupy the Highveld and Lesotho, and speak Sesotho.

In Sotho languages, prefixes modify nouns:

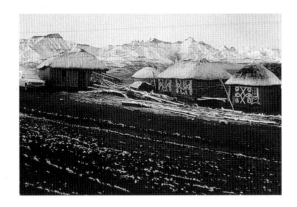

"se-" indicates "the language of," "ba-" specifies "the people of." Therefore, to say "the Basotho" is redundant. On the other hand, simply to say "the Sotho" instead of "Basotho" can cause confusion, since it might also be used to refer to all the various Sotho peoples. It is best to use the term Basotho. "Mosotho" is the singular noun.

Early History

The Iron Age ancestors of the Sotho peoples first enter the archaeological record as a distinct culture around 1200 A.D. Probably a mixture of earlier indigenous peoples and immigrants from the north, they exploited the rich resources at the northern edge of the Highveld, where there was abundant timber for smelting metal ore. As their populations grew, they began to splinter into distinct lineages or chiefdoms and migrated with their cattle herds in different directions.

This process of division generally occurred when the sons of chiefs broke away to establish their own following and lineage. Often a breakaway group marked its separation by adopting a new totem animal, or *seboko*: an animal that they would hold sacred by making it taboo to kill or eat it.

One of the most important lineages was the Koena, whose name means crocodile, after their totem. The Koena, or Bakoena (ba-KWEH-na) later came to control much of the southern Highveld and gave rise to the Basotho nation we know today. In the 1400s the Koena were a

strong presence to the north of present-day Johannesburg in the Magaliesberg Mountains, which to this day are named after the Koena chief Mohale. Excavations in this area have uncovered the ruins of large towns. A fragment of carefully painted wall plaster recovered there proves that mural painting was a feature of Koena life in the fifteenth century.

As they continued to expand and subdivide, the Koena crossed the Vaal River and moved south onto the grassy Highveld plains during the 1500s. The first southern Koena favored the river valleys of the northern and eastern Free State. There they joined up with the Fokeng, a group whose origins are unclear, but who had already been settled in the southern Highveld for about two centuries, and had adapted their lifestyle to the environment of the plains.

Together with other lineages, including the Tlokoa and Taung, who settled nearby, these early Sotho migrants laid the foundations for what loosely may be termed South Sotho culture. They formed relatively autonomous settlements that were smaller and more scattered than those of their ancestors to the north. We have no way of knowing what changes their lifestyle underwent from the time of their first settlement until the nineteenth century, when whites arrived in the area and began to record the oral history of Basotho and to chart events. The information obtained at that time provides a picture of these South Sotho communities in precolonial times.

Economy

Cattle were the cornerstones of Sotho society. They were the currency of the economy, the basis of family wealth, a primary source of protein and clothing, and vital in communicating

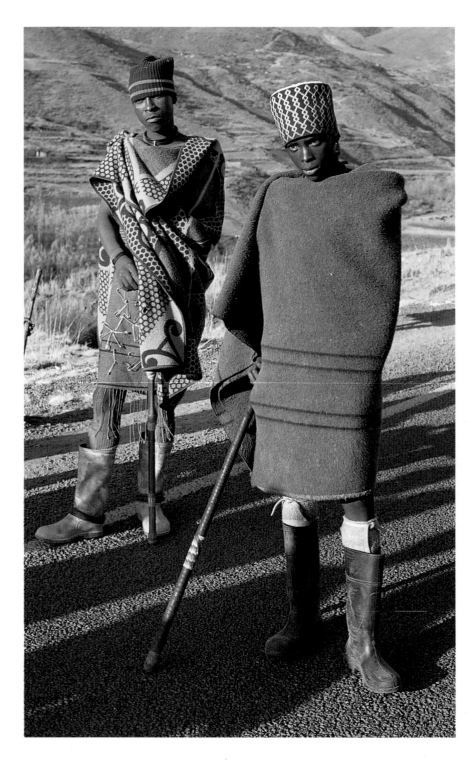

Koena woman with hoe. This nineteenth-century illustration shows the traditional dress of Sotho women, who were responsible for collecting water and firewood, tending crops, and looking after children.

Above:
Basotho milk pails carved from wood.

Right:
Giant grain basket with triangular Basotho hat in foreground.

Opposite:
Outside her Free State home, Anna Mputi grinds corn for her family's dinner. The staple diet of most Basotho is a stiff corn porridge. This is topped with a "relish" of vegetables or meat when available.

with the spiritual world. Cattle were controlled by men. Young boys began their path to manhood by caring for the lesser animals, sheep and goats, until they graduated to looking after their family's cattle. They knew each animal as a named individual with its own personality. They made little clay models of the animals to play with—these are found in archaeological remains from centuries ago, and they are still being lovingly created today in the same way.

In order to marry, a man had to pay the bride's family a price in cattle, known as *bohali* (bo-HAH-dee). Basotho say, "the child is born of the cow," meaning that all the children of a woman who has been married by *bohali* belong to the husband whose family paid for the cattle, regardless of who actually fathered the child. A man wealthy in cattle could afford to marry several wives and build a large family, which provided the labor for his household. He could establish further dependence by loaning cattle to poorer people through a system of usufruct called *mafisa*. A quick route to wealth was conducting raids on neighbors' herds, and there was nothing dishonorable in this practice. A man who acquired sufficient wealth and power by any means could establish himself as a minor chief.

Hunting, performed by men, supplemented the Basotho diet and provided families with hides and prestige items, such as fancy pelts and feathers that were useful in paying tribute and for trading, particularly for iron weapons and tools. Local blacksmiths also made weapons and tools. Men carved household utensils and staffs of wood, and wove the large baskets used for storing grain. Though men did much of the heavy labor of construction and clearing the fields, their primary occupation was taking care of the herds.

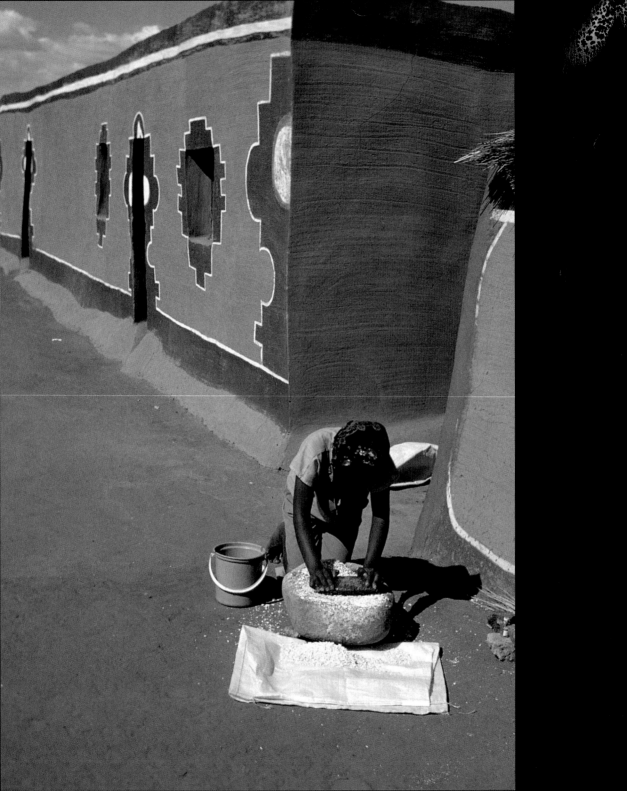

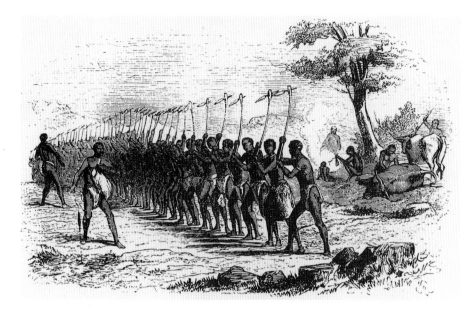

Basotho families were required to perform communal labor for their chiefs as a form of tribute.

The household depended for most of its diet on its fields of sorghum, pumpkins, and beans, which were tended by the wives of the family, who also collected wild plant foods. Women were, in the literal sense, the family's breadwinners. They also took care of the young children and the daily tasks of the home, which included cleaning, fetching firewood and water, and cooking. Women made the clay pots used for carrying, storing, and heating water, food, and sorghum beer. Women were closely associated with the house, but they could not enter the cattle pen, or kraal, which was the realm of men.

Society

A typical household consisted of a man, his wife (or wives) and children, his married sons and their families, and possibly other relatives. The household head owed allegiance to his chief. This entailed a period of communal labor in the chief's fields, participation in communal hunts, which filled the coffers of the chief with tribute items, and military service for cattle raiding or war.

Sotho-Tswana chiefs were not autocrats—they ruled according to the dictate that "a chief is a chief by the people," meaning that he expresses their will and rules through them. All adult men met daily at the local chief's court, the *khotla*. There they debated community issues and decided matters of law and policy. Fluent and poetic argument on any issue was a highly praised virtue, and any commoner could challenge or contradict the chief openly. In this context, however—and in society generally—the elders were accorded great respect for their wisdom and experience.

The chief redistributed his wealth by judicious rewards to his supporters. He allocated land, which he held in trust on behalf of the community, to his followers. The possession of land was not a purely physical matter, for the spirits of its earliest occupants had an interest in it, and they had to be honored and appeased. Similarly, the chief's responsibilities were also spiritual. He had to appeal to the ancestors, "the owners of the land," to bring rain, ensure the fertility of the fields and the herds, and guarantee the well-being of the community.

Religion

The worldview of the Sotho-Tswana was essentially religious, suggests Professor Gabriel Setiloane, an eminent theologian and student of his own culture. For many Sotho-Tswana people today, as in the past, the world is filled with divine presence, *bomolimo* (boh-mo-DEE-moh). It permeates all things, animate and even inanimate: rocks contain it.

The vital force of humans, *seriti,* is associated with their shadows. At the annual Basotho ceremony of Go Tiisa Motse the head of each household incises the joints of his family and applies medicine to strengthen their *seriti.* The same medicine is applied to the "joints" of the house—one of many links between the house and the body in Basotho thought. Seen here is the daughter of Malgowa Mofokeng, behind her home. 1990.

Each thing's unique expression of vital force is in its "shadow" or "shade." The shadow of a tree, *moriti,* is distinguished from the shadow of a cloud, *lesuiti,* and the shadow of a person, *seriti.* Setiloane describes *seriti* as more than a shadow. It is like an aura, a cloud, a mist, a magnetic field, or a radar field that surrounds a person. Because it possesses force, *seriti* can

affect its surroundings. Because the *seriti* of a woman is much stronger than that of cattle, her shadow should not fall on the cattle kraal or pass through a grazing herd.

Seriti waxes and wanes, just as a tree's sap rises and falls in the cycle of the seasons, and it needs periodic strengthening through religious ceremonies. One of the most important

traditional religious ceremonies of the Sotho peoples, called *Go Tiisa Motse,* meaning literally "to keep the household intact," is designed to strengthen *seriti.* At this ceremony, the male head of each household incises the principal joints of each family member's body and applies medicine to each cut in order to strengthen the body's *seriti.* The same medicine is applied to the principal points of articulation of the house, its doors, windows, and corners, demonstrating the close parallel between the house and its occupants.

Seriti is an abstract force that glues together all humans and all being, but human *seriti* is physically seated in the blood. Blood is what ties humans to *balimo,* the ancestors or shades. The blood of sacrificed animals, particularly cattle, calls the spirits to gather round and drink. This moment of the ancestor's proximity is the ideal time for humans to concentrate their appeals to *balimo* (bah-DEE-moh), who have the power to affect the lives of their living relatives. They work to ensure fertility and harmony, punish infractions of the moral code, and mediate between the community and still higher and more remote powers.

Ancestors are particularly important in bringing rain, the lifeblood of the earth. The earth is regarded as a body: the rocks are its skeleton; vegetation is its flesh; the rivers are its veins. The strength of the flow in rivers is an index of the *seriti* of the earth.

When Christian missionaries arrived among Basotho in 1833 they concentrated their energies on discovering a Basotho equivalent of the concept of a Supreme Being and Creator. They seized on the Basotho concept of Molimo, a remote divine force, and translated this as God. Setiloane points out that Sotho-Tswana concepts relating to Molimo were incompatible with Christian conceptions of a monotheistic God

with whom humans can communicate directly. The name Molimo, he says, was so sacrosanct that ordinary people never uttered it, lest this invite calamity. The prefix of the name puts it into the category of a special class of nouns in Sotho-Tswana languages, the "me-mo" nouns, which describe ineffable things such as fire, smoke, mist, wind, and lightning. Only by doing violence to the language could the missionaries ascribe personality to Molimo and call Molimo "Him"; rather Molimo should be regarded as a divine It.

Molimo could however be indicated by personal attributes. It is Motlhodi, the source of all divinity, presence, or being, and of the cosmos. It is "The Great Constructor," an architect. In Sepedi, It is Mmopa Batho, the worker of mud, the molder of humans. It is judge, solid as a rock. In the Rolong dialect It is *"ha O je sebodu,"* the one who will, literally, take no shit. If taboos are violated, It punishes with disaster: drought, hail, plagues. It is remote, reached only via the ancestors, but all pervasive.

Molimo is particularly associated with the sky and with the highest peaks. In Sotho-Tswana custom it is extremely ill-mannered, indeed taboo, to point at the sky or to gaze up there looking for clouds, as if to rebuke It for withholding rain—something for which early missionaries were publicly reprimanded in the *khotla.*

Lightning, the "Bird of the Sky," is Molimo's special agent. No one mourns a death by lightning strike, for it is said that the Lord has claimed It's own. The harmless bolt that kills nobody is It returning to Itself, and the scorched trace of divinity at the point of It's disappearance is powerful medicine. These ideas linking the Creator with rain and storms are important for understanding the symbolic values behind Basotho houses and murals.

Changes

The communities of the southern Highveld were relatively prosperous. Their chiefs were allies or rivals, depending on circumstances. By the 1600s some Koena lineages began to move into the fertile Caledon River valley, which now forms the border between Lesotho and the Free State. Already settled there were San (or Bushmen) groups, Fokeng, and other peoples who had crossed up onto the Highveld over the Drakensberg from the coastal regions.

In 1652 the Dutch established the first permanent European settlement in South Africa at Cape Town. Colonization had begun, but its impact was not directly felt on the southern Highveld until the early 1800s. The events of that period transformed the southern Highveld completely, and they led to the formation of the Basotho nation under the leadership of one of the most outstanding characters in African history: Moshoeshoe, the first Basotho king.

Moshoeshoe

Moshoeshoe, son of a minor Koena chief, was named Lepoqo at his birth in Leribe in present-day Lesotho in 1786. At the relatively late age of nineteen he underwent initiation, during which young men are isolated for several weeks in a school in the bush. Under harsh conditions and strict discipline they are drilled in practical skills and the history and moral values of their people. Circumcision and graduation from the school transform them into adult men, ready to play sober and responsible roles in the community. However, Lepoqo, who was then called Letlama, Binder, or Tlaputle, Busy Body, after graduation, was a fiery young man. Traditional accounts suggest that he already felt destined to

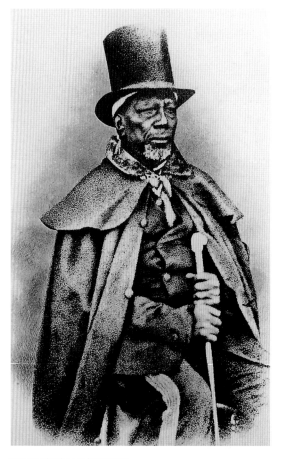

King Moshoshoe in later years.

become a powerful chief, and had killed peers who did not show him the respect he felt was his due.

Letlama's father and grandfather were alarmed by his behavior. They sent him to visit a prominent relative, Mohlomi (moh-SHLOH-mee), a highly respected chief on the north side of the Caledon River, whom they hoped would serve as a role model.

A famed doctor, prophet, and rainmaker, Mohlomi traveled widely, forging an extensive network of contacts that stretched far beyond

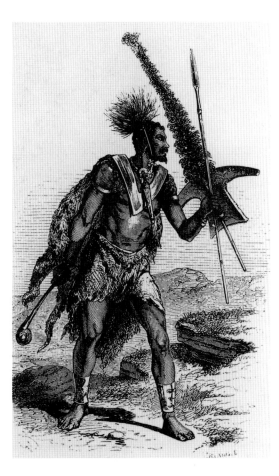

A Mosotho warrior with his distinctive shield surmounted with feathers attached to the handle. The V-shaped brass ornament around his neck is a badge of honor.

Mohlomi received his new disciple Letlama most graciously, blessing him by brushing their foreheads together. Mohlomi's teachings and his example cooled the young Moshoeshoe and kindled in him instead the dream of founding a chiefdom based on Mohlomi's principles: extend influence by marriage, promote peace, judge carefully and impartially, relieve the distressed, and distrust witchcraft as a road to power and never put anyone to death for it.

No kingdom is begun without capital extracted at someone else's expense. Letlama launched his bid for power with a dashing raid on the cattle herd of a rich neighbor. This event was celebrated in a verse of praise that gave Letlama the name that was to become famous: Moshoeshoe. The verse hails him for fleecing his neighbor of his herd as easily as if he had shaved off his beard. The name Moshoeshoe is an onomatopoeic evocation of the *shweh-shweh* sound of shaving with a *moshoashoaila,* a shaver.

Deeply influenced by Mohlomi's model, Moshoeshoe began to marry well, and established his own village in 1820 on the flat-topped mountain of Botha-Bothe, close to his first wife's father, a Fokeng chief. While he was there an era of dreadful conflict in southern Africa dawned. It is known in Sesotho as the Lifaqane, the Time of Catastrophe.

Lifaqane: The Time of Catastrophe

The troubles began among the coastal North Nguni peoples living below the Drakensberg Mountains. In the late 1700s several powerful chiefdoms competed to control the region and monopolize the lucrative trade that had developed with the Portuguese at Maputo, capital of present-day Mozambique. By 1818 Shaka, chief of the Zulu, had emerged as the undisputed

the Highveld. He invested his earnings in building up followers and contracting numerous strategic marriages with wives from powerful families. Visitors from distant places kept him informed of developments in the subcontinent. His wisdom, experience, and strong sense of justice made him the judge to whom disputes were frequently brought, and a mentor to many young men who came to learn from him. His political perspective was that peace and prosperity, rather than conquest, promoted the accumulation of wealth and power.

ruler of the region. Using innovative military strategies he ruthlessly crushed his opponents and brought them under Zulu control.

Shaka was a tyrant who ruled with an iron fist. Those who displeased him were executed. When his beloved mother died, Shaka had thousands of his subjects killed so that the nation could share his sorrow. Those who had reason to fear Shaka, including his own trusted generals, began to flee. Often they left hurriedly and in secret, taking little or no cattle or food. Many crossed onto the Highveld, which had suffered a severe drought and a cattle epidemic. There was insufficient food for the peoples of the Highveld to support the refugees, who soon turned to raiding for food, putting into practice the devastating military tactics they had developed on the coast.

Settled Highveld people who lost their cattle and stores to the invaders also became refugees. Many were forced to become raiders themselves to survive. Whole communities were wiped out; others were scattered. Survivors sometimes joined their victors in the hope of sharing the spoils of the next attack. This unleashed a vicious chain reaction that plunged the interior of southern Africa into violence. It is said that for decades afterward fields of bones remained strewn over the landscape. Thousands starved to death; many turned to cannibalism to survive.

In 1822 the Caledon River valley was invaded by the Ngwane, one of Shaka's main enemies. Their army, led by Matuoane (muh-TOO-wah-nee), defeated Moshoeshoe, who avoided further conflict by paying Matuoane tribute. Moshoeshoe probably also began to pay tribute to Shaka at this time, figuring that he could enlist Zulu support against Matuoane.

Moshoeshoe urged nearby chiefs to forget their petty rivalries and unite to strengthen their

During the famine of the Lifaqane, only the victors who captured stores of food and herds of livestock ate normally. Those who were starving turned to cannibalism, eating the fallen or capturing live victims. Lions, too, developed a taste for human flesh. To escape them, people began to build houses on stilts or even in trees (above)—which testifies to the adaptability of architecture.

hand against the invaders. Few heeded his advice. One nearby community, the Tlokoa under their chieftainess 'Manthatisi, were displaced by Matuoane and became notorious raiders. They besieged Moshoeshoe on Botha-Bothe in 1824, setting fire to the crops below the mountain. This was a rash tactic, for the besiegers soon suffered more than Moshoeshoe's band, who had stored provisions.

During the siege, Moshoeshoe sent out scouts to locate a more defensible mountain. They returned with reports of the mountain of Thaba-Bosiu (tub-bah-BOSS-yew), about fifty miles to the south. A vast mesa with steep sides, few accessible ascents, and abundant springs, it sounded ideal. As luck would have it, or perhaps because Moshoeshoe himself manipulated

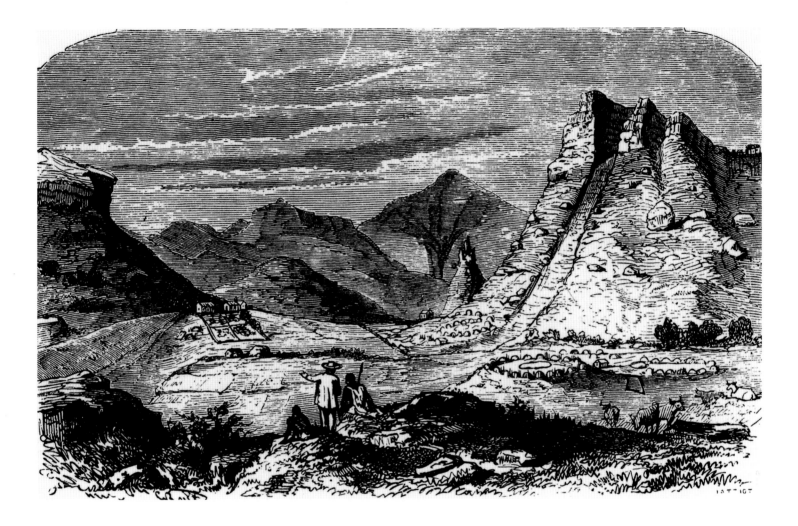

Thaba-Bosiu, on the right of the picture, was the birthplace of the Basotho nation. Here it is pictured as it looked in the 1830s, after French missionaries had established a settlement in the valley below. They had also built a European-style house for King Moshoeshoe, which is visible on top of the mountain at the extreme right.

events, the Tlokoa suffered a Zulu attack. They relaxed the siege to lick their wounds, providing Moshoeshoe's people with the opportunity to set out on what turned out to be a hazardous, two-day walk through country scoured by canni-bals. Moshoeshoe's grandfather, traveling in the slower of two parties, was captured and devoured by the cannibals of Rakotsoane, who hid out in the high sandstone caves and swept down like hungry swallows on unfortunate passersby.

As war raged all about, Thaba-Bosiu soon proved itself an impregnable island of peace. From here Moshoeshoe sent tribute payments to Shaka, but then informed him that the precious goods were being intercepted by Matuoane. This brought the wrath of Shaka down upon Matuoane, who was defeated by the Zulu in 1826. He returned to attack Moshoeshoe two years later, but was repulsed. The harried Matuoane fled to the eastern Cape. There he suffered defeat at the hands of the British,

who had wrested control of the Cape from the Dutch and were extending their presence up the east coast of southern Africa. Confounded, Matuoane returned to Zululand, where he was murdered by Shaka's brother, Dingane, who had assassinated his brother and usurped the throne.

The threat of Matuoane yielded to the far more terrifying depredations of the Matabele, under Shaka's former star general Mzilikazi. After conquering the powerful Pedi in the north, the Matabele turned south again and devastated other Sotho communities on the Highveld. When it was Moshoeshoe's turn to face this formidable foe, Thaba-Bosiu once again proved its value. The Matabele warriors could not scale the slopes against the rain of rocks and spears from above. Moshoeshoe soothed Mzilikazi's defeat by sending him a gift of cattle and a message saying that he did not wish the army to suffer hunger during its withdrawal. Mzilikazi was astonished by this unusual gesture and never troubled Moshoeshoe again.

By this time Moshoeshoe had accumulated so many followers from disparate groups of refugees that they had attained the status of a nation. He apparently adopted the name Basotho for his people from the derisive term *amaShanto,* used by Nguni peoples to mock the fact that people of the interior covered themselves with loincloths, which they wore knotted at the rear. Moshoeshoe's people adopted this custom and the other traditions and language of Moshoeshoe's branch of the Koena.

The Lifaqane was disastrous, but it gave birth to the Basotho nation. It also spawned new African polities and states in southern and central Africa that were more centralized than they had been before. But the whirlwind of war had emptied the landscape of many of the

Drawing of a warrior of the Mahlaphahlapha chiefdom, which survived by cannibalism during the Lifaqane.

smaller communities that had been settled there. This was to have important consequences, because as whites later began to venture into the interior of southern Africa they found much of it vacant and proceeded to lay claim to it. They might have been warned by the bones that whoever had lived here before had not relinquished their hold willingly or lightly.

The Lifaqane had been partly precipitated by the presence of Portuguese traders well to the north of Zululand in the late 1700s. The British established a foothold closer to Zululand, at Natal, during Shaka's reign, bringing new

trade opportunities and technologies, notably firearms. They were simultaneously extending the frontier of the Cape colony ever eastward along the coast, pushing the southern Nguni groups before them. Although the British had not penetrated the Highveld in the 1700s, these events would not have escaped those chiefs of the interior whose courts welcomed travelers bringing news.

During the Lifaqane, Sotho communities witnessed how whites could influence events. The first missionaries to settle among a Sotho community established themselves at the capi-

tal of the Tlhaping, a Tswana group. When the Tlhaping were threatened by an army of Lifaqane marauders the missionaries appealed for help to frontiersmen of mixed race who had acquired arms and horses from the Cape. The armed horsemen easily fought off the formidable horde, clearly demonstrating that the equations of power were greatly changed by the presence of missionaries and the ownership of horses and guns. Refugees who fled to the Cape colony during the Lifaqane also brought back firsthand accounts of white society.

Missionaries

Moshoeshoe decided that he needed missionaries, no doubt because he felt that they would give him strategic advantages. This combined with the great curiosity about foreign ways that Mohlomi had encouraged in him. It is said that Mohlomi's widow had fled to the Cape and urged Moshoeshoe to acquire missionaries. He gave a frontier hunter named Krotz 200 cattle to "buy" him one. Krotz's opportunity came in 1833. Two missionaries of the Paris Evangelical Missionary Society (PEMS), named Eugène Casalis and Thomas Arbousset, accompanied by the artisan Constant Gossellin, were on their way to join the famous missionary Robert Moffat at his London Missionary Society station among the Tlhaping. Moffat's mission, however, had recently been overrun by the Matabele, and when Krotz told the PEMS missionaries that Moshoeshoe needed missionaries, they saw this as a divine injunction to change their destination and head for Thaba-Bosiu.

In his 1889 book, *My Life in Basutoland: A Story of Missionary Enterprise in South Africa,* Eugène Casalis recalls his first sight of Moshoeshoe:

King Moshoeshoe as Casalis first saw him.

"There is Moshesh," said Krotz to me. The chief bent upon me a look at once majestic and benevolent. His profile, much more aquiline than that of the generality of his subjects, his well-developed forehead, the fullness and regularity of his features, his eyes, a little weary, as it seemed, but full of intelligence and softness, made a deep impression on me. I felt at once that I had to do with a superior man, trained to think, to command others, and above all himself.

He appeared to be about forty-five years of age. The upper part of his body, entirely naked, was perfectly modeled, sufficiently fleshy, but without obesity. I admired the graceful lines of his shoulders and the fineness of his hand. He had allowed to fall carelessly round him, from his middle, a large mantle of panther skins as lissome as the finest cloth, and the folds of which covered his knees and his feet. For sole ornament he had bound round his forehead a string of glass beads, to which was fastened a tuft of feathers that floated behind his neck. He wore on his right arm a bracelet of ivory—an emblem of power—and some copper rings on his wrists.

After we had looked an instant at each other in silence, he rose and said, Lumela lekhoa, *"Welcome, white man!" and I replied by holding out my hand to him, which he took without hesitation.*

Eugene Casalis

This somewhat romantic account defines the start of a firm friendship built on tremendous mutual regard. It also marks the onset of Basotho society's encounter with whites and Western culture. In the decades that followed, the king and Casalis spent a great deal of time together and cooperated on developing diplomatic strategies to ensure the survival of the Basotho nation. They faced enormous challenges as Afrikaners invaded Basotho territory and laid claims to the land. One of their first diplomatic initiatives, in 1834, was to obtain official British recognition of Moshoeshoe as Basotho sovereign. Moshoeshoe entered several treaties with the British as a steadfastly loyal ally. The British, however, were more concerned with placating the troublesome Afrikaner trekkers, who encroached on Moshoeshoe's land and continually challenged his sovereignty.

Between the 1830s and the mid-1860s, several major disputes arose between Basotho and the Afrikaner settlers. Boers occupied the land and Basotho raided their cattle. Each time, the British intervened on the side of the Boers and ceded to them Basotho territory. Moshoeshoe's

Thomas Arbousset at age 22, before he set out for Africa.

territory was steadily eroded. On one occasion he remarked bitterly, "You white people do not steal cattle, it is true, but you steal whole countries; and if you had your wish you would send us to pasture our cattle in the clouds."

Every loss of land pained Moshoeshoe. According to Basotho concepts relating to the possession of the land, he held all the land of the kingdom in trust on behalf of his subjects. Private ownership of land was impossible, and division of land was an offense. This view of the land is clearly reflected in the following account of Moshoeshoe's reply to white traders who requested to buy land, as reported by Eric Rosenthal in his 1948 book entitled *African Switzerland: Basutoland of Today:*

> "You ask me to cut the ground?" exclaimed the Chief. "Listen to a story which is, I am told, in your great book. It happened once that two women disputed about a child before a very wise king. The latter ordered the child to be cut in two, and half to be given to each of the women. 'It is quite just,' said the pretended mother. 'Let it be divided instantly.' 'Oh, no,' cried the real mother, 'I would rather lose it entirely.' That is the story. You, my friends, who are the strangers, you think it quite natural that my ground should be cut. I who am born here, I feel my soul revolt at the thought. No, I will not cut it. Better lose it altogether."

When faced with this Solomonic dilemma on a larger scale—when it was the mighty British Empire that demanded the division of land, rather than whites hoping to set up shop in his territory—Moshoeshoe realized that if he refused he would indeed risk losing his kingdom and its land altogether. He would either be directly crushed by the British, or, if they no longer regarded him as an ally, they would reward his defiance by aiding the Boers, or at least turning a blind eye to their aggressions. By 1866 Moshoeshoe had been forced to sign away his most fertile territory. He sent a famous appeal to Queen Victoria for her protection, saying that it was his desire for Basotho to become "the lice in the Queen's blanket." In 1868 this wish was granted when Basotho were declared British subjects. Basotholand became a British protectorate in 1869.

Moshoeshoe died the following year. Though he had lost much of his territory, he might have consoled himself with the fact that his skillful diplomacy had ensured that his nation survived its encounter with colonialism relatively intact, while most other African states were destroyed. Basotholand's protectorate status within the British Empire, and after 1966, its independence as Lesotho within the British Commonwealth, allowed it to stave off repeated attempts at incorporation by South Africa.

Moshoeshoe also witnessed the enormous impact of European culture on Basotho society. The missionaries introduced new technology and crops, but the innovations that most impressed Moshoeshoe were the abstract ones. Writing amazed and delighted him. He rejoiced that the missionaries set about developing a written form of the Koena dialect, which they would use to translate the Bible and communicate with their Basotho congregations. Their transcription of the language distinguished it from that recorded by Robert Moffat among the Tlhaping people to the west. It also served to entrench Moshoeshoe's own dialect among his followers, who consisted of an amalgam of people of different backgrounds. In 1840 Moshoeshoe, observing the missionary Thomas Arbousset writing *Missionary Excursion into the Blue Mountains,* an account of the journey they were taking together, remarked about his language:

> *"Thanks to the little books of the missionaries, it will not be altered: there it is written; oh! oh, your paper; that paper organizes everything well."*
>
> *At this I burst out laughing, listening to the chief, pointing out to him that there was no dearth of blots on this paper he so much admired.*
>
> *He replied that he had also noticed it; but that these blots "could be washed with the soap of learning. [Laughter] The stains in a cloth are not the cloth itself," he continued, "and then, I only see words that are being changed because they are Setlhaping words. My language remains my language on paper. If that paper came from some remote corner of the Maluti Mountains, and if it arrived by itself at Thaba-Bosiu, it would be recognized as . . . one of [my] subjects."*

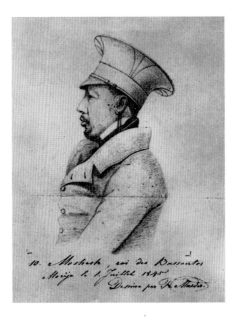

A drawing of King Moshoshoe in 1845.

Moshoeshoe was also deeply intrigued by the missionaries' view of the philosophical and spiritual questions of human existence. Arbousset also reports that Moshoeshoe said to him:

> *These fundamental matters are the concern of all of us. It is two summers since my men and I opened our eyes to the light of the Gospel. It leads us a long way. Even if you and I and your colleagues all disappeared, and even if nobody any longer knew what became of us, the news that you have brought into the country would remain. My people will never forget it.*

During the journey with Arbousset, Moshoeshoe called upon his nation to rejoice:

> *We have all reason to rejoice, on account of the news we have heard. There are a great many sayings among men; and among them, some are true and some are false; but the false have remained with us, and multiplied; we ought*

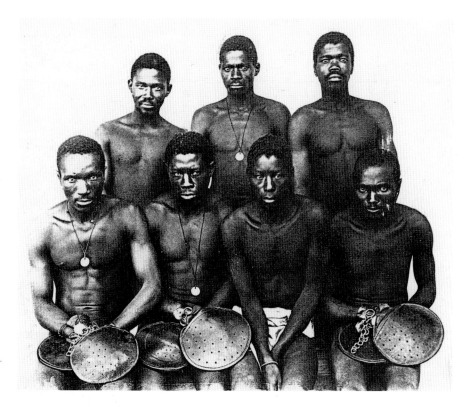

These miners wear paddle-like gloves to prevent them from stealing diamonds. Diamond miners suffered inhuman humiliations for their hard-earned wages, including invasive body searches and concentration-camplike living conditions.

therefore to pick up carefully the truths we hear, lest they should be lost in the rubbish of lies . . . thou, Makara, hast heard these words, and thou sayest they are lies. You that are grown in years are the great men to us, therefore, we look to you; but if these words do not conquer, the fault will lie with you. You say you will not believe what you do not understand. Look at an egg! If a man breaks it, there comes only a watery and yellow substance out of it, but if it be placed under the wings of a fowl, there comes a living thing from it. Who can understand this? Who ever knew how the heat of the hen produced the chicken in the egg? This is incomprehensible to us; yet we do not deny the fact. Let us do like the hen, as the hen does with the eggs under her wings; let us sit upon them, let us place these

truths in our hearts, and take the same pains, and something new will come of them.

Moshoeshoe was farsighted. The Christian message did take hold, and Basotho did indeed hatch for themselves an understanding and practice of Christianity that is in many ways unique to them. As Moshoeshoe's address reveals, many Basotho elders were skeptical of the missionaries' message. They were outraged at the missionaries' attacks against key aspects of their society, including polygyny, the bride-price payments of *bohali,* and the honorable pastime of cattle raiding, which the missionaries viewed as theft. Far more fundamental, however, was the missionaries' insistence that worship of the ancestors and all the customs connected with it were wrong—initiation schools for men and women, ceremonial singing, dancing, and drinking beer, and traditional medicine, divination, and rain making. These customs were the key to being Basotho. Many Basotho saw no good reason to give them up or adopt other changes that the missionaries insisted on, such as Western clothes and rectangular houses laid out in straight lines. Today all of the customs connected with ancestral worship live on in some form, often integrated into a Christian outlook.

Moshoeshoe himself never converted to Christianity, largely because of the strong opposition to Christianity among many of his people. He did allow two of his wives to separate from him so that they could embrace Christianity free of the sin of polygyny. He encouraged his sons and close relatives to acquire European education and accept Christianity. Shortly before his death, in 1870, Moshoehoe finally set the date for his own public baptism, but he died two days before the appointed time.

This interesting drawing shows migrant laborers greeted by their Basotho kinsmen upon returning from the Kimberley diamond mines. Wearing Western clothes and carrying guns and other goods that they have bought with their wages, they are the harbingers of the Western cash economy, the modern era of industrial capitalism, and South Africa's system of migrant labor.

The Modern Era

The 1870s saw the beginning of industrial capitalism in southern Africa. The discovery of diamonds at Kimberley brought an international influx of prospectors and entrepreneurs. South Africa's first great capitalist monopoly was formed: the De Beers Diamond Company, which still monopolizes the world supply of diamonds today and promotes their product through the invention of "traditions" such as the diamond engagement ring.

Mining required labor. Black men from all over southern Africa were hired at low wages by companies that made enormous profits from their work. Miners were housed in compounds designed like concentration camps and were subjected to humiliating body searches to prevent them from stealing diamonds.

Diamond mining introduced the system of migrant labor, and the discovery of gold in Johannesburg in 1885 extended it. The people who controlled De Beers also soon dominated gold mining under the name of the Anglo-American Corporation. During the next century, they grew to control most of the South African conglomerates that dominated the economy of the entire subcontinent.

At the gold mines near Johannesburg, miners from all over southern and central Africa were grouped together in single-sex hostels. The mine managers—echoing the apartheid system as a whole—separated the laborers according to ethnic groups and emphasized ethnic differences and rivalries. This encouraged cohesion and pride in cultural identity within ethnic groups, such as the Basotho dancers seen here, performing in a mine compound. But it also led to tensions and tribal clashes among the labor force. These played into the hands of the mine owners and the state, which both understood only too well the principle of divide and rule.

The 1870s were very prosperous for Basutoland. To supply the mine workers at Kimberley, food production was stepped up by using ploughs pulled by oxen and driven by men instead of the traditional agriculture of women using hoes. Many Basotho produced superior grain for sale by leasing land owned by Boers, who had always concentrated on farming cattle. Men and women migrated to Kimberley and other towns, and to white-owned farms to earn wages or sell items and services that were in demand. Many wanted cash to buy guns, cattle, horses, and blankets. Trading stores sprang up throughout Basutoland, where traders offered Western goods for cash, or in return for commodities such as wool from goats and sheep, of which the Basotho produced great quantities of high quality. Basotho, along with the rest of southern Africa, had entered the modern era.

Wars

Britain and its Cape colony hoped to unite the two British colonies of southern Africa, Natal and the Cape, with the two Boer republics, the Transvaal and the Orange Free State, to form the Union of South Africa. But the Boers would never agree to this if the African societies had access to guns, so the British tried to disarm all Africans. The Basotho refused to surrender their arms, and a rebellion called the Gun War broke out in Basutoland (1880–81). The Cape government—to which Britain had ceded control of Basutoland—spent so many millions of dollars trying to quash resistance that the Cape government fell, the idea of a union collapsed, and the Cape asked Britain to take back control of Basutoland. Basotho became the only black people in South Africa who kept the guns for which they had worked so hard. British authority returned in 1884, but with a new policy of indirect rule. This meant that the British used the chiefs as instruments for implementing colonial policy, instead of trying to undermine the chiefs' power as they had done before.

The Gun War was a victory for Basotho, but it highlighted new tensions in Basotho society. Firstly, Moshoeshoe's sons were divided, taking positions on important issues that opposed Letsie (Moshoeshoe's heir) and, later, his descendants. Secondly, the introduction of a Western money economy had changed the power of chiefs. Commoners who had become wealthy through farming or trading could run their own lives with unprecedented autonomy.

Under British indirect rule many chiefs became corrupt and lost the respect of ordinary people. Many commoners began to believe that the best plan for the future was to abandon tradition—at least their traditional leaders—and follow the route of Western education and Christianity. Finally, Lesotho quickly became overpopulated, overgrazed, and too intensively farmed, leading to land shortages and bad erosion. More and more Basotho chose to farm as tenants on the white farms in the Free State, and they were so successful there that the Boers soon began to demand laws to suppress them.

In the mid-1890s a cattle epidemic wiped out much of Basotho's wealth. Fortunately for the Basotho, war finally broke out between the British and the Boers. At stake was control of the goldfields in the Boer republic of the Transvaal. The Basotho regained their losses by supplying grain and horses to both sides during the Anglo-Boer War (1899–1902). Most Basotho hoped that the British would win the war, return their land, and protect the rights of Africans that Boers denied. The British did win the war, but once again it was more important for them

to keep the Boers happy than to pay attention to the hopes and concerns of Africans. In fact, from the formation of the Union of South Africa in 1910, through the apartheid era that began in 1948, and until South Africa became a democratic country in 1994, Lesotho lived in fear—fear of being incorporated into its racist neighbor or fear of oppression supported by South Africa or connected to the situation there.

The Twentieth Century

Moshoeshoe's great-grandson, Letsie II, joined other chiefs and educated elites in forming the African Native National Congress in 1912, which later became the African National Congress (ANC). For half a century it tried peaceful means to ensure equal rights for blacks, but it was eventually outlawed. Its leaders, including, of course, Nelson Mandela, were imprisoned in 1963, and the ANC was forced to consider itself at war with the racist South African government. Basotho leaders such as Stimela Jingoes and Keable 'Mote played a leading role in South Africa's first trade union. Such unions would become a key factor in combatting unfair labor conditions in South Africa and in battling the entire apartheid system.

Between the two World Wars, in which thousands of Basotho soldiers fought loyally for the British, tensions in Lesotho between chiefs and commoners increased. The chiefs and British authorities cooperated with one another and had two main critics. The first was the Christian-educated elite of the Basotho Progressive Association (BPA), which was in favor of modernization and abolishing chiefly privileges. The second was the Commoners League. The league believed that Basotho should return to their traditions, restore the proper caring relationship between chiefs and commoners, and reject white culture and government. They agreed with the Africanist message of African-American Marcus Garvey, who proclaimed, "Africa for the Africans." This political perspective became known as Pan Africanism.

Britain realized that Lesotho needed democratic reform to prevent trouble. Reforms began to reduce, limit, and control the power of chiefs in line with the demands of commoners, who gained more representation in government. The power of the kingship was reduced and became increasingly answerable to a National Council.

In 1952 Ntsu Mokhehle formed the Basutoland Congress Party (BCP), which combined the modernizing ideas of the BPA elite with the Africanist position of the Commoners League. It was linked both to the ANC in South Africa and to Pan Africanists in South Africa and other parts of Africa.

Religion played an important role in these political developments in Lesotho. The PEMS who had first come to Lesotho became increasingly identified with the democratic demands of commoners, while the Catholic church largely supported the chiefs. The Africanist views of the Commoners League were echoed by separatist Basotho prophets such as Walter Matitta. Influenced by African-American missionaries, Africanists argued that Africans should develop their own separate Christian organizations.

In 1957 two new political parties were formed. The first was the royalist Marematlou Party (MTP), formed by chiefs who wanted the king, Moshoeshoe II, to have real political power and not just be a figurehead in a democratic country. The second party was the Basutoland National Party (BNP), which wanted to cooperate with the white Nationalist Party of apartheid South Africa to prevent friction with its powerful

neighbor. Strongly supported by the Catholic church, South Africa, and West Germany, the BNP also wanted to preserve chiefly power and combat democratization and socialism. Politics in Lesotho since this time have stemmed from continued tensions between royalists, the chiefly elite, and commoners, each appealing to Basotho tradition in different ways.

The BNP won the first elections and led Lesotho to independence, which was granted in 1966. Lesotho's constitution is based on the British system of government. In this system the king is a figurehead and the senate, or upper house, consists of nobles with inherited titles or appointed by the king. Most power lies with the elected representatives in the lower house of commoners.

When the BCP won elections in 1970, the BNP government of Chief Leabua Jonathan refused to hand over power. It declared a State of Emergency, suspended the constitution, threw hundreds of BCP supporters into jail, used the army and police to crush all opposition, and assassinated its enemies. Many felt that South Africa was behind these undemocratic tactics. But as South Africa became more repressive and internationally unpopular, and as resistance inside South Africa stepped up, Chief Leabua Jonathan reversed his attitude to South Africa. He became critical of South Africa, supportive of the ANC, and forged links with the Communist countries of USSR, Cuba, and North Korea. He wanted to turn Lesotho into a socialist one-party state under his dictatorship.

Meanwhile, the BCP still hoped to regain control of the government to which it had been legally elected. It organized the Lesotho Liberation Army (LLA), with support from Libya and the Pan African Congress. Strangely enough, South Africa was now prepared to support the

Walter Mattita, evangelist, diviner, and prophet, was instructed by King Moshoeshoe I in a dream to found the independent Church of Moshoeshoe in the 1920s. This sculpture, on the roof of his shrine at Koalabata, illustrates a prediction of Mattita's that "One day the Black man shall peck out the eyes of Whites."

BCP—which it had once opposed—in its efforts to bring down the dictatorship that South Africa had helped create. Everyone had changed sides.

In 1986 a military coup overthrew Leabua Jonathan but the violence continued in Lesotho. Finally, in March 1993, the military regime fulfilled its promise to hold a democratic election. More than 70 percent of the voters voted and the BCP won more than 75 percent of the votes. After being denied the right to rule that it had won twenty-three years earlier, the BCP was returned to power.

Basotho in Lesotho have long been largely in control of their destinies. The relevance of Basotho traditions in the modern era could be tested, debated, and explored in politics and other aspects of national life. In contrast, Basotho in South Africa had no such avenues open to them. Perhaps this is why the Basotho of the Free State have made their murals and ceremonies their main vehicles for proclaiming their identity.

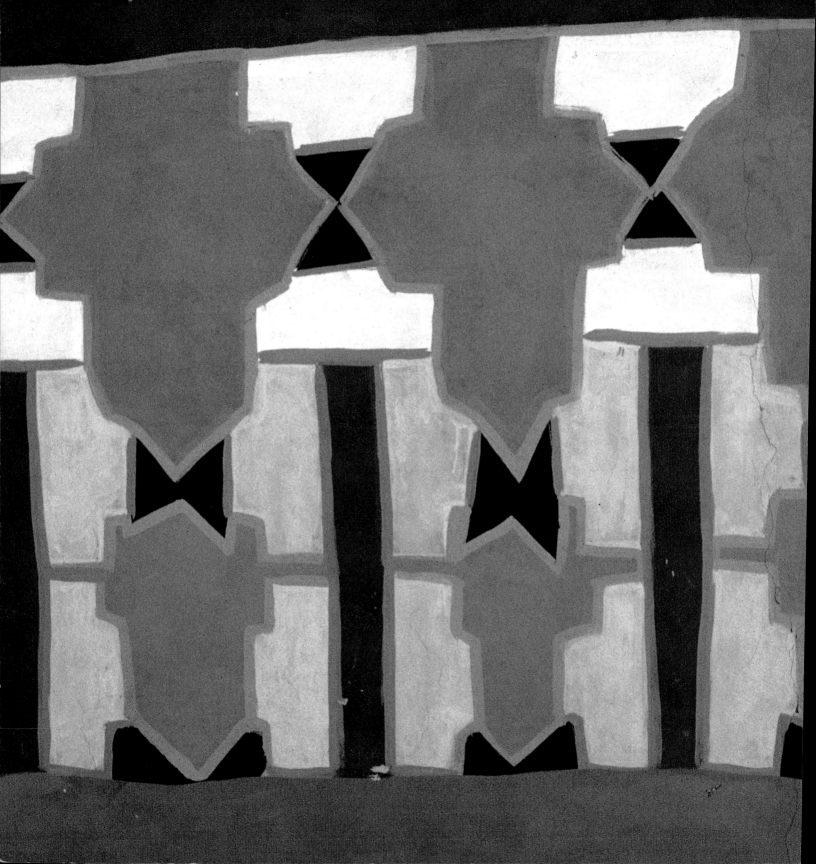

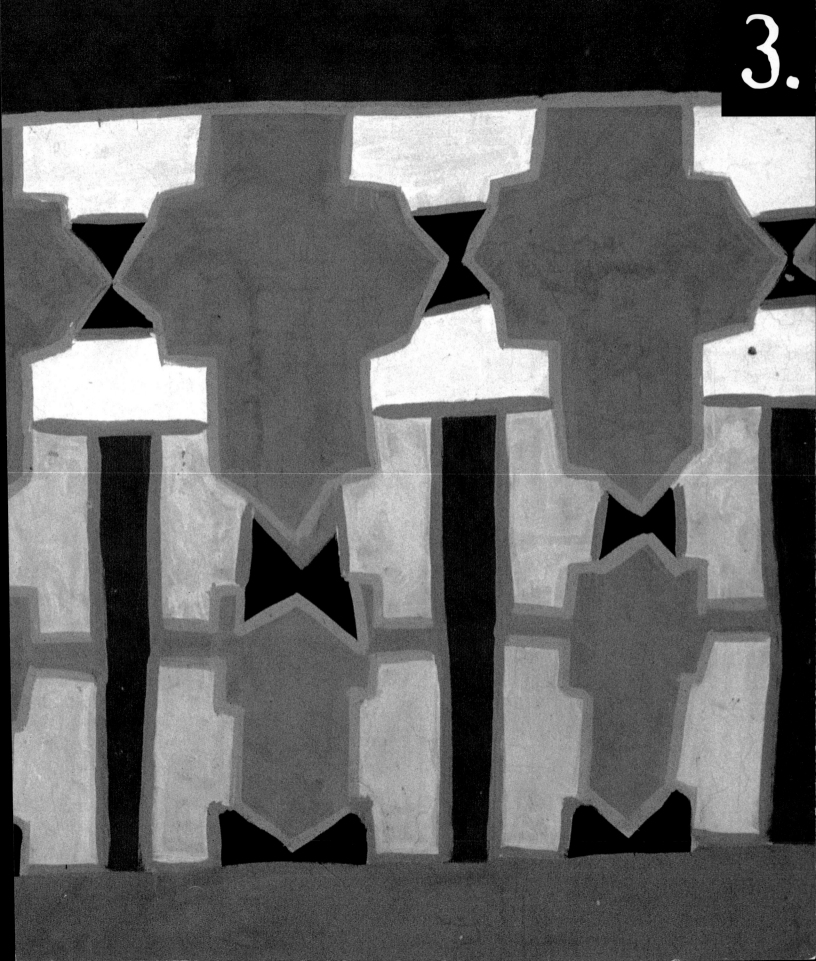

3.

Litema: Art of Earth

Basotho women's mural art is called *litema,* a word derived from the Sesotho verb *ho lema,* to cultivate. *Litema* is the term applied to all four techniques of mural decoration: engraved patterns, mural painting, relief moldings, and mosaic.

Of these four techniques, engraved designs evoke most strongly the relationship of *litema* to the idea of cultivation, because engraved designs look very much like bird's-eye views of fields that have been readied for sowing or that lie fallow, waiting for spring.

Engravings are created by drawing into wet plaster with sharp tools. The plaster is prepared by mixing clayey earth, water, and dung. This mixture, known as *daga,* bonds well to the underlying mud-brick wall and dries into a relatively water-resistant and cementlike skin. The dung assists the binding consistency of the plaster, and its high ammonia content retards the germination of seeds and serves as an odorless antiseptic.

Daga is smeared onto a wall or floor by hand, using sweeping motions of the arm. The plaster is splashed with water to spread and smooth it. A wall is prepared in small, square sections, with the worker generally moving from right to left. Each wet square is outlined with a stick or the back of a fork. This defines the field for a pattern motif, which has been decided on beforehand.

With quick, assertive movements, women engrave the outlines of the motif into the mud.

This motif is then inverted or reversed in adjacent squares, so that every square is the mirror image of its neighbors. In this way, the quickly sketched initial motif, like a seed motif in music, plays out across an entire wall in an hour or two of work. To accommodate doors or windows that interrupt the canvas of the wall women improvise by adjusting the proportions of their motif or coming up with innovative solutions. The same principles of pattern-making apply to painted designs.

Once the outlines of an engraved pattern have been drawn, certain pattern segments are filled in with finer lines. These are made by repeatedly dragging a comb or the tines of a fork through the mud, inscribing a series of parallel lines of a particular orientation. When the lines cross the boundary of the pattern segment that is being detailed the errors are smoothed away with a wet palm. The surrounding pattern segments are then treated similarly, alternating the orientation of the infill lines until the whole design has been textured.

Because agricultural labor was traditionally women's work, Basotho women's *litema* can be viewed as picturing this work in the fields upon their walls and, occasionally, on the floors of their outdoor courtyards. The engravings are African landscapes, composed of the very substance they represent. Like the play of light and shadow across furrowed fields, the engraved compositions are constantly in flux as the sun describes its daily path.

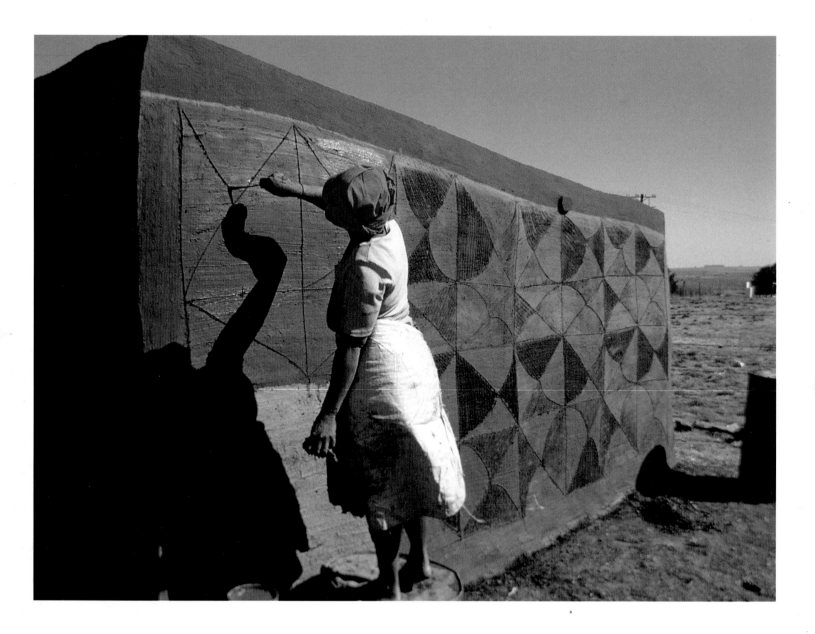

This design by an unknown artist relies for its effect on texture rather than color. The central section is reminiscent of a patchwork of plowed fields. Like a sundial the frame of a tennis racket marks the passage of time in the movement of its shadow.

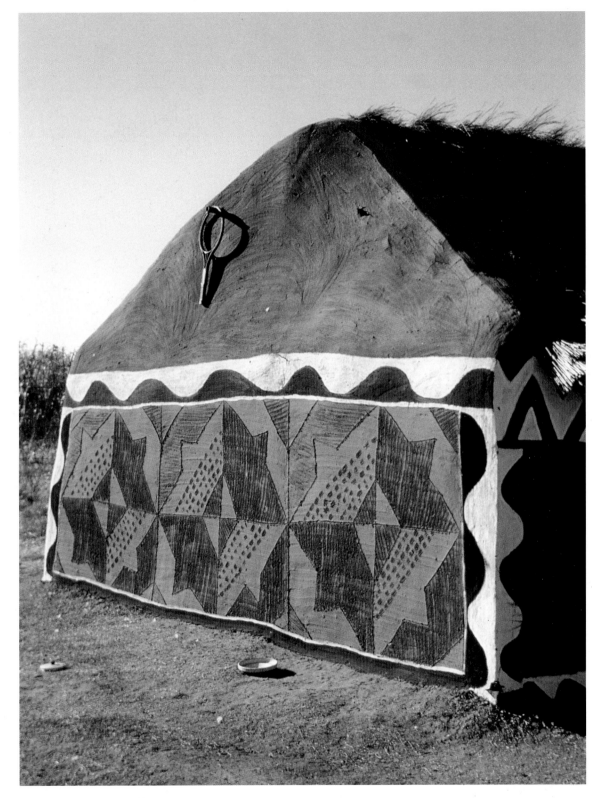

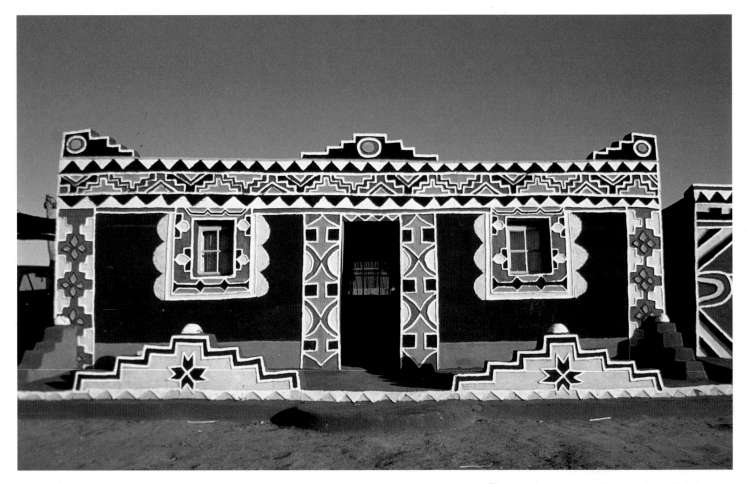

This ornate house includes decorative elements to define the courtyard in front of the house. Emily Mapheello, 1992.

Mud plaster may also be sculpted to create low-relief ornamentation, usually around doors and windows, or to form architectural elements, such as pediments and crenellations to accent the roof line. Mosaic, using stones or peach pits set into the plaster of the wall or the floor, is seldom seen. *Litema* moldings, engravings, or mosaic may be left plain or painted. Sometimes all of these techniques are combined to create compositions that are rich in texture and color.

Painting is an independent *litema* technique that has eclipsed the popularity of engraving and dominates most facades. Today, engraving is often reserved for the sides and rear of houses. Paint is applied either *a fresca* (to wet plaster) or after the *daga* is dry. Painted compositions may have complex patterns, like engravings, or large areas of wall may be simply decorated with a solid color, creating a color field, usually accented with borders of contrasting color.

Page 82:
Detail of a facade by Lizzy Motaung that employs raised relief and features a shieldlike motif. 1992.

Page 83:
A false window with lines of raised relief by Sanna Motaung, 1992.

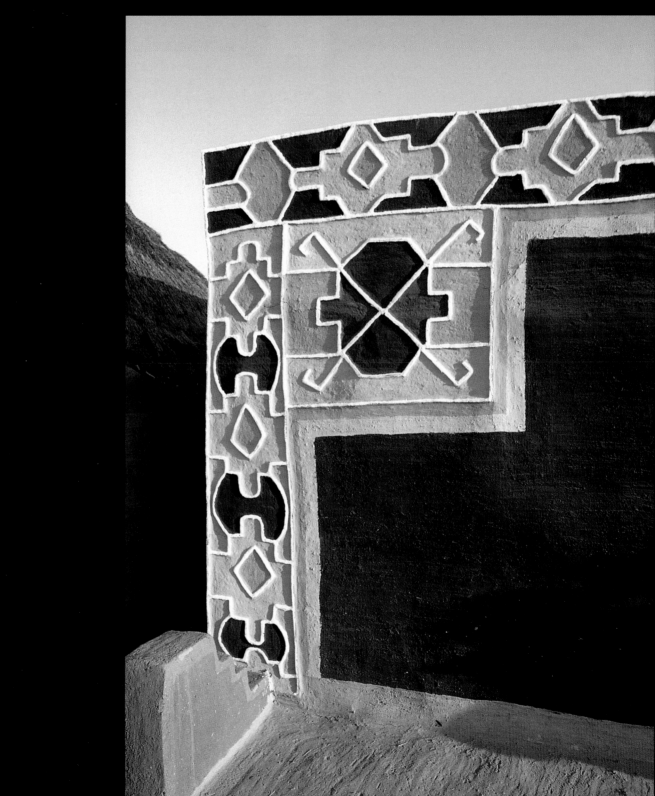

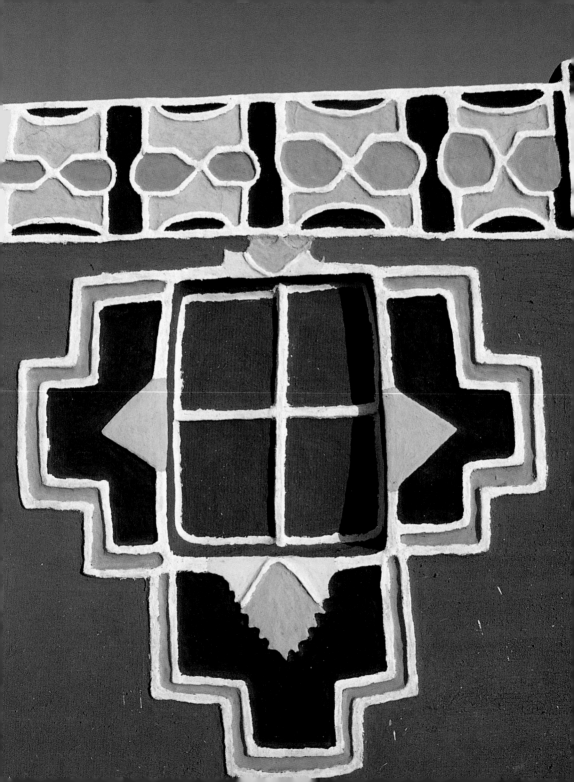

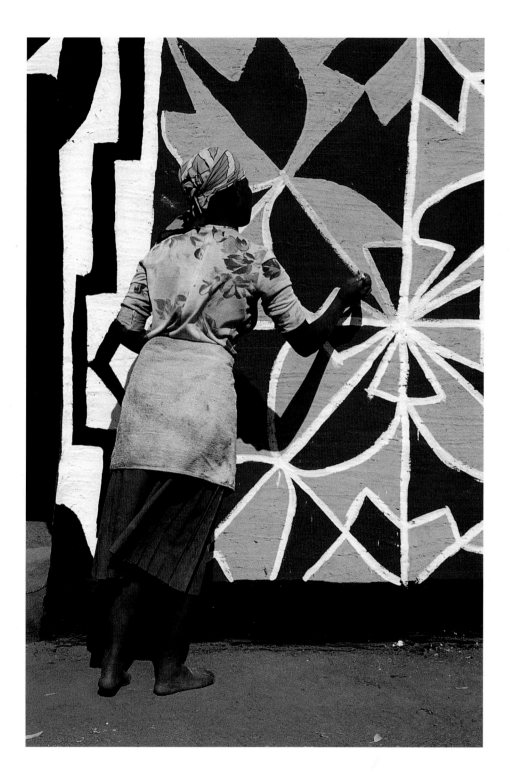

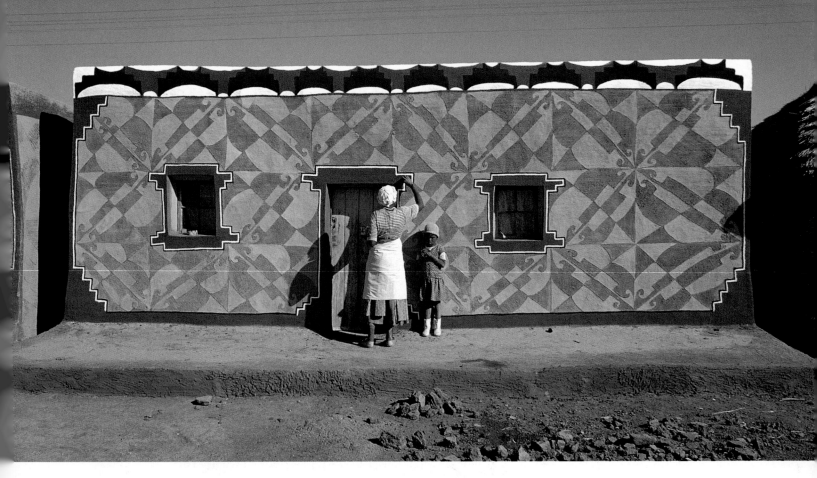

Popi Thlapo paints the fine white outlines to her *litema*. 1990.

Opposite:
Minah Mokwena applies the finishing touch of white outlines to her design.

Overleaf:
This impressive side wall by Malshidi Makhunye contains strong, overlapping motifs—of squares, diamonds, and a circular, radiating design that appears to be a derivative of the mural pattern known as *sekho*, meaning spider web. 1990.

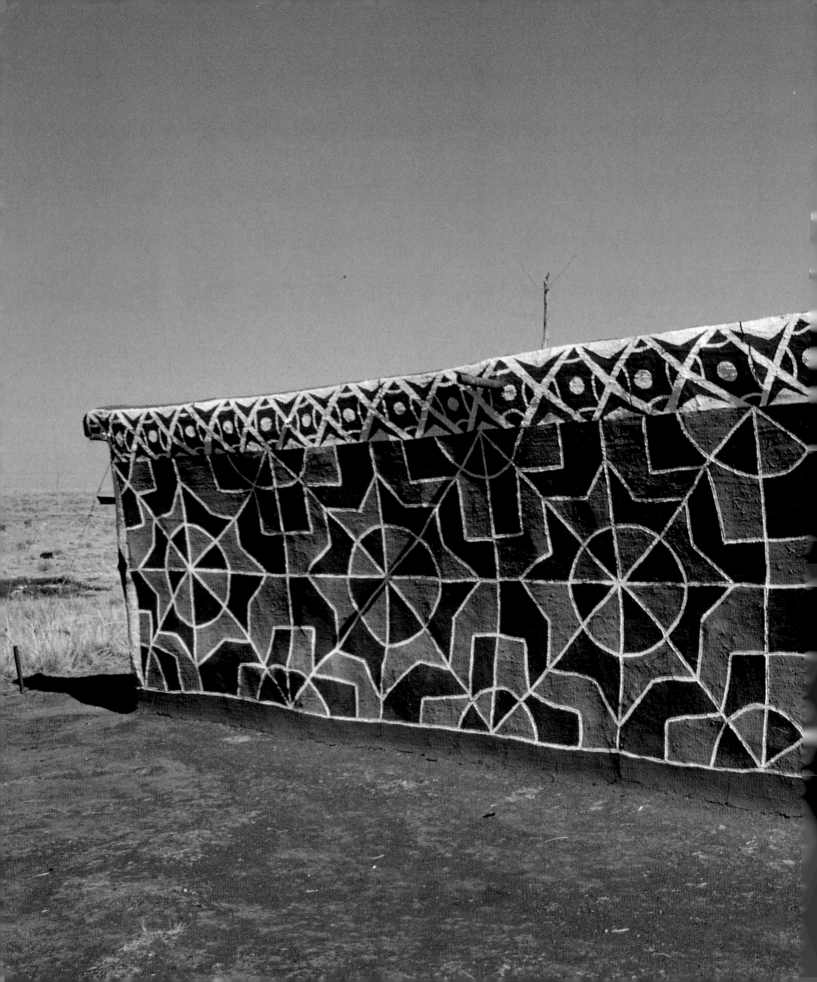

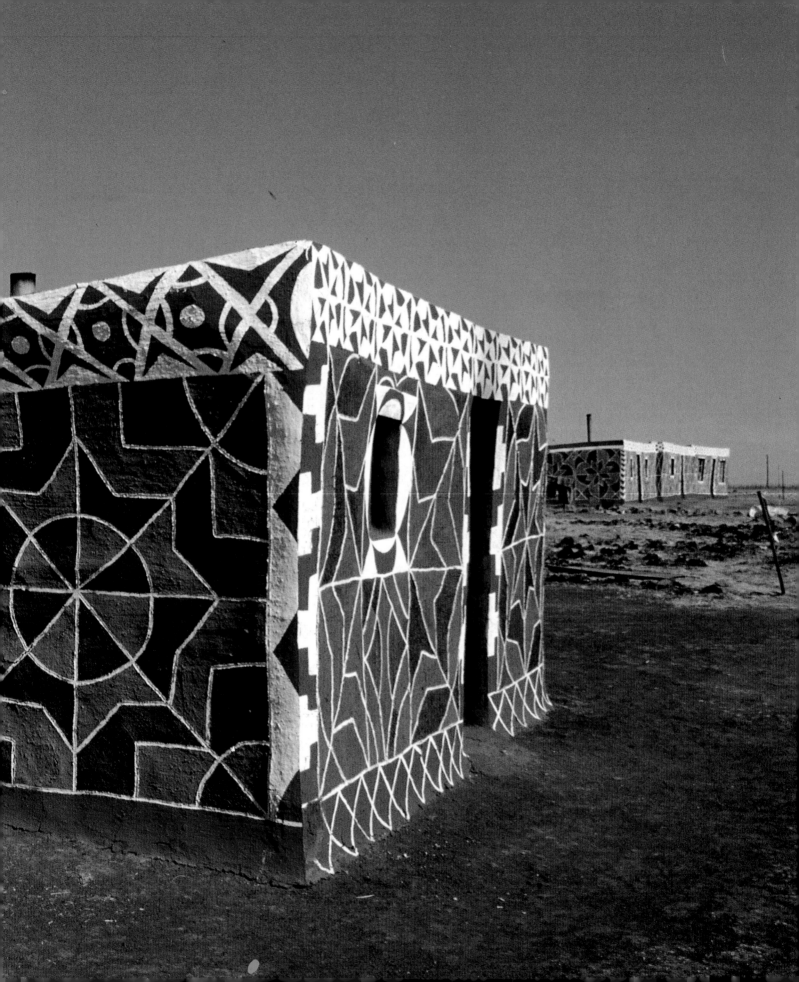

A John Campbell drawing of the interior of the house of a Tswana (or Western Sotho) chief. The painted mud construction surrounds the central pole that supports the roof of the *rondavel*.

We know from Sotho archaeological sites that mural painting dates back at least five centuries. The first European travelers to encounter Sotho communities were struck by the rich mural designs they saw, although they largely reported images of animals and made scant mention of patterns and colors.

The earliest written account of Sotho murals is by a missionary named John Campbell. After a visit in 1812 to Sinosee, chief of the Hurutse lineage of the Tswana, Campbell described interior walls painted yellow and red and decorated with paintings of shields, elephants, and giraffes. He found several houses with "figures, pillars, etc., molded in hard clay, and painted with different colors." Among another Tswana group, the Tlhaping, he observed black and white paintings of lizards, giraffes, rhinos, elephants, lions, leopards, and a tiny antelope called a steenbok. He observed but did not describe similar animal paintings among Basotho.

The houses that Campbell was visiting were those of chiefs with whom he was working to establish diplomatic relationships. Their houses were likely unusual in representing particular animals whose qualities—intelligence, strength, and, in the case of the giraffe, farsightedness—are often associated with leadership. Even images of creatures that are less obviously extraordinary can be explained in terms of their chiefly context: the common ancestor of the Tlhaping was a chief called Phuduhuchoana, the Steenbok; the lizard is noteworthy for its ability to wriggle out of danger by shedding its tail, a neat metaphor for wily leadership; the shield conveys the chief's role as protector of his people.

Campbell's accounts were brought together in the 1880s by the historian George Stow, whose work was posthumously edited by George Theal and published in 1905 as *The Native Races of South Africa*. His book includes some color plates of Basotho mural designs with their date and place of collection. An unpublished letter from George Stow in the South African Library, written in Bloemfontein on September 6, 1880, suggests that Stow himself probably recorded the patterns. He describes designs at a village built by "Bakuena"—the southern Koena known today as Basotho:

Two days ago I rode across the Vaal [River] where I came upon an old ruined Bakuena kraal where a portion of the wall decorations was still to be found—as the patterns were different to any which I had seen. I made a copy of the principal one (from what had evidently been the captain's hut), and shall be obliged if you would introduce it among the illustrations showing the

Bakuena wall decorations. In this instance not only were the exterior walls of the main hut decorated, but the interior of the walls of the surrounding court which were ingeniously built of rubble composed of small rounded pebbles and then smoothly plastered. This is the first time that I have seen any decided attempt at panelling—and it would appear to represent wickerwork. It had a novel effect when contrasted with the other specimens I have before copied.

Stow is apparently describing a mosaic texture achieved by plastering over pebbles, rather than rubble walls. It seems clear in the drawing that he refers to that the textured panels, which have a similar visual effect to *litema* engravings, are separated by areas of smooth plaster, which have bold triangular designs. The other illustrations show simple motifs of dots, stripes, scallops, triangles, lozenges, and zigzags, executed with a restrained palette.

Stow's drawings of Basotho murals are the earliest known. It is curious that they do not include any examples of the curvilinear patterns based on plant motifs that are now frequently found in *litema* mural engravings and paintings. Perhaps these are a more recent development in Basotho mural art, but this seems unlikely. The French missionary Eugène Casalis's passing reference to *litema* designs in his 1861 book calls them "ingenious," an adjective that suggests far more intricate patterns than those copied by Stow.

Unfortunately, almost a century separates Stow's field drawings from the next useful collection, made in 1976 by students at the Lesotho Teachers Training College. They collected twenty-nine designs, publishing the line drawings with the suggestion that they could be useful for students to use in the classroom in geometry lessons or to copy for potato prints. The students' work appears to have continued a tradition of using *litema* in the education system. Basotho schoolgirls in the 1940s were taught *litema* designs as part of their curriculum. At that time women held communal parties for mural decoration, with as many as 200 women taking part. The event was celebrated with all the trappings of a religious celebration, including singing, dancing, and beer drinking. By

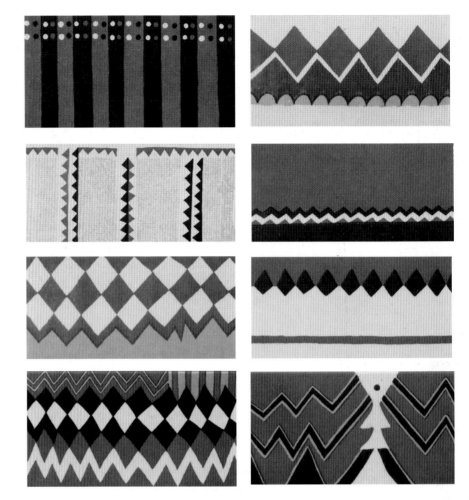

Stow recorded several exterior designs at Rama-roke's kraal in British Basutoland in October 1877 (right column). Motifs include stripes, zigzags, lozenges, and half-circles. Among the designs he recorded as "Bakuena" (left column) are textured panels that appear to represent litema engraving (second from top). His caption describes this design as the exterior mural from an "old ruined Bakuena kraal, Wal Drift, Klip River, Transvaal Territory." The top design is from the exterior of another site in the Free State. The two bottom designs are interior murals.

MOSEME

MALOTI

LETJOI

LITHEBE

LEKOKO

Drawings made by trainee teachers of mural designs found in rural areas of Lesotho during the 1970s. Elderly informants supplied the names of patterns.

MELEBO

MAQOAPI

MORABA-RABA

MALETERE

LESIRA

MALENTE

LIKHULU

LIKHOLE

MAOKA

MAHLOA

MORIRI

MOFAPO

SEKHO

MOHARANE

1976, younger women in Lesotho showed little interest in *litema*; it was elderly women in remote villages who remembered and communicated designs that had probably been in use during the previous half century. Plant motifs dominate these designs.

During my own research I carried copies of these designs to discuss with Basotho women and to give to them. The women in the Free State pored over the drawings, deciphering them more from their names than from the designs themselves. Some of the easily recognized plant designs were of traditional foods such as *maqoapi*, the sorghum plant, and *melebo*, a kind of pumpkin. Some names puzzled them, because the orthography of Sesotho followed in South Africa differs from the version set down by French missionaries in Lesotho. In addition, some of the names believed to refer to shrubs and trees are for species now rare or extinct in the deforested Free State. Apart from food plants and wild plants, several designs referred to grasses or objects that women weave from reed-like grasses. Among these were *lithebe*, a mat women make for grinding grain; and *lesira*, a reed mask that young women wear during their period of initiation. Several designs referred to readily identifiable motifs, including clouds (*mahloa*), the Maluti Mountains (*maloti*), spider web (*sekho*), halter (*maletere*), or hide (*lekoko*).

Three designs are intimately connected with the socialized human world: *moriri* is a hairstyle, *mofapo* is a set of incisions made on the cheek, and *marabaraba* is a game like checkers played on a board that can be scratched out in the sand, a rock, or a plank. All of these are signs of socialization. It may well be that at a profound level all *litema* designs are signs of civilization—not only of cultivating the fields but of being cultured, cultivated humans.

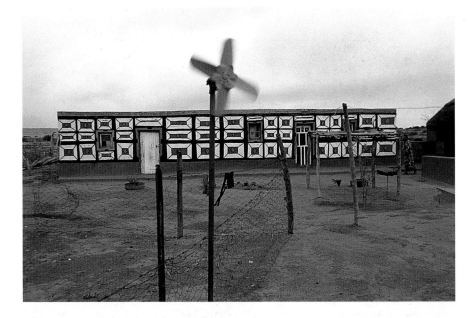

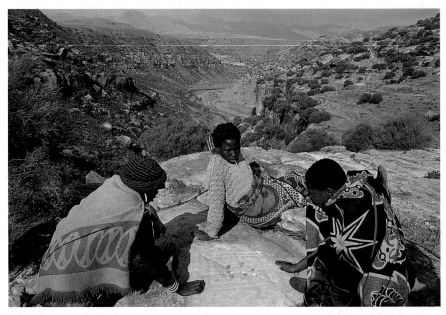

This mural design by Betty Mohapi (top) is based on *marabaraba* game boards, such as the one that young Basotho herdboys have scraped into the rock on a peak in Lesotho (bottom).

This intricate *litema* design at the rear of Tlakiri Mahlaba's house is strongly reminiscent of hairstyle designs. The metal roof sheets are weighted down with rocks, which precludes the need to make holes in the sheets in order to secure them to the underlying metal poles or beams that support the roof.

A sunflower design with crescent moons, executed in stone mosaic and painted in bright colors obtained by relatively inexpensive distemper paints.

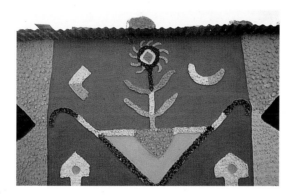

Opposite:
The doorway of Sanna Motaung's home features a pediment ornamented with a cutout flower. The cloudless azure sky blazes through the heart of the flower, as if staring down the appeal for rain and fertility that the murals offer up to the ancestors.

Civilization is the mother of the line, of all incision and inscription. Civilization brings the row in the field, the cutting of the path, the scarification of human bodies, the carefully designed hairstyles. The association of civilization with the line is strong in much African art. The intricate linear detailing of the facial scarification on Yoruba sculptural figures from Nigeria provides one example. For the Yoruba, civilization is literally a "face with lined marks"; to say a place has become civilized one says literally, "This place has lines upon its face." Furthermore, the Yoruba verb for scarification is the same word used to describe the founding ges-

tures of a human settlement: clearing bush for cultivation, cutting paths, and making boundaries. In this sense the Sesotho verb *ho lema,* to cultivate, not only gives birth to the concept of *litema,* but invests the art form with a broader set of associations that have to do with people being cultivated humans and reflecting that civilization through line.

The women who make *litema* do not express such esoteric concepts. Few of them even volunteer that the word *litema* refers to cultivating the fields. In fact, Basotho women in the Free State now commonly call *litema* simply *blomme,* the Afrikaans word for flowers. To them the distillation of their art form now boils down to flowers in the abstract—flowers as signs both of beauty and the promise of fruitfulness, rather than particular plants whose names are well known. Just as the fields, which *litema* engravings evoke so strongly, give rise to a variety of plant forms, so, too, *litema* designs are today primarily inspired by the plant world. The murals celebrate radiant blooms, unfurling fronds, spiraling tendrils, shoots, and sprouts. The murals' fields of flowers are symbolic affirmations of the fruitfulness of both the fields and women, who were exclusively responsible for cultivating them in the past.

In Sesotho and other Sotho languages, words used to describe decoration and beautification are derived from the root *kgaba,* which means to be beautiful, to dress well, to move well, and to be righteous. This root has several derivatives that apply to ornament, adornment, pattern, and art, including *sekgaba,* a beautiful, adorned thing or person; *mokgabo,* beauty, brightness, ornamentation; *bokgabane,* beauty, virtue, honor, moral beauty, uprightness, excellency, something right or righteous; *dikgabane,* a fine or well-dressed person. Morality and beauty are closely aligned. For Basotho painters this is

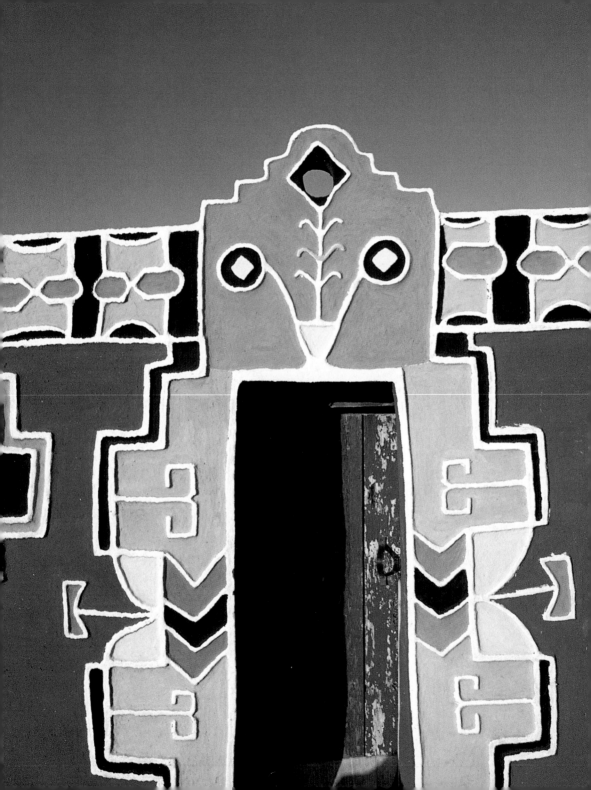

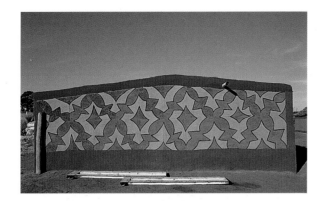

Top to bottom:
Emah Motlaung, 1992.
Emily Malakwane, 1992.
M. Radebe, 1988.

These designs demonstrate some of the aesthetic principles of Basotho murals: the ordering of small pattern fragments; rhythms established by the repetition and variation of particular motifs; and the importance of medians around which blocks of pattern are structured.

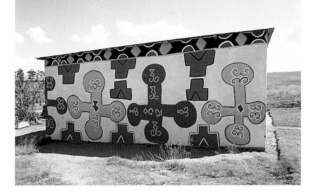

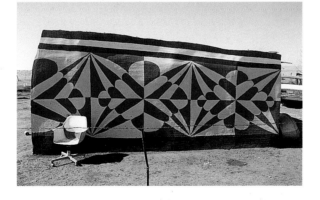

indeed true: they beautify their houses and this shows that they keep a proper, righteous Sesotho home.

In Sepedi, the word *kgabakgabisa* is used both for decoration and for cutting or mincing into fine pieces and mixing together, the work that women do to prepare food. In Sesotho the word is *kgabela.* This suggests yet another strong parallel between mural arts and women's past role as the providers of food: the fine, repetitive processes of preparing food and decorating both require fine incisions, ordering the fragments that result from the cuts, and mixing them together.

The Sepedi word *kgabare* means shoot or reproduction and implies repetition, replication, continuity, and multiplication by division—ideas related both to reproduction and pattern-making. The musical notion of a seed motif is again suggestive here—pattern elements hold all the "genetic" material to generate a whole composition. A pattern beats out a rhythm across a wall: in Sesotho the word *kga* is an ideophone for "beat" and is also used to describe running swiftly. Music exists only in time; here again Sesotho words beginning with "*kga-*" can be applied: *kgabare* is the noun for time or the lapse of time; *kgabaola* is to beat heavily or sound loudly. The same word, *kga,* is also the root for another set of meanings that tie together ideas relating to the fields and women's work: these words describe the picking of the produce of the fields, the drawing of water, preparing beer for a feast, and important matters or big things, which includes heavy rain.

With these concepts in mind, I began to view particular compositions musically: as classical, as pop, as jazz. Unpredictable or unexpected distortions of a motif to fit under a

window became jazz. One example even reminded me of the innovative geometric painting by Piet Mondrian titled *Broadway Boogie-Woogie.* I also began to pay special attention to how Basotho compositions are divided.

Most *litema* murals are organized around horizontal and vertical medians that cut each pattern block into quadrants. If one reads a pattern from left to right, the first median line is a silent beat in the middle of the first design block—and it is repeated in each subsequent block. But one can shift the beat by reading these same lines not as medians but as the borders at the beginning and end of pattern blocks. This reading completely alters one's perception of the pattern, which suddenly takes on new life, much as when one solves an optical illusion or puzzle. Viewing the composition one now sees simultaneously two entirely different patterns, two logics, or two themes that play together and against each other.

The aesthetic effect of murals is largely dependent on the use of the median, which provides a center or axis around which patterns evolve. Symmetry is one of the main features of the designs, but they often deliberately disturb it. They also repeat other centers of strong focus, such as bold dots or the centers of floral motifs.

In Sepedi, the word for middle or center is *kgabakgare* (closely related to *kgabakgabisa,* decoration, and *kgabare,* which means offspring and implies replication). The Sesotho root for center, *hare,* pronounced similarly, does not appear to directly relate to ideas of decoration and repetition, but the Sesotho word *hara* is related to coiled or spiraled things that do have a center or source. Many of the terms derived from the *hare* root have to do with plants in one way or another. The most interesting words in this complex are *kgare* and *kgaratsa,* because

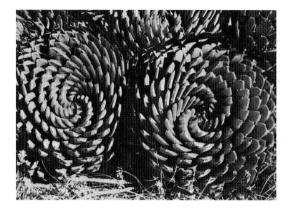

The spiral aloe known in Sesotho as *kgaratsa.*

they are strongly connected to architecture, women, and to the ideas of the crown or top of something—such as a flower.

The primary meanings of *kgare* given in the standard Sesotho dictionary are:

> *ring made of grass and placed on their heads by women carrying heavy loads; apex of a hut, where the thatch is bound in a bundle; crown, top;* - ya motse, *large ring of grass buried in a village to protect it against hostile magic.*

Rings made of plant fiber, which themselves have a definite center, are used to center the things women carry on top of their heads, to define the top of the house, and to magically protect against evil. These ideas, important to architecture, religion, and women's costumes, are best considered in those contexts, rather than in relation to murals, but they are nevertheless important to note here.

Derived from the word *haratsa,* to put in a spiral, is the word *kgaratsa,* meaning spire, convolution, or spiral. The same word is also the name for an aloe found at very high altitudes.

When this, or any other plant flourishes, the Sesotho word used to describe its growing in beauty and strength is *kgabasela.* This aloe's growth creates a beautiful pattern as its jagged, toothed leaves coil outward from the center in a tight spiral. This pattern of growth, no less than the outward radiation of petals that crown a flowering plant, connects the idea of growth with the idea of a visible center.

All of these words, concepts, and associations that can be connected to murals considerably extend the ways they can be viewed: their patterns grow or bloom across a facade, much as a planted field turns to flower; the process by which they are created is one of repetitive actions, like the movements women make in cutting up food; they establish centers and destroy them; they beat out a rhythm that implicates time. Their ultimate rhythm is their own life span. Like the fields, murals are tied to the cycle of the seasons. When the rain comes the murals wash away.

Prayers for Rain

Basotho mural artists say their reason for making *litema* is because it is the traditional sign of a proper Basotho home. It is therefore an essential part of the duties of a Basotho woman. Women summarize the religious function of *litema* by saying simply that *litema* calls and pleases the ancestors. The ancestors recognize that, in following tradition, the creators of *litema* demonstrate that they honor the ancestors, who are thus well disposed toward the household and likely to listen to its prayers. A common Basotho benediction includes the three main positives for which human communities beg the ancestors: *Khotso, Pula, Nala.* Peace, Rain, Plenty.

Peace, rain, and plenty—these three great

goods, are closely connected. If there is peace and harmony, the ancestors provide rain and life is filled with abundance. Bloodshed resulting from violence, however, is an offense that defiles the earth and offends the ancestors, who signal their displeasure by withholding the rain. The great violence that preceded the arrival of democracy in South Africa was accompanied by a crippling drought, which, from a Basotho point of view, was a natural consequence. Wherever I conducted research among Basotho at that time, I found that they prayed to God and the ancestors for peace and the return of rain so that the country could once again enjoy plenty. There was a poignant pointedness to the conventional greeting long used by the Lesotho highlanders: *Khotso*! Peace!

The motifs and colors of much *litema* painting are connected with these ideas, particularly the prayer for rain. Red ocher is particularly important. Called *letsoku,* blood of the earth, its name implies water (the earth's blood). For centuries *letsoku* has played a key role in rainmaking rites among Sotho communities and was an important trade item in southern Africa. Its associations with blood also link it to menstrual blood, which is a sign that women are still fertile, and to sacrificial blood, which, in a kind of bargain of blood, feeds and honors the ancestors so that they will bring rain. Properly honored, the ancestors will cause water to flow through the earth's veins, the earth will be as fertile as a menstruating woman, its *seriti* will be strong. Red ocher in murals is precious earth, dug from beneath the "skirts" of the earth, to sound a special call to the ancestors to feed the earth with the "blood," the rain that the ancestors hold. Today, workers in the Free State still make long journeys to dig the most sought after red ocher of a deep, bloody shade.

Opposite:
Diviner Mmathabo Radebe wears a conventional red outfit embroidered with white beads. The coin suspended between her eyes symbolizes light and enlightenment. She holds a grass switch and has cast her "bones"— divination articles—before her.

The color white connotes peace, happiness, and purity, often expressed idiomatically as conditions of the human heart. To have a white heart implies innocence, good intentions, or joy. White, derived from chalk or other substances, is important in initiation rituals, when initiates are in a delicate state of transition and need to signify the ritual purity they must observe. In mural arts, white paint is a sign of peace and may also suggest clouds. Together with reflective surfaces, particularly silver coins and mirrors, white is also associated with *lesedi,* light, which implies enlightenment. This makes it important for diviners, who also require purity to serve as mediums for the exchange of spiritual forces.

Black is associated with the realm of the shades generally, with *mosima,* the abyss in the earth where they are sometimes thought to dwell, and with the dark rain clouds they bring. Blackness can imply impurity or defilement in some circumstances, but it is also associated with protection in some contexts. Magical twigs called *mofifi,* for example, are inserted in the roofs of houses because they are believed to shroud the interior of the house in darkness so that evil influences can not see inside.

Red, white, and black are the primary symbolic colors in mural arts and in rites of initiation. While they mark the bodies of those in transitional states, they are similarly often used to mark the zones of the house that can be considered transitional: its outer edges—the roof line and the foundation line—and the surrounds of doors and windows. Generally at least two of these colors are combined in the designs of transitional zones.

Apart from plant designs, other common motifs in *litema* painting can be rather difficult to explain, particularly because their painters do not readily identify them with particular

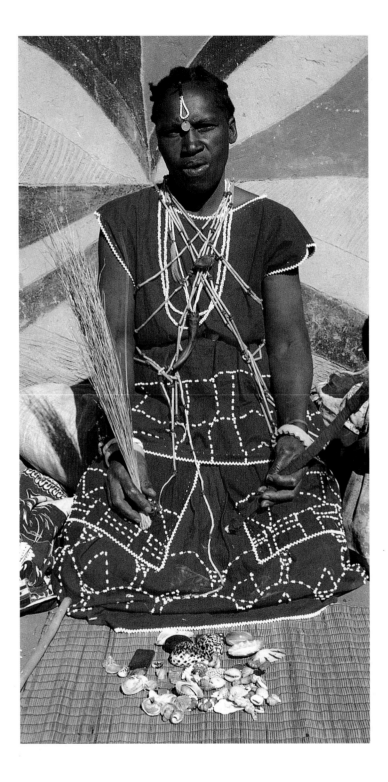

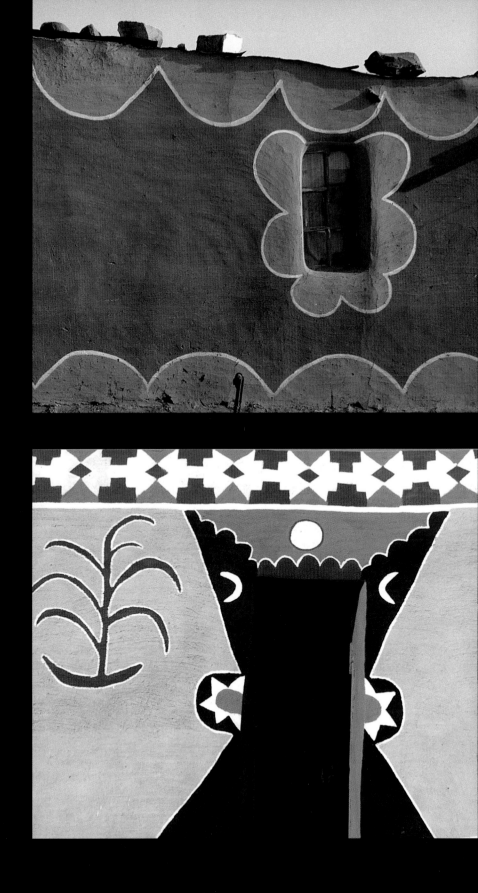

meanings. Many of these motifs, such as dots, scallops, and patterns based on triangles, clearly have considerable antiquity, since they are found on pottery at Basotho archaeological sites. They may now be used simply because they have accrued the venerability of long-standing tradition. Perhaps at one time the half-circle, termed *kwena* in Sotho languages, was a sign of Koena cultural identity, but such early meanings for signs cannot be verified today.

Research does reveal that some specific meanings are ascribed to certain ancient motifs today—dots, for example, represent seeds and curving lines symbolize rivers. But such specific meanings can be quite contradictory. One researcher states that upward pointing triangles in Basotho art are phallic signs of fertility; another that the same triangle is a sign of women. Whatever meanings may be applicable today, there is nothing to prove that particular motifs meant the same thing at any moment in the past.

Indeed, some motifs appear to have experienced bursts of popularity at particular times. Crescent moon motifs are an interesting example of the latter kind. An ethnographer in the 1930s remarked that crescent moons were painted on houses in Lesotho to promote human birth. Such moons are seldom seen today. Earlier research suggests that the new moon was once closely connected to fertility in the Basotho worldview, and was also used to time such key religious ceremonies as the new year festival, when the chief tasted the first fruits of the season and performed rituals to protect and renew the people and environment. I heard of no such ceremonies in the Free State during my research, and ceremonies were timed to coincide with Western holidays and weekends so that people could attend.

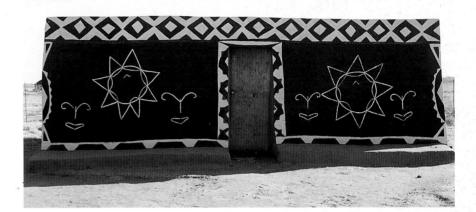

This black house combines sun and seedling motifs in unusually representational styles. (Painter unknown)

Sun motifs may have arisen among Basotho because of the obvious warming and germinating power of the sun and/or the more abstract associations of the sun and light with creation and enlightenment. Used today, however, they might just as easily be inspired by the bold sun logo on tins of Sunbeam floor polish, or chosen purely for their radiant graphic qualities.

When I asked Basotho women why they had chosen particular motifs, such as suns and moons, they told me either that they were chosen because they were beautiful, or because the ancestors had dictated the design to them in dreams, in which case they would not even concede that the dictated shape was, in fact, a crescent moon or a sun. That, presumably, was a matter upon which only the ancestors themselves were qualified to pronounce.

Opposite:
The design by Maria Lebethe (top) uses half-circle scallops colored with the earth on which the house stands. At the base of the house this has the effect of unifying the ground plane with the wall; at the roofline it emphasizes the ground plane more than the plane of the wall. Elsie Nhlapo's doorway (bottom) combines sun and moon shapes and scallops suggesting clouds. The corn plant to the left emphasizes fertility.

The silence of painters on the interpretation of motifs may be a tacit concession that deep, ancestral values are encoded in particular motifs, whether or not women know these meanings. The women artists in the Free State, however, frequently expressed the feeling that they were ignorant because of "living on the farm," and were alienated from profound Basotho values, and even "high Sesotho" language. The awed response to the drawings I showed them of designs from 1976 evoked the wistful explanation: "Hauw! We don't get such Sesotho things here on the farms." This seems to suggest that it is unlikely they would know a repertory of archaic meanings for very old motifs such as triangles. Rather, triangles are just one of a stock of motifs on which they draw.

I was particularly fascinated by the problem of the meaning of triangles during my research, because they are used so frequently and because, in different combinations, triangles create lozenges, squares, and zigzags. I was frustrated by the fact that no painters provided an interpretation of the meanings of triangles. Instead, I turned to linguistic interpretation of the name applied to the zigzag motif, *ditswedike*. This noun refers to zigzags, curves, and things that wind around; in the verb form it describes the action of winding something.

The same root, *tswedi,* also forms the noun *motswedi*, which falls into the special class of "*me-mo*" nouns. Nouns bearing these prefixes are often sacred or ineffable things, such as Modimo (God), or fire, smoke, mist, wind, and lightning: *mollo, mosi, mohodi, moya, maane.* *Motswedi* has two meanings: source, and "an unidentified bird that must not be killed." These meanings are worthy of in-depth consideration.

Source is a concept associated with origin and with Modimo, one of whose praise names is the Source. In the traditional Basotho view, the most visible appearance of Modimo is in the form of lightning, which is Modimo returning to Its source in the earth, completing a cycle. Lightning bridges heaven and earth by visibly connecting them for a split second as it pierces the sky. The zigzag of lightning is both a rift and a seam.

In Sotho mythology, Modimo's special messenger is the Lightning Bird, who is also the carrier of the rain. Though essentially mythical, the Lightning Bird is usually identified as a species of small heron known as the *hamerkop,* or hammerhead, though there is some debate on this score. For this reason hammerheads are never killed. It is surely to this bird that the noun *motswedi* applies.

Taken together, these linguistic connotations suggest that zigzag motifs may hold deep significance. The meanings relate not only to the Creator and to rain, which are central to the broader meanings of the architecture and the murals' appeal for rain, but also to the idea of things that wind around: a term that is applied during the construction of a house to such activities as thatching the roof. It may also be that the idea of winding, of performing repeated circles, can be applied to the cycle of the seasons and of life itself.

Taken to the deepest level, the root meaning of the word and the motif can be interpreted as describing the cosmic path as one of constant change, reverse, alternation, and opposition. Interlocking triangles that create zigzags often decorate transitional zones of the house, suggesting a broader implication of transition and alternation: they are a charge between one state of being and another, a charge that occupies the threshold where one thing becomes another. Often the zigzag is not a drawn line, but con-

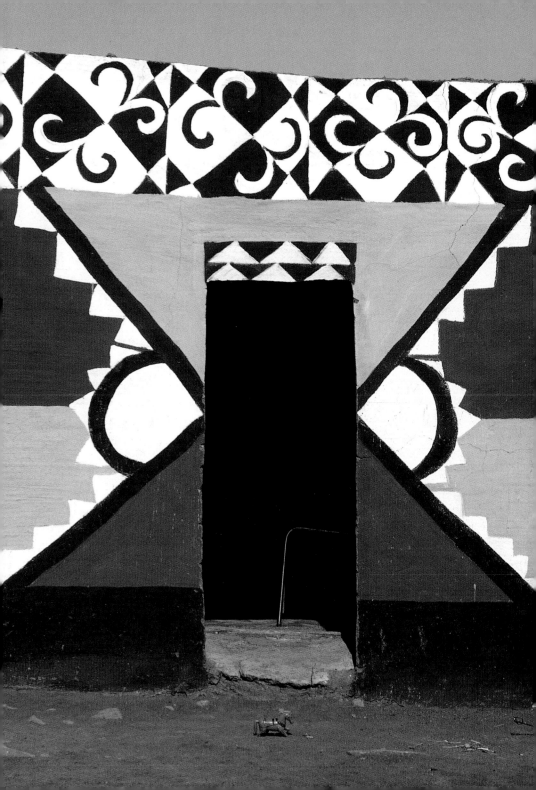

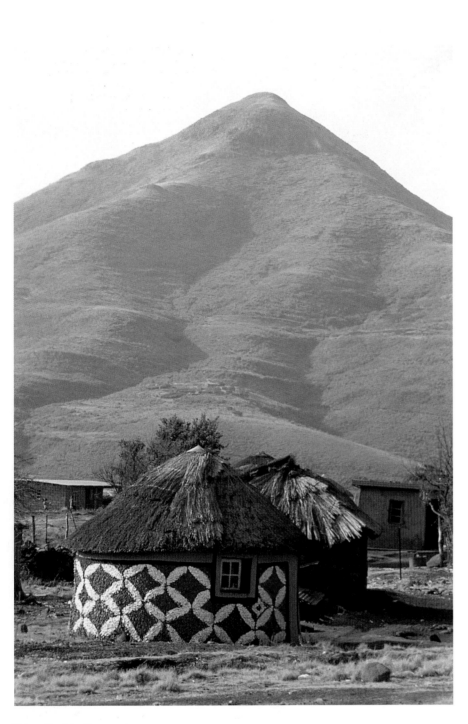

This *rondavel* dwelling near Roma, Lesotho, features a mosaic design.

sists solely in bringing together contiguous rows of differently colored triangles. Then the zigzag is merely a visually charged frontier between zones of difference—an unrepresented representation, an undecidable line.

Architecture: Earthen Wombs

Litema also derives much of its significance from its architectural context. Basotho houses are metaphors both of the womb and of creation. In the Basotho creation myth, humans were formed in a cave deep in the bowels of the earth; bowels is a Sesotho euphemism for womb. The first humans crawled up a long passage to reach the surface of the earth. They emerged into the light of day through a muddy bed of reeds at a place called Ntsoana-Tsatsi (in-TSWUH-na-TSUT-si). The name is probably derived from *go tswa,* to come out, and *letsatsi,* the sun, implying Place of the Rising Sun. This name ties ideas relating to light, particularly dawn, to the concepts of birth and origin.

Archaeological research at Ntsoana-Tsatsi a mountain between the towns of Vrede and Frankfort in the Free State, proves that Basotho occupied this site from at least 1600. At that time they were relatively new Koena immigrants, living among a Fokeng group that was already settled there and adopting their architecture. Koena traditional building was the *rondavel* form—a conical roof of thatch, assembled separately, placed on top of a circular wall that consisted of a wattle framework plastered inside and out with mud—the cone-on-cylinder house. In the Free State the southern Sotho house became the *mahlongoa-fatse* (muh-SHLONG-gwuh-FUT-si), which literally means "circle of sticks planted in the ground."

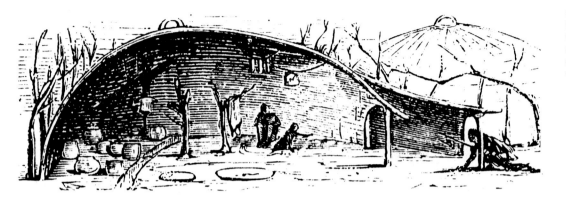

Casalis's illustration of a section through a *mahlongoa-fatse* shows the raised pottery shelf at the rear of the dwelling and a person crawling into the *mathule*, the entrance tunnel.

The *mahlongoa-fatse,* very rarely seen today, was an igloo-shaped dwelling. Windowless, it was dark except for the little light at the end of the long, tunnel-like entrance passage, called the *mathule,* which was so low that it had to be crawled through. The house framework was created by planting a circle of pliant saplings in the earth, bending them inwards, and fastening them together at the top of the dome; these arches were externally reinforced by several horizontal rods. The *mathule* was similarly constructed of arched saplings, supported along the top by a spine of straight branches. This skeleton was clad with reeds and thatched with grass. The surfaces could then be plastered with mud.

The architecture of the *mahlongoa-fatse* echoes the creation myth both in its form and the building materials of mud and reeds. The cosmic connections are strengthened by the symbolic value of light. The center of Basotho settlements—their life's blood, as it were—was the cattle kraal, a corral surrounded by stone walls. Settlements were oriented so that the first light of dawn fell on the kraal, as if giving a divine blessing. The main houses also faced east. Emerging from the house at the start of the

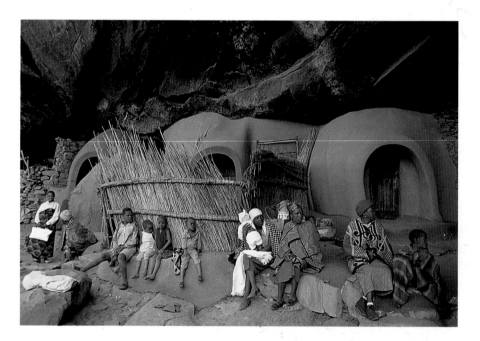

These womblike Basotho houses at Ha Kome, Lesotho, hark back to earlier times. They nestle in the rear of a cave, from which a clan of notorious cannibals swept down upon passersby during the Lifaqane. Their igloo-like shape, including a residual *mathule* tunnel entrance, is an extremely rare example of architectural conservatism in Lesotho, as is the reed fence that screens the forecourt of one of the houses. It is likely that the *mahlongoa-fatse* type of house was often plastered externally, as in these examples. This would explain an early description by a European visitor of Basotho houses shaped like the nests of swallows but it does not explain why the current inhabitants choose to preserve this historical form—particularly since their reputation suggests that recalling their past would be unsavory to most.

Archaeological remains of Basotho and earlier Southern Sotho settlements dot the Free State. They primarily feature extensive stone walling surrouding kraals, or livestock corrals, and houses. Such walled settlements are still seen in remote parts of Lesotho.

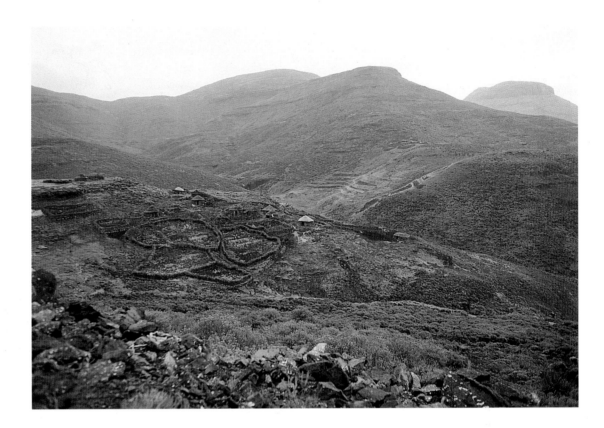

day was to begin life anew. King Moshoeshoe is said to have uttered a prayer of gratitude every morning for seeing a new day.

In Lesotho, such settlement layouts can still be seen where villages have formed in the traditional way and continue a cattle-based economy. In contrast, the Basotho houses on Free State farms form villages brought together purely by the needs of the white farm owners; the workers seldom own livestock of any kind. Basotho traditionalists, however, still place the old and the sick in the doorway of the house to keep their eyes on the source of light and life in the east. The dead are removed from the house feet first, so that their eyes look toward the rising sun. In the past, corpses were buried in a

crouching position facing east, together with a reed that had to be used to measure their graves. Today, even when people are buried lying down in fancy coffins, they are positioned so that the first rays of dawn would strike their foreheads.

Because Basotho architecture is a microcosm of the creation myth, it may be appropriate to translate Ntsoanna-Tsatsi not merely as Place of the Rising Sun, but more specifically as House of the Rising Sun. It may be possible to take this one step further and suggest that the name is a polite reference to the Creator. According to Basotho custom it is rude to speak a person's name directly; rather one refers to them by the place from which they come. The injunction

Two riders, swathed in Basotho blankets and transporting a coffin, hurry as a snow storm approaches Semongkong, a remote village deep in the mountains of Lesotho. Basotho ponies are famous for their surefootedness on rugged mountain paths.

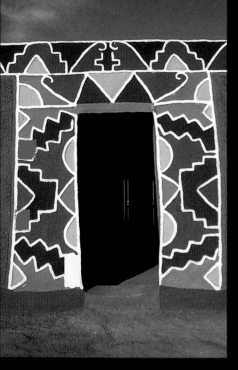
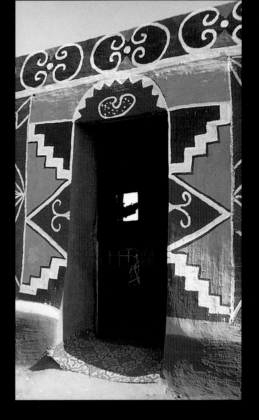
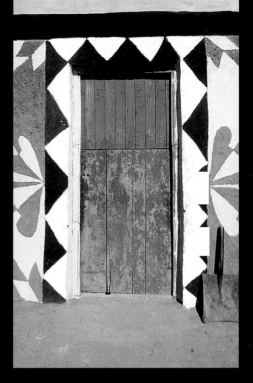
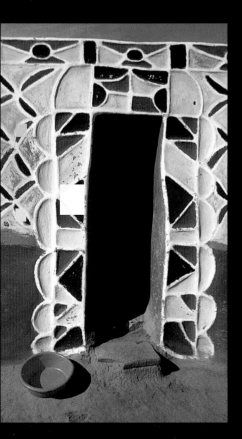
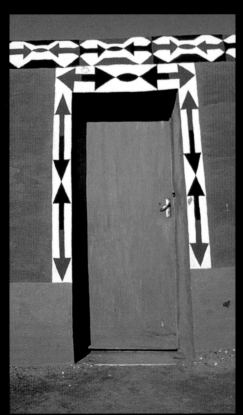
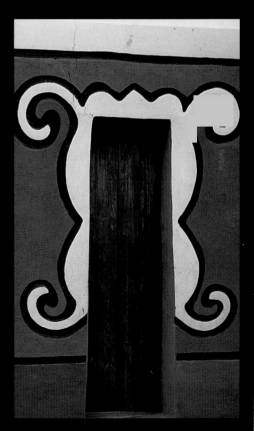

against speaking the name of the divine and remote Creator was so strong that to violate it was to invite death. It is plausible that the place of origin and other metaphors of divine light are euphemistic references to Modimo. Perhaps, then, Ntsoanna-Tsatsi might be translatable as House of God.

The more material metaphor of the *mahlongoa-fatse* as a symbol of the human womb must have been very clear when people had to exit the house by crawling down the *mathule,* like a birth canal. Even in the 1960s, when Basotho architecture had changed a great deal, a missionary in Lesotho told me that women clearly saw their houses as symbolic wombs. None of the Basotho women I spoke to in Lesotho or the Free State expressed this idea.

The womb symbolism, however, is still clear in other ways. When a baby is born inside a Basotho house, the event is marked by placing a reed in the thatch above the doorway, or, among the Tswana, across the threshold. This warns men away in order to protect the child, who is regarded as being in a liminal state, hovering between the world of the spirits and the living. The child is only truly born into the human community when it crosses the reed into the light of day. The doorway of the house is a symbolic vagina through which the baby is born from the dark interior, just as the human race emerged through the bed of reeds at Ntsoanna-Tsatsi. Similarly, pregnant women should never hesitate on the threshold of a house; this invites a difficult delivery.

Early Basotho houses opened onto a small private forecourt or courtyard, the *lapa,* which was screened from public view by a wraparound, curved reed fence, called the *seotloana.* The house was for sleeping and refuge during bad weather; the courtyard was the focus of

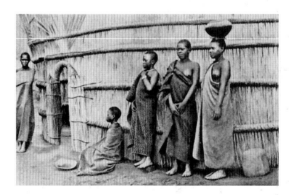

A reed fence, or seotloana, once surrounded the lapa, or courtyard. Such fences are rare today.

The *lapa,* or courtyard, in front of Basotho houses may be likened to an altar because it is the place most closely linked with the family's ancestors. The *lapa* is often carefully decorated with ornamental walls, relief work, or designs scraped into the floor while the plaster is wet. This example from Malealea has a border of inset soda cans. Elizabeth Kholoanyane, 1992.

Opposite, top row, left to right:
Ester and Emily Nguni, 1992.
Paulina Noktuta Shabalala, 1992.
Mmaoupa Shabangu, 1988.

Bottom row, left to right:
Letia and Elizabeth Moshoadiba, 1992.
Makomho Mosebi, 1990.
Julia Mabaso, 1992.

These crockery racks, made entirely of mud, replace the pottery shelf found in precolonial houses. The circle design in the center of the example at right, by Maria Mokhethi, has two points of focus—a crescent in the middle and the bridal couple ornament from a wedding cake. Emily Shabalala's rack below has Christian crosses and a discarded hub cap from a car at the base of the cross.

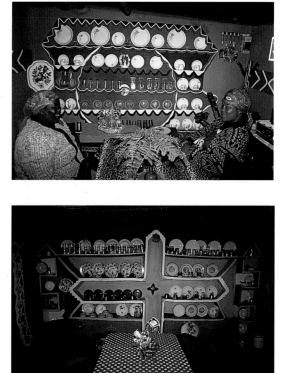

daily life and the venue for entertaining and religious ceremonies. As Gabriel Setiloane observes:

> The missionaries, who were looking for temples and altars were misled. They could not have got to the heart of the people's religious understanding until they had known them at this point, at the lapa. Here is the altar on which the whole life of the household is lived. Therefore, the policy of the [apartheid] government of moving people from their ancient habitations is tantamount to the destruction of their temples.

Daily meals, taken outdoors in the courtyard, were religious moments. Food and drink were dropped to the *lapa* floor to feed and honor the shades. Female ancestors had a particularly strong presence in the *lapa* because, in some Sotho communities—particularly among the Tswana—women were buried in the *lapa* and their graves were marked by mounds of earth. Most Basotho now eat indoors at dining room tables but, at special ceremonies, offerings are still strewn on the *lapa* floor.

The most sacred part of the *mahlongoa-fatse* was a raised shelf, called the *mahaoloane*, at the rear of the interior on which the pottery vessels were stored. Men and children were careful to avoid this part of the home, strongly associated with women and ancestral presence. Pots were made by women and used by them for carrying, containing, and cooking food and water for the family. Not surprisingly, the word for pot is another euphemism for the womb. Perhaps this explains why archaeological digs at Sotho sites have discovered infants buried in pots. It also gives special significance to seeds being stored in pots, and to the fermenting of grain in pots to make beer. These imply human fertility and conception, which occur in the depth of the womb, just as the pottery shelf occupies the deepest recess of the house.

The shape of the *mahlongoa-fatse* is itself reminiscent of an inverted pot. This association is strengthened by a special fiber ring attached inside to the top of the roof. Termed the *kgaratsa*, it is like the *kgare* ring that women place on their head to center and stabilize pots and other loads, which they carry on their heads. The other meaning of the word *kgaratsa*—the beautiful spiral aloe—completes a set of links between the house, women, and the plant world.

In contemporary Basotho houses the pottery shelf is replaced by racks for storing modern

crockery. A rack, or *raka,* is built by first apply-
ing a ridge of mud to a sheer wall. With great
patience, the ridge is gradually extended hori-
zontally until it forms a narrow shelf. This
requires numerous layers of mud, each allowed
to dry completely before the next slight exten-
sion is added. Carefully designed, contemporary
racks often include several niches and may fea-
ture a central motif such as a Christian cross, a
circle, or a star. The rack creates an elaborate
visual focus that continues to celebrate the con-
nection between the ancestors and the food and
drink served by the wife of the house to the fam-
ily. Also placed there are treasured ornaments
and decorations, which may include shiny hub-
caps that have spun off the wheels of the cars
that speed by on rural roads and highways.

 Although the rack looks most like a Christian
altar, the courtyard space, or *lapa,* remains the
operational focus of Basotho religion. Today,
domestic courtyards are often marked by solid
altars, usually painted white and sometimes
marked by the flags of Africanist church sects
that combine the worship of ancestors with
Christianity. Here, local church members gather
on Sundays for religious ceremonies that blend
Christian prayer and Bible readings with tradi-
tional music, singing, and beer drinking.

 The first missionaries among the various
Sotho communities did not realize the impor-
tance of the *lapa* as the primary altar of the
people they sought to convert. Basotho architec-
ture was one of the first things that the mission-
ary priest Casalis set out to change, together
with covering up the naked breasts of Basotho
women. He insisted that his converts take "the
first step towards civilization" by settling in the
valley in neat rows of thatched rectangular cot-
tages built in stone with whitewashed façades.
These contrasted with the traditional circular

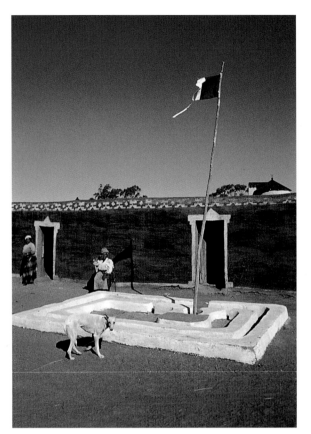

Today, altars for Africanist
Christian church meetings are
often erected in the *lapa.*
Mampheelo Mokwena flies a flag
for her church from the altar she
has erected in her *lapa.*

settlements of igloo-shaped houses built with
impermanent materials on hillside slopes,
which Casalis termed "rude encampments" and
where "barbarous songs" were heard as the
inhabitants circled in their "heathen dances."
For Casalis the barbarous circles, the slope, and
the *mahlongoa-fatse,* which he saw as so flimsy
that it suggested a people hovering on the brink
of nomadism, were pitted against the rectitude
of the rectangle and the solid civilization of
the valley.

 At the very least, converts were encouraged
to adopt the *rondavel* form used by Sotho

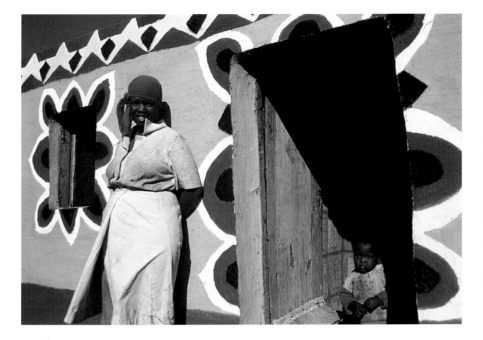

Windows share the symbolism of doorways and receive as much decorative treatment.

European-style roof, however, the weight of the earth caused their roof to collapse.

The *rondavel* was gradually adopted by Basotho, with one innovation: a porch extending from the doorway, which recalls the protrusion of the *mahlongoa-fatse's mathule* entrance. The retention of this feature has strong symbolic value. The *mathule* is not only like a birth canal, its opening is associated with the labia. It is traditional for Basotho women to elongate their labia by stretching them. This heightens sensual pleasure during intercourse, as the labia blanket the penis —a feature that evidently made Basotho prostitutes highly desirable among migrant mine workers in the fleshpots of Johannesburg and other cities.

Despite their symbolic overtones, however, the Sesotho terms applied to the *mathule* structure refer to the bones of cattle, rather than to female anatomy. The arched sides are called *digopo*, ribs, while the roof poles are *mokokotlo*, the backbone. This apparently divergent symbolism is, in fact, consonant with feminine symbolism, because the wife is regarded as the "backbone of the family," as Setiloane observes. Furthermore, the legality of a proper marriage, the foundation of a house, and the legitimacy of children all depend on *bohali*, the bride-price of cattle. Children are thus "born through cattle." From this perspective the *mathule* is a passage through the body of a cow; its exterior is the animal's hide.

Before the introduction of Western clothing, Basotho wore cloaks made of cattle hide. Born through the cow, they remained clothed by the cow throughout their lives. The stripe formed by the ridge of hairs along the animal's backbone was always worn hanging down the wearer's own spine. White traders quickly discovered that Basotho would not buy blankets that lacked

communities to the west and north. The *rondavel* is airy and appropriate for those hotter, drier regions. For the roof beams and supportive pillars, it also requires strong timber, which is rare in the southern Highveld. In fact, the *mahlongoa-fatse* was an appropriate and economical design solution for the climate and materials available in its location. Here the winters can be bitterly cold, with frost every night, and the plastered dome of the *mahlongoa-fatse* provided far better insulation than a thatch roof. The torrential rains of the region also tend to seep through thatch—as the PEMS missionaries soon discovered with their own cottage. In an attempt to seal the roof, they plastered it, probably imitating external plastering applied to the *mahlongoa-fatse* in the rainy season. On the

a stripe that could be positioned in a similar way.

This suggests that strong connections might once have been drawn between the *mathule*, hides or blankets, and labia. If these connections continue today, they are part of the arcane and esoteric knowledge communicated to women during initiation and protected by the strictest rules of secrecy. On a more superficial level, however, it is still clear that the doorway of houses is singled out for special ornamentation, either by painting, or by extensions on *rondavels* that hark back to the *mathule*.

The other house design introduced among Basotho is the parapet form, in which the roof is hidden by parapet walls on the front and sides of the house that serve to hold the roof in place. The roof, consisting today of corrugated metal sheets, slopes down toward the rear for drainage. This parapet design was used at the Cape by the British and by Malay slaves and spread eastward with the influence of the Cape colony. Before metal sheets became readily available in the late nineteenth century, parapet houses had reed roofs that could be plastered for additional waterproofing.

The first Afrikaans settlers in the Free State initially built A-frame reed houses and then more permanent mud-brick or stone dwellings of the rectangular parapet style. President J. P. Hoffman, first president of the Boer republic of the Orange Free State, was born in a house very similar to those now inhabited by Basotho farm workers in the Free State.

When adopted by Basotho, the parapet house form became distinctively their own through mural decoration. The symbolic importance of the house, the pottery shelf, and the courtyard remained intact. The courtyard could be defined in various ways—by a traditional

An elaborate painted interior boasts "windows" with a view. Lizzy Motaung, 1992.

Parapet-style house of the type built in settler towns of the Free State.

reed screen, low mud walling, or simply as a defined open space kept immaculately clean.

The deep meanings encoded in the architecture underlie and greatly enrich the significance of *litema*. Seen as a whole, the decorated Basotho house is an art work that strongly proclaims women's vital importance. Women are the providers of food, the guardians of the seeds, and the backbone of the home. They are the link in the chain of being that stretches backward to the people's earliest ancestors and the creation and forward into the future.

A gallery of windows:

Overleaf, page 112,
top left to right:
Sarah Makhalemele, 1992.
Ester and Emily Nguni, 1992.

Center:
Julia Mabaso, 1992.
Tomwelele Mata, 1990.

Bottom:
Selinah Mzimunkulu, 1992.
Maria Msiya, 1992.

Page 113,
top left to right:
Maria Sejake, 1992.
Letia and Elizabeth Moshoadiba, 1992.

Center:
Mantombi Masemanye, 1990.
Magenemoze Shabalala, 1990.

Bottom:
Minah Mokwena, 1992.
Puleng Motloung, 1990.

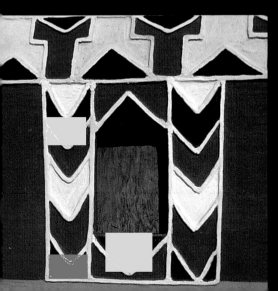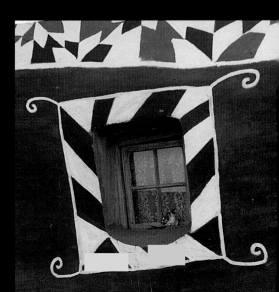

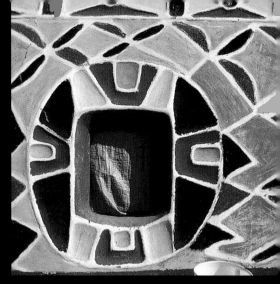

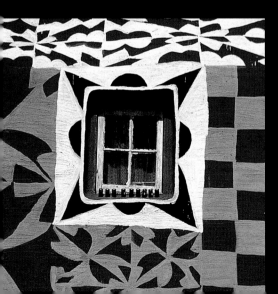

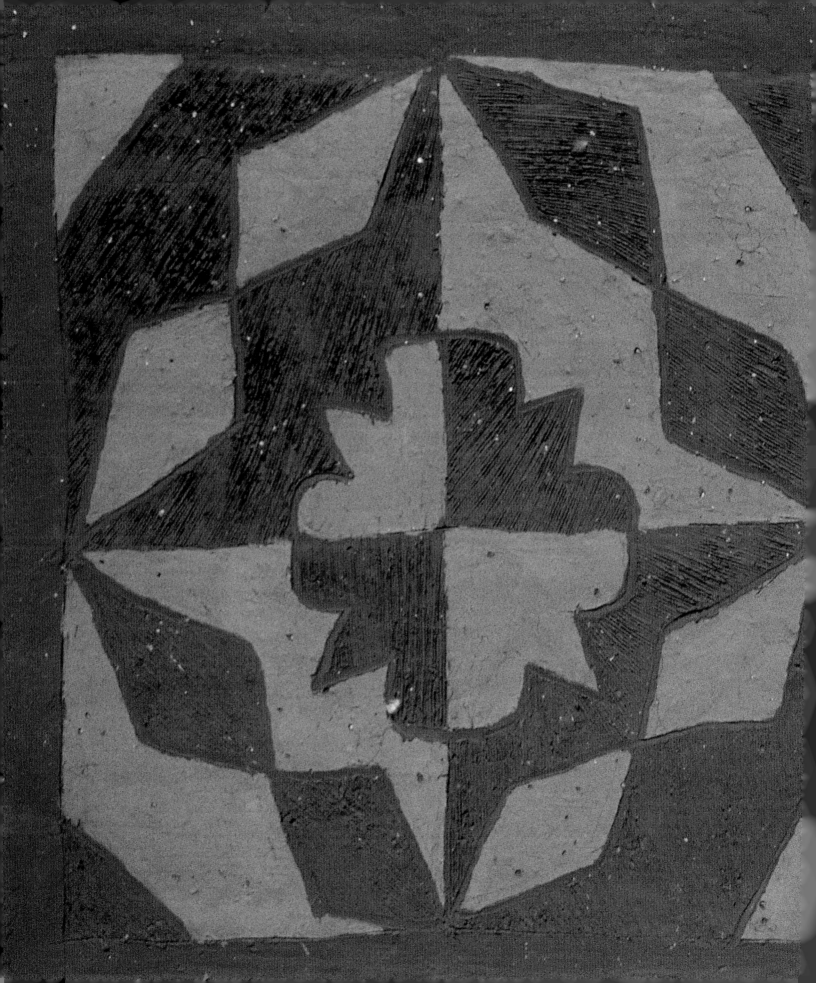

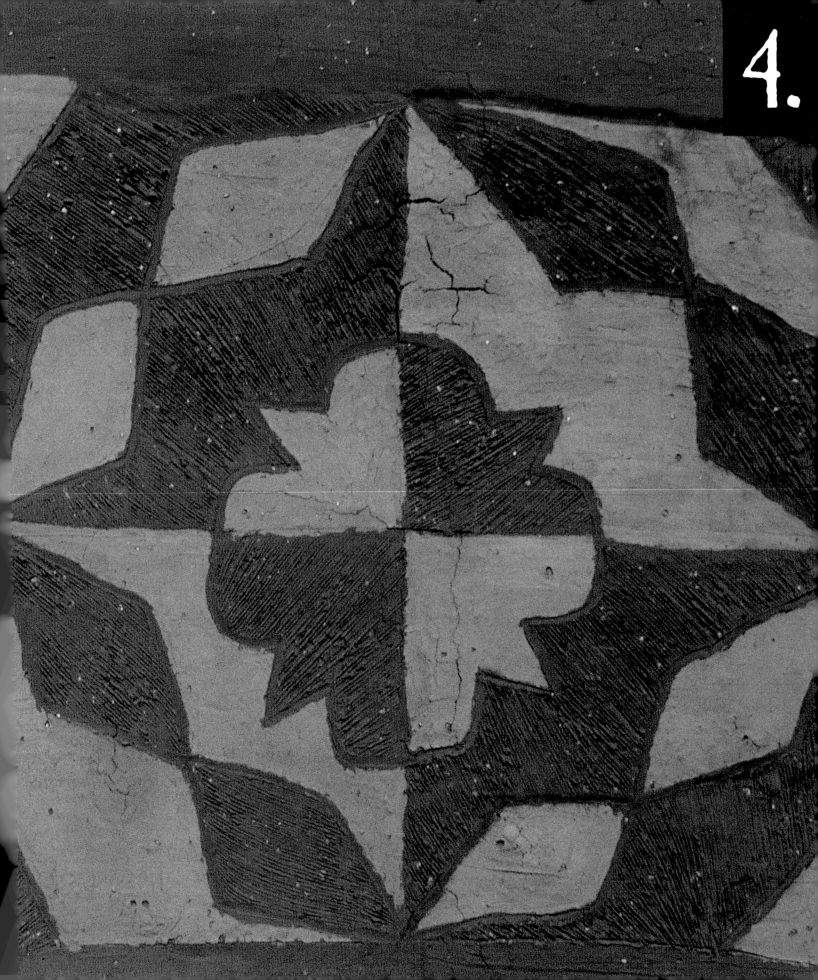

Becoming: Initiations

Young Basotho men and women attend special, separate-sex initiation schools, called *lebollo,* when they are in their late teens. The initiates live apart from the community for several weeks, during which they are taught the core values of their people and knowledge relating to their traditional gender roles. Although the schools are protected by strict rules of secrecy, several initiates have discussed their experiences or even published accounts of them that enable us to form a general idea of what occurs at the schools.

Women are instructed on their roles as wives, mothers, and guardians of the house and the *lapa,* although women today no longer grow the food for their families. Men are taught about their responsibilities as husbands, warriors, members of the chief's court, and controllers of the herds, although today most men are wage earners and may seldom attend a chief's *khotla.* Both sexes are taught the traditions, customs, sayings, and songs (*likoma*) that constitute the "way of the ancestors." After their public graduation celebrations the young people are regarded as marriageable adults, ready to play responsible roles in Basotho society.

From the early 1800s onward white missionaries among the Basotho tried to stop initiation schools. They realized that once a young man or woman graduated from what was known as a bush school he or she was likely to be dedicated to the traditions followed by the ancestors, many of which the missionaries sought to modify or eradicate. From that time until relatively recently, Basotho teenagers were often faced with a difficult choice: if they took leave from their regular schools—often run by Christian organizations—in order to attend initiation school, they might be refused readmission into the Western-style school system.

Tradition was placed in opposition to modern education. Many of those who chose Western education became part of the educated elite that played a leading role in national affairs, but traditionalists often viewed them as perpetual children who had offended the way of the ancestors. The political and other tensions between traditionalists and the Basotho elite have greatly influenced events in the last century, but they are too complex to explore fully here.

Recently, the opposition between ideas of heritage and progress has eased. Initiation schools no longer require young people to spend several months in training, and both government and religious schools allow pupils to attend initiation schools during vacations. Today, some older Basotho who never underwent initiation are entering schools despite their age. Others sometimes choose to repeat initiation training to rededicate themselves to tradition.

The graduation ceremonies that end the initiation schools are joyful public celebrations, particularly for the parents of young men, because the initiation of men is very demanding physically. Secluded in an initiation lodge far from home for a long period, during which they are circumcised, the young men are subjected to harsh physical discipline and great discomfort. Though it is seldom true today, in the past mothers would wait anxiously for a son's return, dreading that the leader of the school might silently present her with his clothing—a sign that he had not survived the ordeal of the school. Women's initiation is a gentler process, and during it, the women live in a hut within the village and are in contact with their families.

During my research for this book, I attended four initiation graduation ceremonies, two for men and two for women, during which the photographs here were taken. The content of the initiation process itself is secret, but any observer of the ending ceremony immediately becomes aware that these graduations are elaborate symbolic performances that powerfully dramatize what the initiates have learned.

Women's Initiation

Plant imagery and materials, and the sacred colors—black, white, and red—play key roles in the architectural arts with which women are so closely associated, and they are also featured prominently during the various stages of initiation.

Traditionally timed by the lunar cycle, the stages of transformation in a girl's initiation begin with the painting of her body in white ocher. White symbolizes the calm and purity that are associated with enlightenment and which the novices require for the ritual period.

The initiates are taken down to a secluded river or water course to meet a man or woman who plays the ritual role of *motanyane oa maliba,* which may be translated as "deep river snake." It has been reported that the *motanyane,* or snake, uses a clay phallus to penetrate the initiates' hymens, and teaches the women about sex. Other connotations of the root word *tanya* suggest that this highly secret encounter may be less daunting than one might first imagine. The noun also refers to sweet and delicious food, and, in verb forms, *tanya* refers to speaking nicely, and to a boys' game of tossing clay balls into a river so that they break the surface smoothly, with scarcely a ripple. While the *motanyane* figure at initiations is held in awe and even fear, perhaps the initiation embraces some schooling in sensual pleasures. In any event, this ceremony is a *petit mort,* in that the initiates' childhood dies, and they are painted black to signify this death. They then spend several weeks in seclusion in their initiation hut in the village, where they learn feminine skills, such as weaving grass mats, making pots, and housekeeping.

In the third phase of their initiation, women put on costumes that have strong parallels with the architecture of a Basotho house. In front of their faces they wear reed masks, just as the private *lapa* of the house is traditionally screened by the reed fence, the *seotloana.* The name of the mask is *lesira*; the same word means windbreak, and also implies a screen that stands between someone and the light or the fire. When they emerge from these masks the *bale* (initiates) will be born as women. The *lesira* can be seen as both a parallel of the house and a reminder of the deeper symbolism behind the house itself, which like the first Basotho, emerges from the ground, through reeds, and

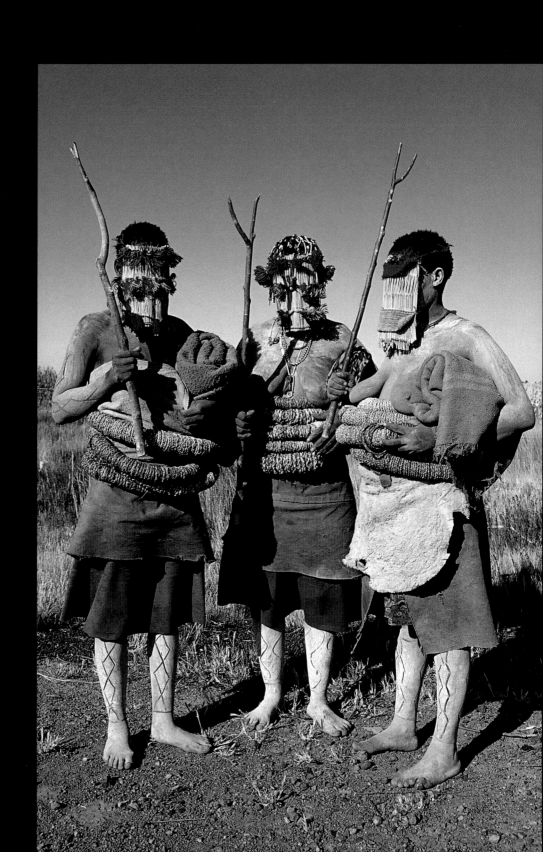

into the light of the sun. The final element required to complete the set of symbolic associations—earth—was included in the past by ornamenting the reed mask with small, round clay beads made by women elders. Today, imported glass and plastic beads or bright wool are generally substituted.

Around their waists the *bale* wear elaborate belts of grass, called *likholokoane,* that are reminiscent of the horizontal rails that support the *seotloana* fence. These *likholokoane* are essentially grass hoops, like the *kgare* rings for balancing loads on the head and attaching to the top of the house. They are made by the repetitive, cyclical motion of winding grass around a core —and it should be recalled that the word for spiralling or coiling has the same root (*hara*) as *kgare.* Certainly, the *likholokoane,* like the *kgare,* is another instance of woman's mastery of plant materials.

On a more abstract level, the *likholokoane,* like the *kgare* rings, may emphasize the significance of all spirals and circles as signs of eternal cycles. Another meaning of the word *likholokoane* is "arranged order," suggesting that ideas of order, and possibly cosmic order, are indeed associated with the *likholokoane.*

Related to the idea of eternity, the *likholokoane* are said to have no beginning and no end. Their closed circles mean that evil can find no place to enter. Interestingly, yet another kind of *kgare* ring, called *kgare ya motse, kgare* of the village, was traditionally buried in Basotho settlements to serve the same apotropaic function for the community.

The reed masks may carry a similar esoteric connotation of protection from evil, for an alternative referent of the word *lesira* is a traditional medicine that prevents the enemy from seeing—an idea of protection that is one of the primary meanings of the root word *sira.*

Yet another aspect of the costume of the *bale,* the forked sticks they often carry, also appears to be related to protection from harm. Forked twigs, called *mofifi,* are hidden in the roofs of houses to render the inhabitants invisible to evil influences, and are also buried around fields to ward off misfortune.

The white clay with which the *bale* are painted is called *phepa.* This whiteness symbolizes their liminal state and the purity that is required to effect their transition. It is also thought to deflect malevolence. Into the clay on the women's legs are inscribed *litema* designs. Similar designs emphasize the door posts of the house, and here they draw attention to women's reproductive importance. Through their bodies and the costumes they wear at this stage, the *bale* are metaphors of the house, which are in turn cosmic metaphors of birth. At this stage the women are about to be born as adults. The next and final stage is their graduation as full-blooded women who are ready and able to marry and establish their own houses.

A great public feast called *lelingoana* celebrates the end of the initiation school. In the Free State, where Basotho of many lineages are initiated together, this feast is marked by the *thojane* ceremony, which is participated in by only unmarried girls from particular Basotho lineages. *Thojane* begins after midnight, ushering in the graduation ceremony that begins at dawn. Guests wait outdoors, huddled in their blankets against the bitter cold until the leaders of the school decide that the time is right to kindle a giant bonfire.

As the flames come to life, the initiates file out of their hut into the light. Avoiding eye contact with their friends and relatives in the crowd, they walk as stiffly and silently as

Opposite:
The costumes of these women initiates echo traditional Basotho architecture in several ways. The women are shielded from view by their reed masks, which are like the reed fence that screens the *lapa* from public view. Their thick grass belts are like the waist rails on the reed fence. The designs scraped into their legs are like the *litema* designs on the house, particularly around the doorway. Their forked sticks are like the forked twigs placed in the roof of the house to deflect evil. This iconography points to the close relationship between women, the plant world, and the house.

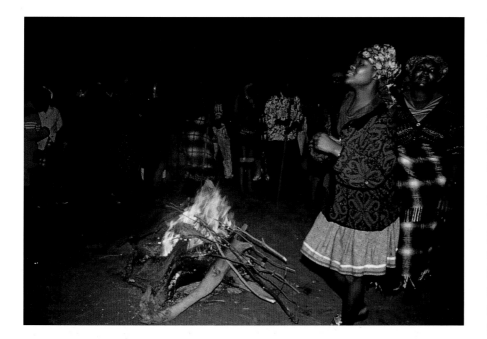

wooden puppets, without bending their limbs, and leaning on wooden staves. Bare-breasted, they wear cowhide skirts or fringed pubic aprons and bright coatings of *letsoku* around their shoulders and faces. I was struck by the fact that the *letsoku* was mixed up as orange, which visually linked the women to the leaping flames and was the color that dominated the night.

To the rhythm of song and dance, the crowd begins to eddy clockwise around the bonfire. The initiates stand like expressionless statues, leaning stiffly on their staffs, as men and women dance joyfully, circling the fire. The initiates are drawn into some dances with their mothers or other female relatives. Putting their staffs aside, they stand behind a relative and place their hands on her shoulders. As the older women sing and dance, the initiates follow behind, maintaining their stiff-limbed posture. To take a step, they swivel their pelvises, throwing forward one leg after the other. All movement focuses on their tilting hips, which are both erotic and emphasize readiness for childbirth. The choreography and the young women's silence, however, show that they are not yet "supple," not yet complete women.

During the *thojane* ceremony, which begins at midnight, initiates and their female relatives circle a bonfire lit in the middle of the *lapa (above)*. At regular intervals during the *thojane* ceremony the initiates stand in a stiff pose, facing the bonfire and supporting themselves on long staves *(right)*. Their rigid limbs indicate that they are not yet supple, not fully adult until they have completed their graduation ceremony the following morning.

Opposite:
On the morning of their graduation, the relatives and friends of the graduates pin gifts onto the grass mats that the young women have made during their initiation school. Before the final graduation procession, the women are ranked by their instructors (far right, wearing beaded headdresses).

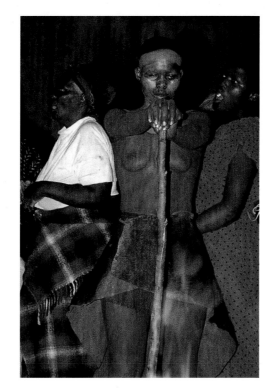

On the morning of their graduation, the women assemble in the *lapa* where the ceremony is being hosted. Their relatives and friends attach gifts onto marriage mats that the initiates have woven from reeds during their school. The mats become carefully structured montages, combining a wide variety of decorative, functional, and symbolic items. The arrangements are usually dominated by gifts of patterned facecloths, kerchiefs, and shawls folded into triangles. Many attached gifts relate to personal beauty and toilet: cakes of Lux soap with

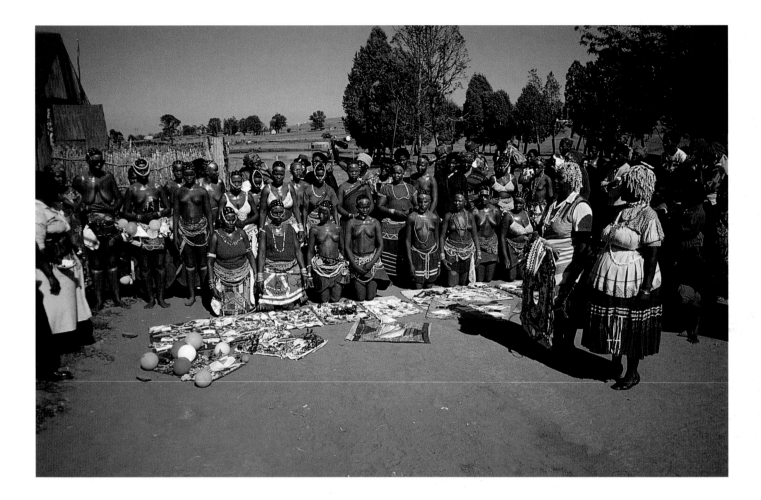

wrappers featuring a white model; combs (often beaded); toothpaste; and mirrors—sometimes of the kind bought at pet stores. Other gifts, such as Christmas tinsel, are used for decorative beauty. Garlands of chocolate bars or lollipops convey sweetness. Lapel buttons that feature popular motifs such as Mickey Mouse or *Vogue* models are also popular.

Brightly colored balloons make a particularly interesting gift. These balloons are symbolically rich, for they recall the use of inflated goat gall bladders that were attached to the heads of diviners and initiates after goats have been sacrificed to honor the ancestors. The gall bladder is particularly significant because its bitterness suggests the digestion of herbs that are used in healing and rituals of worship. Filled with human breath, a gall bladder or balloon also captures and renders visible the intangible air that epitomizes life and makes it possible. They also symbolize the swelling of the womb with spirit and new life.

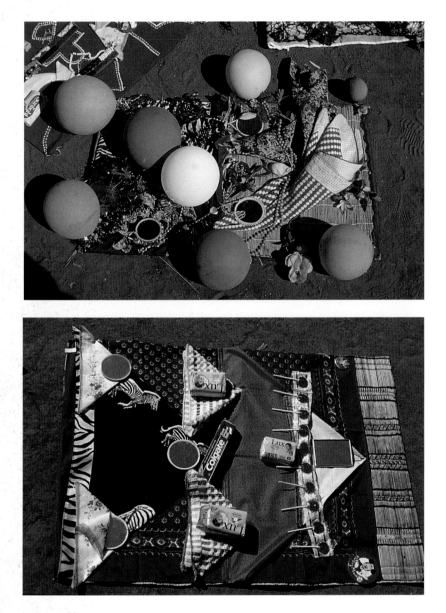

Above, and opposite:
Many of the gifts relate to grooming and feminine beauty. Mirrors, tinsel, and other shiny materials reflect light, which is symbolic of purity and enlightenment. Candies connote sweetness and are a poignant reminder of childhood; balloons are pregnant with deep symbolism.

The hair of the graduates is painted with white dots. Contrasting starkly with the black of the hair, the dots may be symbolic of seeds, or of the hole that is dug for planting a seed. The young women's shoulders and faces are again painted with *letsoku.* Those initiates who are already married or have had children cover their breasts, generally with bright red shirts. Relatives dress the girls for the final graduation parade with many layers of beads, including strands of seeds. Some graduates wear long strings of white beads. Anchored below the nose, these white strands circle the head and form a trail down the neck and spine. White, the color of purity and calm, is thus strung below the nostrils as if to ensure that the breath is calm and measured, the spirit and posture pure. Paper money is also sometimes attached to the hair.

The final procession of women forms a dramatic finale. To the accompaniment of a drum beaten by their female instructor, or *mokhu,* the women gather into a long column, two abreast. They are accompanied by their female relatives, who sing along and cheer. The graduates preserve the silence and composure that were observed during the *thojane.* Their calm reserve shows their discipline and moral rectitude.

In recent years it has been observed that some initiates carry Barbie dolls, held in both hands, clasped just below the breasts. In one procession that I witnessed a bare-breasted Barbie carried by one of the column leaders held the place of honor. I was told that Barbies were used because they are beautiful. Since the reasons and symbols behind the initiation are secret, I did not probe too deeply on why dolls are carried at all. Basotho, however, do have a tradition of fertility dolls. Traditionally these were made of natural materials and decorated

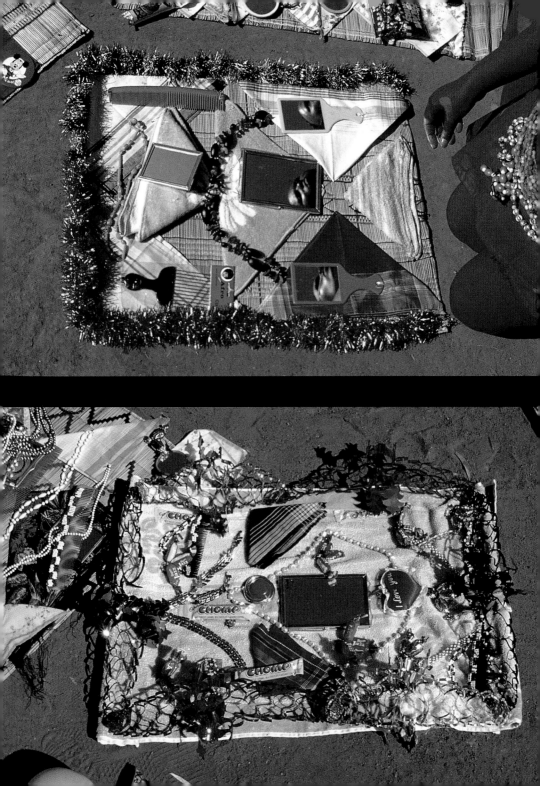

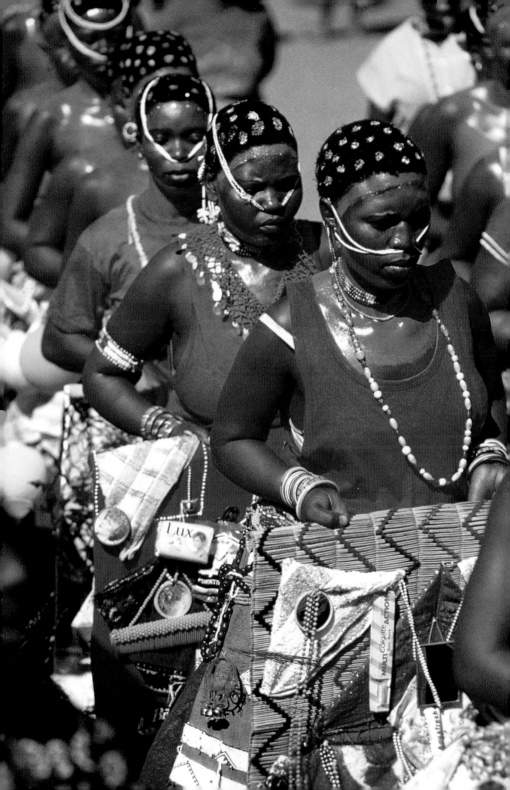

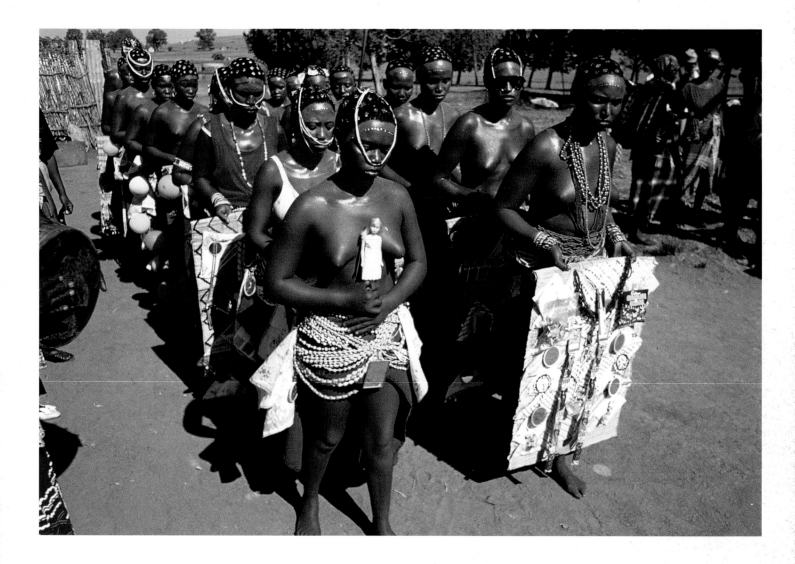

with beads and miniature replicas of Basotho costume.

I found the white Barbie dolls highly incongruous in a ceremony that is a cornerstone in the construction of Basotho female identity, although I realized that black Barbies can be very hard to find, particularly in the Free State. When I expressed my surprise that a white doll was chosen, the *mokhu* of one initiation school

told me that it did not matter that the doll was white; it was a suitable model for the beauty of women. Despite the antipathy many in the West feel about Barbie as a symbol of the ideal woman, in the Basotho context these Barbies, naked except for ornaments around their waists, stood for the moral and physical beauty that Basotho women should reflect on their graduation day and throughout their lives.

Above, and opposite:
During the graduation procession the women maintain somber expressions that connote self-control, dignity, and calm. They march stiff-legged to the beat of the drum, swiveling their pelvises to swing their legs forward for each step.

Upon reflection, I came to believe that the Barbies are not incongruous. Just as the Basotho mural tradition has great dynamism and freely incorporates contemporary motifs and materials in the name of beauty, so, too, the construction of feminine beauty is neither rigid nor constrained by race. Both murals and Barbies are regarded by Basotho women as things of beauty, and beauty is the vehicle that transports tradition into the future. Surrounded thus by beauty, the initiates, beautiful in appearance and virtue, will transmit Basotho values to the next generation.

The procession of graduates snakes in a slow, stiff-legged walk (called *tebuka*) out of the *lapa* and proceeds a short way toward the ravine in the bush where they met the Deep River Snake. After this symbolic reminder of that moment, they turn back to their hut, the *khoali*. As they stoop to enter the low reed doorway, carrying their mats, they have completed a symbolic cycle: they are fully formed women, symbols of houses, and they return to the dark entrance of the lodge where their formation took place.

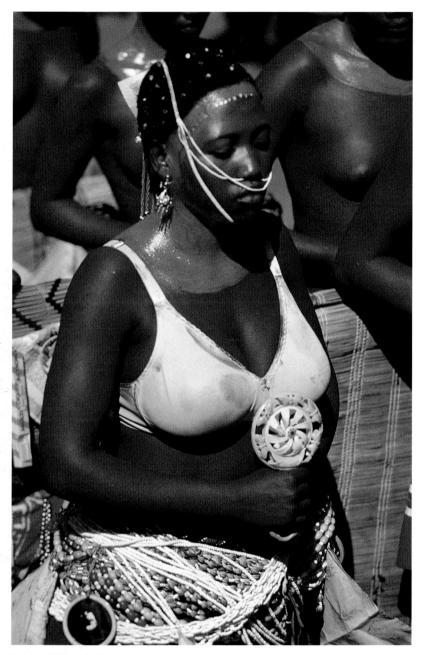

Barbie dolls (far right) have largely replaced beaded Basotho dolls (right) as symbols of ideal womanhood and fertility. Above: this married graduate's covered breasts and rattle indicate that she already has a child.

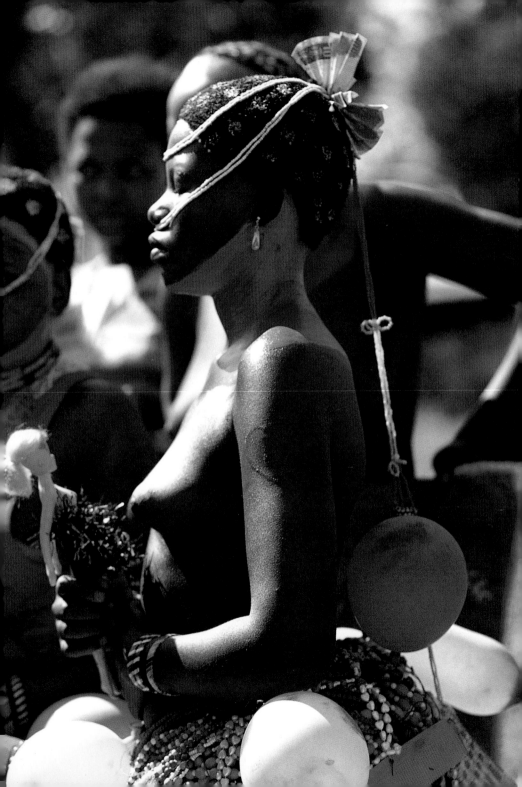

Men's Initiation

A men's graduation was the first major Basotho ceremony to which I was invited. Witnessing this event was my entrée into a deeper understanding of Basotho experience—in a sense, it was my own initiation. Fieldwork had been rather frustrating up to this point. The questions I asked Basotho women about their art and their outlook on life were not leading in the direction I had hoped. They did not think or talk about art in the way that a Western art historian does; their creativity is not driven by a consciousness that can be readily discussed.

One afternoon, after a tiring day of fieldwork, I decided to detour past a farm where I had not been able to photograph the beautiful murals because I had run out of film. At the first house, belonging to the Mokoena family, the women were at home while the men were at work on the farm. Following usual procedure, Lisa and I went through the slow and polite Sesotho method of greeting. The cold wind was whipping up the dust. We were invited inside to talk. This moment was always a sign that the ice had broken—the division between the races in apartheid South Africa was strongly felt at every threshold. The white farm owners seldom set foot in the *lapa* of a worker's family, let alone entered the house, unless they came in rage or in a case of emergency.

We sat in the dining room of one of Mrs. Mokoena's daughters-in-law, who lived on the farm with her husband's family while he worked in the nearby town of Heidelberg, coming home to visit on most weekends. Three of the four Mokoena sons lived and worked in the cities, but their wives and children lived here.

One end wall of the dining room had a crockery rack. It displayed the inexpensive household items the young couple owned, many of them wedding gifts. The individual items were ordinary—bright plastic plates, enamel bowls and dishes in muted pastels or with screenprinted designs, glassware, ornaments—but their aesthetic arrangement created a beautiful composition.

A big, blue, five-pointed star radiated in the center of the *raka,* and placed in its heart was a very large enamel bowl of pale blue with a black rim, like an eclipse of the moon. Between the shelves the wall color alternated in pink and blue. Pendant triangles of the same alternating shades pointed down from the edge of each shelf. The decorative edgings were reminiscent of oilcloth shelf liners that Victorian women cut for their pantries and Welsh dressers. The corners of the composition were sectioned off to form orange triangular niches that linked the eye to the walls alongside. The same orange picked out a thick, rusty iron pipe that had been rescued to function as a beam for the sheets of zinc roofing. The plates and the black mugs suspended from cuphooks like dark notes on staves vibrated and syncopated as if the star centerpiece was twinkling. Set in the star were two car spotlights, reminiscent of a 1950s aesthetic called *mabone* which dictated that cars should carry as many lights as possible to be cool and snazzy.

Mrs. Mokoena called her daughters-in-law to join us at the table. The word for daughter-in-law is *mokoti.* The same word, with a different prefix, means "deep hole, niche, or mine"; a *mokoti wa balimo, mokoti* of the ancestors, is a "natural hole, narrow and deep", like a birth canal in the earth. Because my Sesotho is poor, we used the lingua franca of the farms, Afrikaans—few Basotho farm workers speak any English—mixed with Sesotho and gesture.

I explained my interest in *litema* and the film we were making about life in the Free State, and they agreed to participate. For the women, however, the video camera was the source of bashfulness first, and then banter, because some of the them did not know that it is not necessary to freeze in a pose to capture an image on film.

Soon we were laughing and joking, and deeply engaged in halting Afrikaans conversation about the meaning of *litema* and its relationship to *balimo*. Soon, friends and neighbors dropped by to join in and the room filled up. The women were amazed at our interest and at what we knew, and were fascinated by the diagrams of *litema* collected in Lesotho years before. But they did not have specific names for the specific mural patterns they used and created, nor did they have a set of meanings for particular shapes, such as triangles.

At one moment I realized that once again my professional interest as an art historian in uncovering the religious and cosmological meaning of symbols was leading nowhere, which did not bode well for my project. So I changed the drift of my questions away from what specific things mean to discussing life in general and the situation in South Africa. Here our common ground was firm underfoot. Women discussed poverty, how difficult life was on the farms, how inhumane and baffling they found the behavior of the white farm owners in the Free State, the drought, and their desires for peace and a more equitable sharing of the wealth of the land, of which there was plenty for everyone. They broke into eloquent, impassioned, rhetorical statements that rose and fell with the cadence of prayer, speaking out for peace and social justice from the moral and religious standpoint of Botho, the Basotho view of what it is to be human.

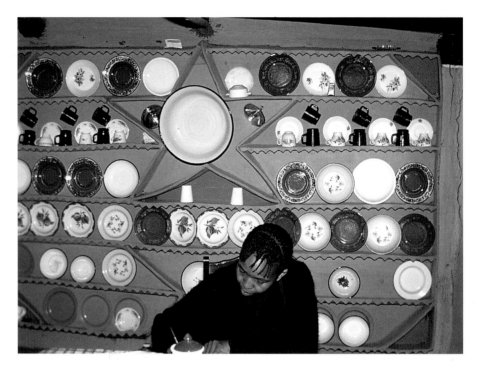

Masepeke Sekhukhune seated in front of one of the Mokoena's crockery racks.

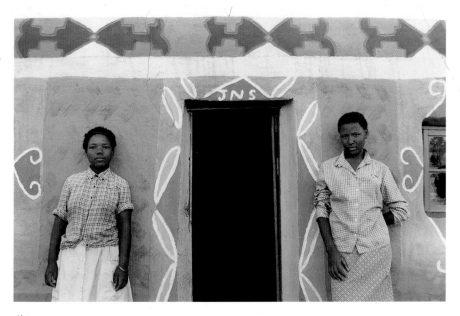

Above:
Elsa Mofokeng and Selinah
Motaung, 1992.

As eloquent as the Mokoena women were, they could not help me understand *litema* according to my "open Sesame" model of anthropological art history, one in which the symbols are suddenly laid bare to reveal the entire art tradition as a miniature, crystallized distillation of the culture: as if all its principles were etched on a computer chip. The women were not able to explain their mural flowers as symbols of life and women's role, but they did say that the floral murals were part of a woman's responsibility as keeper of a Basotho home. The murals were *mooi,* Afrikaans for beautiful, in both a moral and aesthetic sense. They called to the ancestors and pleased them.

With the Mokoena women we had discussed the meaning of life, but our talk had nothing to do with cosmogonic myth or abstruse cosmology. What the women expressed was that present concerns, about their family's needs and the country as a whole, inhabited their conscious-

ness and their home. This reaction was echoed a thousand times by other women throughout the Free State. They were almost always willing to discuss art and to help if they could, taking pride in the fact that we admired and enjoyed their murals, but they returned to the grain of everyday life as fundamental.

The murals are, however, against the rub of everyday life. They are extraordinary celebrations, sharing beauty not only with other visible things but with other things and moments that are *mooi,* both beautiful and good. From the point of view of Basotho, the highest, moral sense of beauty is expressed in community: people are human through other people. In turn, the deepest sense of community is when humans commune together with the ancestors. I was mistaken to try to learn more about art by asking analytical questions; to gain deeper insight into beauty it was necessary to experience community. The Mokoena family, eager to help, embraced us into their family and performed this reversal of orientation. After our afternoon of conversation they invited us to attend the homecoming celebration they would be hosting for the men in the initiation school that their son, Johnny, was attending.

We arranged to return to the Mokoena's after a month's research in Lesotho to confirm the date of the homecoming, which had not yet been set. No farm workers have telephones, and for them to ask the farm owner to use his phone was out of the question. The nearest town with a public phone was always many miles away.

After the homecoming weekend had been decided upon, however, a bloody massacre occurred in Boipathong, a black township south of Johannesburg. F. W. de Klerk's government said that Zulus had attacked ANC supporters and innocent people of other ethnic groups,

hacking women and children to pieces. Progressive South Africans recognized this as just another in a string of covert operations by the state, designed to heighten ethnic tensions and so undermine the ANC's prospects in the forthcoming elections. The ANC and its allies jointly called for a weekend of massive protest, which conflicted with the planned homecoming. The leader of the initiation school decided to return the men a week early, much to the disappointment of their families, many of whom arrived, like us, a week later, on the appointed day. Someone bitterly remarked, "The land is dying of drought through the slaughter by De Klerk and his men in the townships."

We had made elaborate preparations for the graduation weekend, hiring additional video equipment, engaging Masepeke Sekhukhune, who assisted with sound and lights while Lisa filmed, and buying food to add to the feast. To soften our disappointment, the Mokoenas fed us a special meal of mutton and cake, and Johnny recited the praise poems he had composed during the school. We did not have long to wait to witness a full ceremony though, because the Mokoena's brother-in-law, Dhalmini of Middelpan farm, was the leader of another initiation school that was returning in a fortnight, and Mr. Mokoena arranged for us to attend their graduation.

At Middelpan, the farmer, in very short khaki shorts, gave us a glowering but unsurprised glance as we turned onto the track to his workers' village. Everyone knew we were coming. Mr. Mokoena had paved the way. A sheep and an ox had been slaughtered outside the Dhlamini's courtyard. Some men and old people were cooking and eating the parts of these animals set aside for them and drinking some cooked blood. The dogs and chickens were

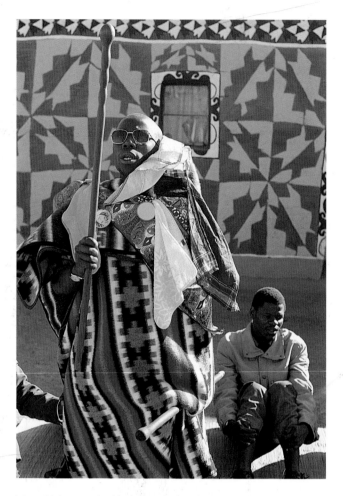

Johnny Mokoena recites his *thoko,* or praise poem.

shooed away from the blood on the ground, which, traditionally, is reserved for the ancestors to feed on.

Mrs. Dhlamini gave us tea and cakes while preparations for the homecoming feast, called *lelingoana la noto,* went on about us. Her husband was leading the school and her son was one of the initiates. They had been in the bush for several weeks and she looked forward to their return. "Hauw, mothers worry! It's like white boys going to the army. You can't be sure they'll come home alive. Anyway, you know they're suffering." She called a child to bring one of the presents she has bought: a blanket of deep reds that she had edged with blue beads and little jangling bells. It was of the finest quality, very expensive, pure wool.

While we talked, Mr. Mokoena kept popping outside to look for a column of smoke off in the

The initiates, wrapped in blankets, are led back from their "bush school" by two slightly older peers who have already undergone circumcision. The school instructors flank the initiates.

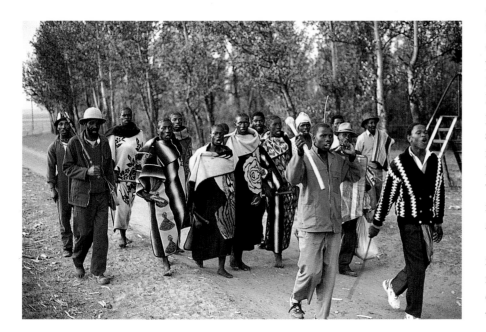

north where the circumcision lodge was hidden and soon would be torched. At that moment boyhood—all its foibles, its fantasies, daydreams, its solitary moments taking care of animals up on the slopes wrapped only in a woolen blanket—would be over. The boys would rush away from the burning place, forbidden to look back. In their flight, which Setiloane describes as like the biblical flight from Sodom, they leave behind all their old clothing. In the past, they would return home naked, today, they would be shrouded in old blankets.

Soon the smoke was seen and a band of men came over the horizon, singing, raised sticks in hand. Over at the farm sheds, the farmer and his son watched through binoculars, curious but not coming close. They pulled back when I turned my camera lens on them. Driving cattle before them, the new men walked down a corridor between the barbed wire fences of two fields. Their singing sounded mournful, but, as they approached, a touch more exuberance animated the initiates' companions, including Mr. Dhlamini; the elderly doctor, or *dingaka,* of the school; a man of about thirty years of age who I suspected was Thipane, Little Knife, the circumciser; and two young men who had been recently initiated. These young companions leapt into the air and stabbed their sticks into the sky. The seven initiates, cocooned in their blankets and flanked by their escorts, looked like an edgy flock herded by sheepdogs. Their hands peeked out from their robes, clutching their knobkerries out in front of them, horizontal with the earth.

Lisa, Masepeke, and I ran backwards in front of the procession, intent on capturing the moment without getting tangled in our power cords or caught in the cross fire of our angles of vision. We were struck by the dreadful expres-

sion in the initiates' eyes, staring, startled, the haunted look of traumatized soldiers.

The women in the *lapa* began to ululate as the procession approached and entered the *lapa*. The new men looked straight ahead without greeting their families, and immediately filed into a zinc lean-to, called the *mokhukhu,* attached to the house. They sat in an order of seniority that had been established during their period in the school. The leading graduate was covered in red ocher, a sign of his honor. Until dawn they remained in the *mokhukhu* while the guests feasted. *Mokhukhu* also means the feast is on. Previous graduates performed war songs and praise chants.

Not for us, however. To recharge our batteries for the next day, we had to get to a power source in a nearby holiday resort hotel on the banks of a dam. It was only very recently that blacks had been allowed to stay in hotels, motels, and holiday cottages, something that outraged conservative Afrikaners. Lisa, Masepeke, and I were viewed by most local whites with distaste for sitting together in the front seat of our pickup. In the Free State blacks sat in the open back, no matter how cold it was. It was no rare sight to see a farmer driving with his dog beside him in the cab as his black workers froze in the rear. Our presence here was a harbinger of the democratic, nonracial state that conservative Afrikaners resisted violently, but which was just around the corner.

I went up to the reception desk of the hotel, speaking English. By law a member of the public should be answered in whichever of the two official languages—Afrikaans or English—they chose to use. The hotel's Afrikaans owners viewed and answered me in English coldly, but the place was patently empty and they did not pretend otherwise. The resort looked like it needed our money. The dam was dry and this was no place for a holiday or a picnic. When I gave my Afrikaans surname I became doubly abhorrent to them; I sensed that they saw me as a traitor to their cause and wondered if I could speak *Die Taal*, the Language, Afrikaans. I decided that next time I did this I would pronounce my name the way Americans do, as "van-wick," instead of the Afrikaans "fun-vake" to witness their reaction when I spelled my name out in Afrikaans. But that would probably just confirm for them that I was thoroughly anglicized— what some call a "detribalized Afrikaner."

Traveling throughout the rural Free State we favored resorts with equipped cottages, where we could cook and have privacy. But we often had to stay in little country hotels, where the bar is the gathering place for the white farming community. I usually went into these bars to gauge the local atmosphere from the tone of conversation. I was often accompanied by Lisa or other traveling companions, but I never took Masepeke into these bars.

The worst bars were genuinely frightening, full of white supremacist slogans and paraphernalia, mixed with sexist and scatological odds and ends, inhabited by gun-toting, guffawing, beer-swilling boors, the air filled with a heavy mix of liquor, libido, and an arrogated license to kill. Looking around I could imagine these men plotting the sabotage attacks and killings that were plaguing the Free State, and I could feel their open hostility. These were places to keep silent, even when overhearing snatches of conversation that contained veiled remarks about you and provocative taunts.

Villiers is the town closest to the Mokoena's, a typical Free State *dorp*, or town. On the south bank of the Vaal River, it stands beside the first tollgate on the superhighway that links Johan-

The wagonwheel motif (top) on the cast-concrete wall of this white-owned house in Villiers recalls the Boers' Great Trek. Decorative brick work on some houses (bottom) may have influenced some Basotho mural designs.

iron filigree topping the roofs. This period taste in architecture and in linoleum patterns, wallpapers, and fabrics, seems to have influenced the *litema* tradition. Some *litema* murals imitate the face-brick of which many of the settlers' homes are built.

When we arrived at the Villiers Hotel the bar was literally filled with fish—plasticized taxidermist trophies from the Indian Ocean. Above the picture window in the lounge, where drinks could be sipped in comfort, was a leaping marlin so enormous that the tip of its spike disappeared behind the pink velvet drapes. Varnished, it glistened wetly to hint that it had just risen from the depths in an improbable flash of electric blues, jarring with the riot of red and pink roses on the chairs. Sunset seascapes in gilt frames echoed the lurid scheme of pink and blue. The blend of simpering femininity and overblown machismo made the setting feel unstable, a snow-dome souvenir of Neptune's boudoir that could invert without notice and flake from the floor.

In the Villiers bar I was plied with free drinks and treated like an exotic bird that had flown in. Where did you come from? What brings you here? What is your story? What do you think about what you find here? I found people eager to debate the changes that were happening in South Africa, to hear about life in black-ruled Zimbabwe and in New York. Although at first fresh acquaintances were careful to find common ground and disclaim racism, a few stiff drinks usually flushed out deeply racist perceptions of the order: "their brains are smaller," and "they stink." I found myself proselytizing for the New South Africa, often in Afrikaans. Conversations would sweep through cool logical argumentation and into rhetoric. One of my most effective debating gambits was to say,

nesburg to the coast. Courtesy of the South African Police, cars are given crayons and coloring books to keep the children quiet on the four-hour journey to the sea. Dominated by the towering silos that bank the local farmers' wealth, Villiers is a poor white town—the black "location" or township is about a mile away. In Villiers, the yards of many houses have low, precast, fibro-concrete walls. The walls are sometimes prettied up with decorative panels, on which the favorite motif is a wagon wheel that evokes the Voortrekkers' Great Trek. Concrete dwarfs and miniature windmills dot the gardens. Verandas have well-tended potted plants and copper plaques with Christian messages. Some turn-of-the-century homes have wrought-iron fences with curling motifs and lacy, cast-

"How would you feel if you were one of the Basotho workers on your farm, knowing that your people once owned this land?" At a certain point the Socratic method failed though, particularly when people were drunk enough to fall off their bar stools, and the time came to cool tempers that had begun to fray by turning to harmless jokes.

Sometimes these interactions were rewarded with an invitation to visit a farm with especially impressive *litema*. Away from the bar and their neighbors, farmers were often far less hard-line than their public faces suggested. They were ready for fundamental change in South Africa, but they feared that the ANC was Communist and might confiscate their farms and abolish the church. They would give me names of like-minded farmers who were not part of the right-wing Afrikaner Weerstand Beweeging (Afrikaans Resistance Movement) and who would welcome us visiting their farms. One farmer I met this way gave his workers' wives free paint every year to paint *litema*; his wife gave a prize to the house she judged best. Others were supportive in less patronizing ways, such as lending the farm truck for expeditions to collect ocher from distant sites.

Our need to charge our batteries when we were filming forced us to connect with a white world that felt far more alien to us than the Basotho one. Often we felt like masqueraders, changing costumes and masks to go onto the white stage. Another benefit of staying in holiday cottages was not having to go through such extensive performances, and having time to let the events of the day settle.

On the night of the men's graduation ceremony, our minds were filled with the emotional impact of the men's return from the bush that we had seen at dusk. Masepeke said that the initiates were less scary than she remembered from her childhood in a North Sotho community. Like the other girls she thought the *mokoloane* could abduct and rape you. If you accidentally broke the taboo against seeing them near their lodge, they could kill you. Today, they looked much smaller than they used to, she said, and they seemed frightened and vulnerable.

Their eyes got to us all. I've seen white boys back from fighting on the Border with the same crazed, icy glaze they call *bosgevok,* bush-fucked—post-traumatic stress disorder. When we closed our eyes, we all saw their eyes, one boy's in particular. It was hard to sleep. We needed no alarm to wake long before dawn to go and fetch Mr. Mokoena.

At first light the initiates, ranked in order, stood in the chill facing east, dressed only in shorts. As the sun arced over the horizon they took a mouthful of beer, which had been doctored with medicine, and spat toward the rising sun. Their life as men had begun. The men's relatives now approached them, laden with new blankets and gifts. Some had *letsoku* and Vaseline, which they mixed in their palms to form a red ointment. There was something lingering, caressing in the way they anointed the graduates and then swathed them in new blankets, pinning and repinning them until they hung just right. Like the sleeping mats of women graduates, the blankets became the canvases on which gifts were carefully hung, with much rearranging. The young men stood patiently, like sheep being sheared, their faces showing only the faintest flickers of expression. The finishing touch to the costumes was a pair of sunglasses, which proved useful as the boys fell into rank and faced the glare of the rising sun. One unfortunate boy, the last in the line, had

At dawn on their graduation day the initiates are made to face the rising sun and spit a mouthful of beer toward it. This signals the end of their adolescence.

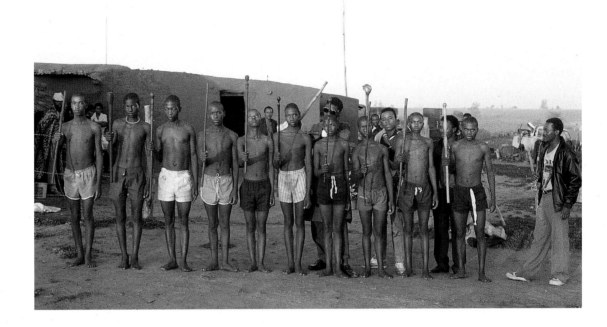

Opposite:
Relatives dress the graduates in new blankets to which they pin gifts. This initiate, Amos Mokoena, wears a beaded chest-piece of combs and mirrors. He was first among the initiates.

Pages 138–9:
Men recite their praise poems: from left to right, Anthony Shibas Moloi, David Lefu Tumane, Daniel Tehane Mokoena, Elias Khulu Kumane.

no relations pampering him and nothing but a new blanket. A woman gave him her sunglasses and brought him a spare pair of earrings from inside, pinning them both on one ear.

Mr. Dhlamini was very drunk. He ranked his charges in order of their status, and sat on a chair at the left of the row. Thipane, the circumcisor, wearing blue overalls with a gash high up on the thigh, began the ceremony with poetic praises. Women ululated; one put a coin in Thipane's top pocket, another pinned a handkerchief to his chest. Thipane smiled shyly, arched his eyebrows at Mr. Dhlamini, seemed diverted, and forgot his lines. "Whoops," he said, and looked over his shoulder for a prompt.

Beginning with the highly honored boy in rich red ocher and multiple new blankets, the graduates one by one stood up, raised their sticks, and chanted their praise poems, known

as *lithoko* (dee-TOH-koh). During the school, each had composed his own *thoko,* which defined his new identity in poetic and rhetorical phrasing.

Over several weeks or months in the school the young men have been instructed in the secret knowledge of Basotho identity, which is conveyed in special songs, called *likoma. Likoma* concentrate both on the history of Basotho, with special emphasis on the history and heroes of each *seboko* (clan or totem), and on moral outlooks and behaviors. The initiates also learn many other songs of a less sacred and secret nature, versions that may be sung in public. All of these songs are literally drummed into them; those who forget the lines or make mistakes are beaten. The circumcision operation presses home the point that the ways of pleasure are subordinate to the painful responsibilities of manhood.

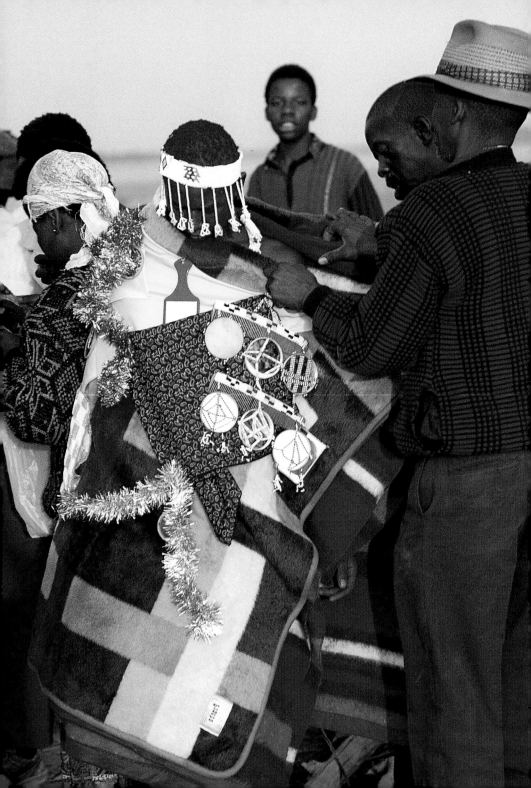

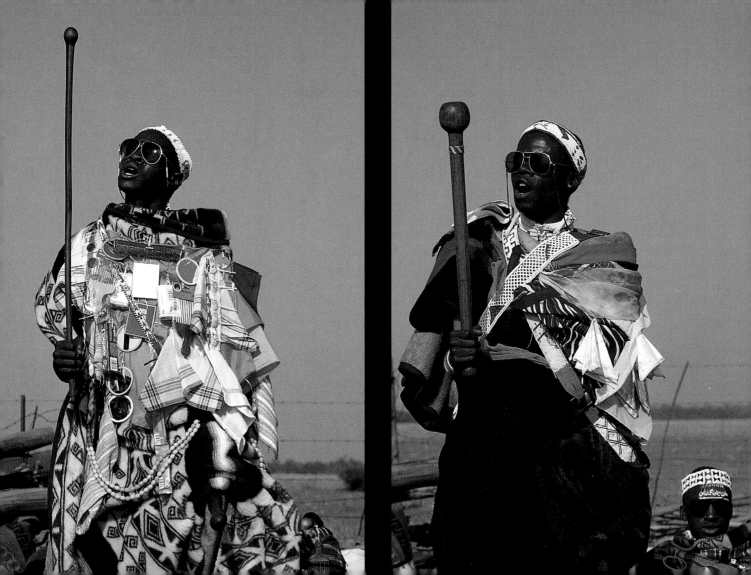

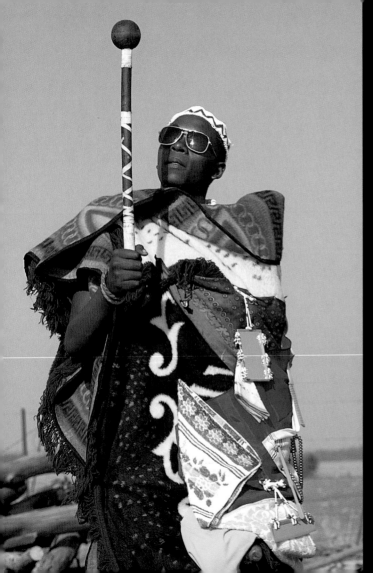
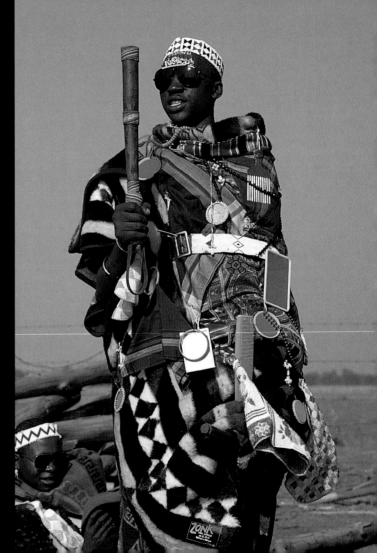

The *lithoko* are individualistic chants that demonstrate each graduate's unique synthesis of Basotho tradition with his own intelligence, outlook, aspirations, and expressive style. The more poetic, evocative, and insightful the *thoko,* the more admired the man. The initiation process is likened to the tanning of a hide; the schoolmaster is called *Mosuwe*—from *suwa,* to tan skin. Frequent beating creates a skin that is tough yet supple, and the fluency of a *thoko* is the public demonstration of a supple tongue. The audience expresses its approval by cheering, ululating, and placing gifts on top of the initiate's bare feet as he chants, or attaching pins and kerchiefs to his costume.

The last boy in line was the forgotten one. Some observers were concerned that no one came to his graduation. But this was a South African Saturday. Who knows how far away his relatives worked, how hard they might have begged their employers for the day off. His voice was cracking and his face and neck were wet with tears as he hailed his mother and father, *'mme* and *natate,* the cries stretched out into sobs, "*Mmmme, Ntate.*" The young official from the school came with a handkerchief to tenderly dry his cheeks and his chin, and the borrowed sunglasses hid his tears as he looked up to the sky. Everyone found this moving; the women ululated in support; coins were placed on his feet. A quick collection was taken and a ten rand note was pinned to his bare blanket. Someone added a crumpled handkerchief. He finished and sat weeping. Dhlamini made him stand and sing some more to wash away the sorrow.

Then it was Dhlamini's turn to address his charges and the crowd. He passed up and down the row, shouting and waving his stick, exhort-ing. When he was done he was presented with the beautiful red blanket intended for his son, who had already been quite spoiled with an abundance of presents. Dhalmini's sister, an enormous woman, pinned the blanket to the bony old shoulder; his gray skull lost between her breasts. Perhaps it was the bride-price that her own marriage brought that had provided the cows he needed to pay for his own marriage. Brothers and sisters are linked through cattle; the blanket is a modern replacement of the hide.

Finally, the graduates were dismissed and they filed into the *mokhukhu,* but the last boy was still crying so Dhlamini shooed them all out so he could sing again. Then it was over and the feast could begin. For the first time in weeks the young men were able to enjoy really good food, but they remained in their shelter. The food was a delicious mix of tastes and colors: rich roast meat; sweet, bright orange pumpkin; puce, earthy beet; stiff mountains of fluffy white corn porridge; dark green bitter rape. The feast was washed down with tart and tangy traditional beer or the bite of ginger beer, followed by cakes.

We sat with Mr. Mokoena and other honored guests inside at the table. One relative complained all through lunch about how he hated "*die plaas,*" life on the farm, and couldn't wait to go home to the city. He clearly did not set much store by all this tradition, which did not endear him to the others. Another guest told me that his initiation had made him empathize with Jesus Christ because his experience was a kind of crucifixion.

On the way home I meditated on the dominant visual symbols of the event: sticks and blankets. A man's stick is a symbol of his man-

hood. In the past sticks were never brought into the house, and if they were in the way a woman would have a child move them. The shapes of the knobkerries, with their bulbous heads, are certainly phallic; each stick is shaped and decorated— one might say fetishized—in individual ways. Held horizontal on the return from the initiation school, the sticks were raised high during the recitation of *lithoko,* symbols of manhood and virility. The graduate's heads and sticks provide the focus during his performance.

Before traders introduced blankets, a male graduate wore a cloak hide, advertising his family's ability to provide him with cattle for a bride-price. Bride-price negotiations today often include mention of the fact that the prospective groom has many fine blankets. In the past, the graduate's hide demonstrated his readiness to marry, establish his house, and have legitimate children "born through the cow"—an idea also evoked by the architectural symbolism of the *mathule* tunnel as both the body of a cow and a vagina.

An ethnographer of the Basotho observed that the word for blanket, *koba,* also means vagina, because it is said to clothe a person just as the vagina encloses the penis, and is a symbol of the elongated labia. The verb *ho sarolla* is applied to stretching both the labia and a wet animal skin. From this point of view the sticks and greased bodies of the graduates are phalluses wrapped in elaborately decorated blankets.

In the past, hide cloaks worn by a Basotho group and the group's cattle both carried the same brand marks, emphasizing that the members were linked through cattle. People belonging to the same group—such as a chiefdom—are said to be covered by the same blanket.

This was the concept behind King Moshoeshoe's famous request to Queen Victoria to allow Basotho to become the "lice in her blanket." Clearly, blankets have layered meanings; if they unequivocally imply the vagina, Moshoeshoe's request would have been a touch too intimate, even if, between sovereigns, the idea of subjects as irksome bloodsuckers might be amusing.

The development of a market economy during the Diamond Rush of the 1870s made blanket trading viable, and demand for blankets among the Basotho increased because of livestock epidemics and the scarcity of wild animals in their now-reduced territory. Bayer blankets, made in Germany, consisting of columns of color, were early entries into the market. The Frasers Trading Company of Basutoland sent designs of Basotho murals and a sample leopard *kaross* to an English blanket mill in 1885. The ready adoption by Basotho of British soldiers' regimental blankets with heraldic motifs provided another avenue for design. A Queen Victoria blanket, celebrating her diamond jubilee, was produced for the Basotho market by 1887. For a century, Frasers played a leading role in the design and supply of what became known as Basotho blankets, sold in trading stores wherever Basotho lived. In recent decades, trade sanctions against South Africa and an unfavorable exchange rate led to a decline in the quality of the blankets and the complexity of pattern that could be produced. Inexpensive acrylic blankets with simple weaves have largely replaced the wool blankets.

Basotho blankets functioned as a cultural unifier—the Basotho nation as a whole was figuratively "covered in the same blanket." Different weights, colors, and patterns were worn on different occasions and by people of different

status. It was customary, for example, for young men entering initiation school to wear the sober Moholobela blanket, whose name means to make a lot of noise and refers to the fact that initiates make a great hullabaloo to drown out any cries of pain as each is circumcised. The motif on this blanket, picked out in the sacred colors of black, red, and white, is unique—a stylized bud that may allude to the circumcised penis.

Murallike motifs, stripes, feline dapples, and British heraldry are the dominant motifs of Basotho blankets *(opposite)*. Numerous designs relate to plants. The *sefate* (meaning tree) designs combine signs of fertility and abundance with floral patterns. Some *sefate* designs are exclusively for women, such as *Sefate Ea Famahadi* (Tree of a Senior Woman), which shows bulbs in bloom. Several *sefate* patterns are based on playing card motifs, because commercially ground corn has long been sold in packages with these motifs. Similarly, several blankets feature corn or are named after it. The *kotulo* (harvest) blanket carries similar associations of agricultural abundance.

A great number of blankets are more political and manly in both their iconography and their names. The *Pitso* blanket is named after the great gathering of all men at a time of national crisis or decision making. *Boipuso* (literally meaning independence, reign, sovereign, administration) juxtaposes the British crown and the Basotho hat to evoke the close relationship between Britain and Basutoland. Other British motifs include Victoria's orb, the Prince of Wales feathers, and the Cullinan diamond from South Africa, which formed the basis of the imperial scepter. Basotho soldiers served in Europe during both World Wars and military motifs feature strongly in many designs, such as Leeto Aeroplane (Journey Airplane) and Victoria England Spitfire. Victory is celebrated with the return of softer imagery, such as flowers, spades, and hearts. To mark Basotholand attaining its independence as a sovereign state within the British Commonwealth in 1966, Sesotho symbols come to the fore: the crocodile totem animal, the Basotho hat, the swallow-tailed Basotho shield, and Basotho weapons.

Although blankets are associated with women's sexuality, they are not used in women's graduation ceremonies. In male graduation, however, they provide a symbolic foil through which the man's body penetrates, an idea that is echoed in an interesting past practice: if a man discovered that his bride was not a virgin, he would pierce his blanket with a spear. The image of body and blanket is a reminder that man is born through the "blanket" of women and of cattle, and this idea holds out the promise of marriage and building a family.

Opposite: Blanket designs, left to right, top to bottom:

Leeto Aeroplane; Victoria England; Victoria England Crown.
Boipuso; Moholobela; Sefate Moreana.
Kotulo; Sefate Poone; Sefate Senyesemane.
Sefate Cards; Sefate Morena; Sefate Cards.

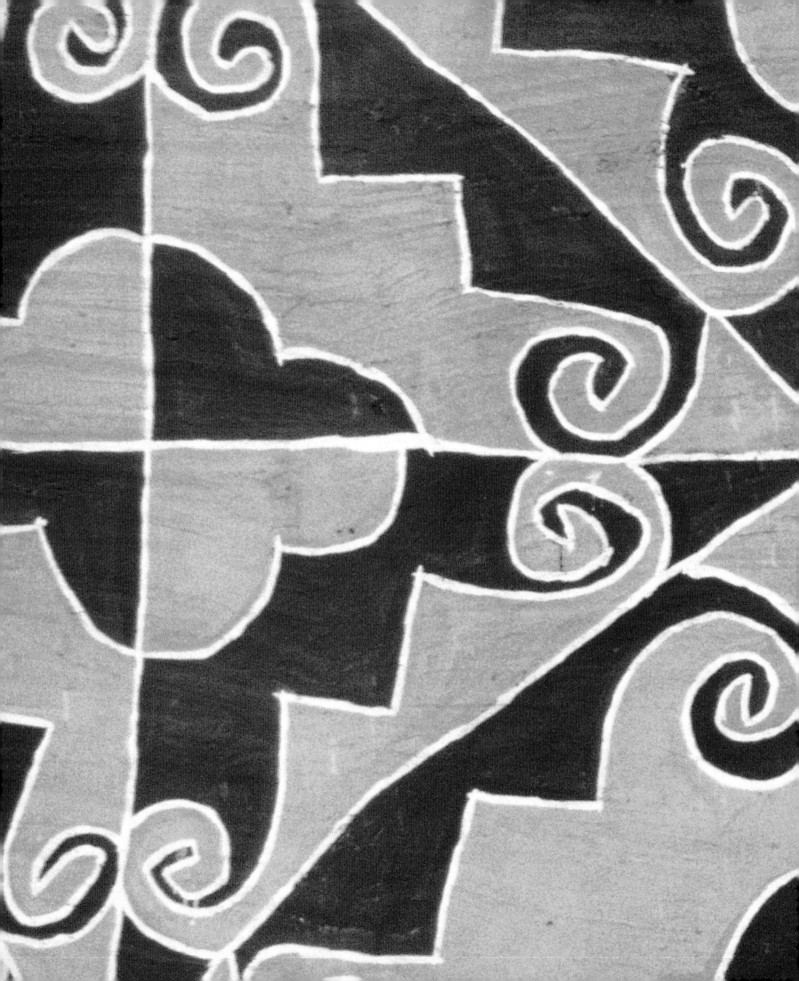

5.

The Sacred Earth:
Peace, Rain, Plenty

For Basotho, the tie between earth and blood is vital. The blood of sacrifice brings the rain, the blood of anger brings drought. The earth is at the mercy of the ancestors who own and rule it; they are the guardians of the earth's lifeblood, rain.

In the years that I worked among Basotho, earth dominated my experience—the houses of earth, the art made from earth, the earth smeared on bodies, the political struggle being waged all around me for control of the land, the driven dust in my eyes and in my mouth. It was as if the earth got into my blood. I could feel its sleep in the cold, its pulse in the summer.

I grew up in cities and beside the sea; I had always loved the summer sun. Now, as it scorched the earth, the white farm owners gazed up at it with spaniel eyes; Basotho, careful not to reproach the sky, looked down instead at the crippled plants. Everyone prayed for rain, and most for peace. In the dry winter, the skies over the Highveld are a fathomless blue from which the hot sun seems to mock. The whole Orange Free State, as it then was called, was neither free nor orange, but beige with dead corn, bleached and brittle, and the fallow earth was tan, red, and chocolate in patches. Through this palette, crazed and bone-dry, animals trudged forlornly, nudging at dead stalks in search of nourishment and trailing dust clouds that whipped up suddenly into dust devils,

which sucked up the long leaves of the corn and twirled them overhead like paper ribbons in a dance. Against this backdrop, Basotho women were painting their houses, offering prayers for rain, and affirming their faith in a new flowering that would, perhaps, come in the spring.

The ache of this waiting for the rain, the ray of hope expressed in paint, and the nexus that the ache and the art have with blood, all these are very ancient in this land. Long before Basotho arrived, the San, or Bushmen, owned the land and held their ceremonies in the caves and beside the cliffs here, leaving behind the traces of their trances and visions in exquisite paintings on the walls. Hunters rather than farmers, they read the meaning of the life force through the death of animals, drawing a connection between the blood that flowed from the orifices of a dying beast and the nosebleeds experienced by trancing humans when they were connected to the life force. The desire for rain figured strongly in their rituals. From living populations of San today, we also know that the harmony of the group is one of the primary functions of their dances, which are said to unite and heal all the members of the group.

The closest I ever came to experiencing this kind of group trance was at the graduation of a diviner, a niece of Mr. Mokoena, who was hosting her coming out ceremony. Guests and diviners came from all over the Free State and the

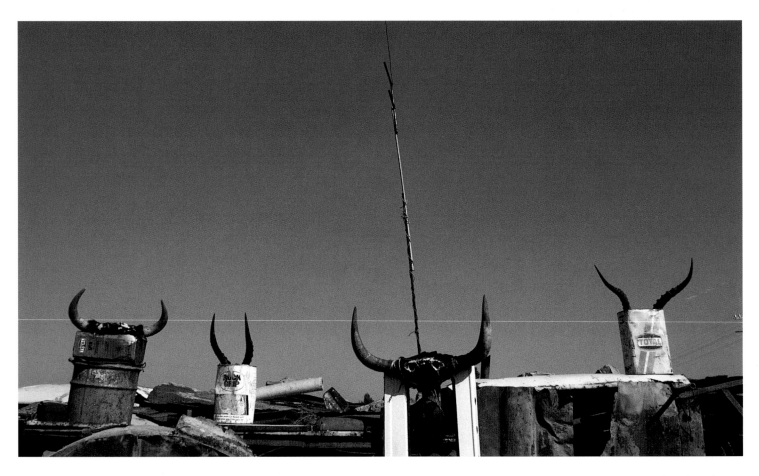

Animal sacrifices please the ancestors but the spilling of human blood pollutes the earth and can cause the ancestors to withhold the rain. The animal horns on this rooftop point up into a sky that holds no chance of rain.

Basotho homeland of QwaQwa—a tiny reserve set aside under the apartheid homeland policy. The rites began toward dusk. The graduate knelt on the earth and addressed the ancestors, praising them and appealing for peace, rain, and abundance. The others interjected periodically, *siyavuma,* a Zulu word meaning "we agree." As the sun began to set, the graduate became possessed, and raced out of the *lapa* into the fields, inspired by the vision of a particular animal in the herd that had been reserved for her. As dark began to fall, she returned, driving an ox. Men drove it into the kraal and lassoed it. She held the halter and prayed in the kraal, where

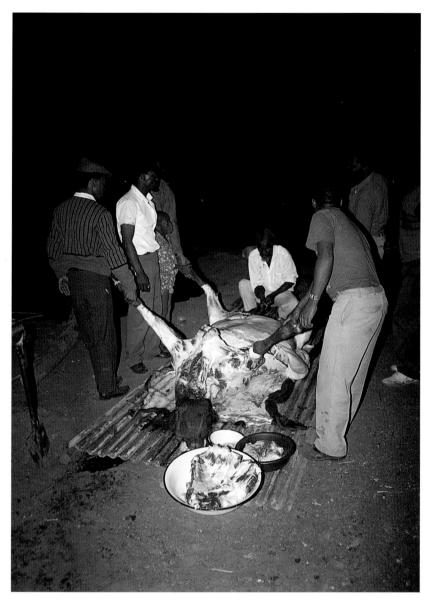

The sacrificial cow provided the feast for the multitude of assembled guests. The tail of the cow sacrificed for a diviner's initiation is usually made into a flywhisk, or switch, that forms an important part of a Basotho diviner's regalia.

women are usually forbidden, except to collect dung. Then the lowing beast was pulled into the *lapa.* Four men threw it down and dug a hole in the ground beneath its throat.

Then, the jugular vein was cut with a knife, and the blood spurted several yards, getting on my lens and Lisa's video camera. As the ox's eyes began to glaze over and the hole in the ground was filling—the place where the ancestors were gathering to drink—the graduate stooped down to the windpipe to catch the least breath, directly drawing the inspiration from the ancestors that she would need for her career. She came away with blood on her mouth, quivering in a deep trance. Senior diviners caught blood in a bowl and anointed her forehead with it, amidst great rejoicing. Meanwhile, the men carved up the carcass. The tail was cut off to make into a flywhisk that would be an important part of the new diviner's regalia. The feast was prepared immediately and soon we were all sharing the dedicated meat.

The main part of the ceremony began at midnight and lasted until dawn. The diviners changed into their professional outfits, their skirts the color of fresh blood and embroidered with beads. Their black headdresses were ornamented with beads of white and/or red, and their staffs and whisks were also decorated with beads. Diviners say that the designs and colors used in their costumes are dictated to them by the ancestors in dreams.

The diviners issued prayers and then began to dance in a counterclockwise circle. At first, the energy of the group seemed dispersed, the rhythm of their singing and steps out of synch. Every now and then they would stop for more prayer, or to scatter offerings of grain on the earth. The spectators were harangued for dissipating the spiritual energy and not showing

proper respect. But as the night wore on the energy became very intense and electric, the rhythms hypnotic. Several diviners became possessed. Their eyes would stare, roll, or start, and they would stumble, as if uncontrollably drunk, or as if they had been punched in the head. Lisa and Masepeke, filming in the middle of this circle, felt swept away and almost overwhelmed by the force around them.

I worked the circle from the outside, deliberately restraining myself from being too drawn into the action. Unlike other researchers in Africa, such as the famous French anthropologist Michel Leiris, who observed that he would rather be possessed than study possessed people, I was often frightened by the palpable power I felt around me. I pulled back, resisting the lure of the vortex. On this occasion, I concentrated on my photography, constantly checking my settings. I had a superstitious dread that my film would not capture this experience, because often pictures I have taken of diviners came out blank, hazed, or distorted with weird rays of light and color. Of the many rolls of film I shot that night of the diviners, only one picture was fit to print.

This picture, perhaps not coincidentally, records a moment when none of the diviners is facing the camera. Barely recognizable as human beings, they all focus their energy through their staffs and whisks toward the ancestors in the earth. Whatever this energy is, it feels like electricity. It is a flux that threads through all Basotho religious ceremonies as obviously as the fact that the electric power lines on the Free State farms always overfly the workers' houses without ever connecting. It is this power that Basotho friends invited me to experience when they sensed that I wanted to understand the deepest significance in life and art.

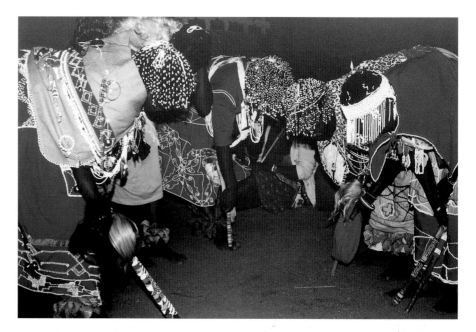

The circle of diviners direct their prayers to the ancestors in the earth.

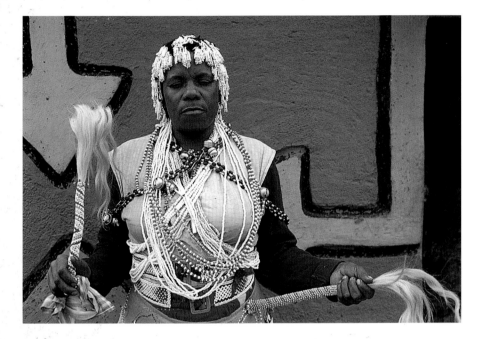

Diviner Maria Mokhethi holds two beaded flywhisks (top) and wears a beautiful skirt (right) that she has beaded with designs that the spirits transmitted in her dreams.

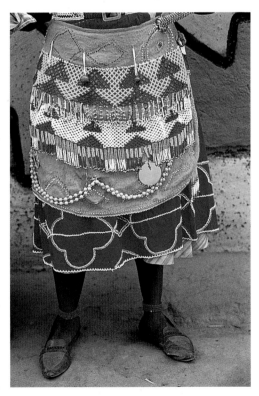

Opposite:
Johnny Mokoena serves as assistant to a diviner who lives in a neighboring house on Forest Creek Farm.

Today in the Free State diviners are almost always women. This indicates a profound shift in more recent decades in the control of religious power away from men and toward women. One factor that may have facilitated this change is the loosening of the bonds that once bound together Basotho communities, which, in the Free State, now consist of workers' villages containing only a few families. In the past, the chief played a crucial role in rainmaking and other ceremonies connected to the agricultural cycle. Initiation schools for men were convened around chiefs' sons, whose fellow initiates were thenceforth closely connected to the chief's son. The powerful doctors and diviners of the community were also closely linked with the chief. Spiritual and political power were closely aligned.

The impact of colonialism wreaked havoc with the political structure of African societies, almost always controlled by men. It seems that one early result of this was the rise of powerful women prophets, who claimed to receive inspiring messages from the ancestors, which predicted that victory over the whites was at hand. This optimistic message had disastrous results among the Xhosa in 1857, when a young woman convinced the nation to slaughter all their cattle and burn their crops, because the ancestors had promised, once this was done, to return, drive the whites away, and replenish the herds and the crops. It is estimated that 20,000 Xhosa starved to death and more than 50,000 had to flee, many becoming workers in the Cape Colony which they had hoped would be defeated. The power of the Xhosa was crushed.

One outstanding prophetess among the Basotho, Mantsopa, had already risen to prominence in the 1840s and had the ear of

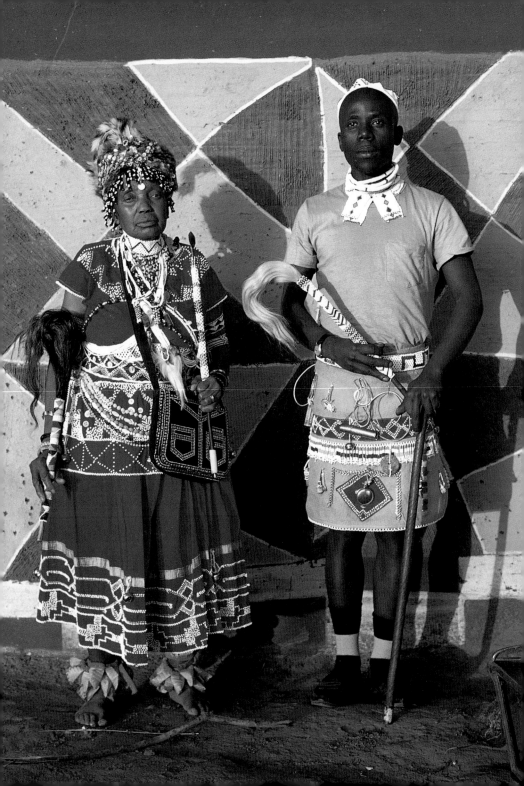

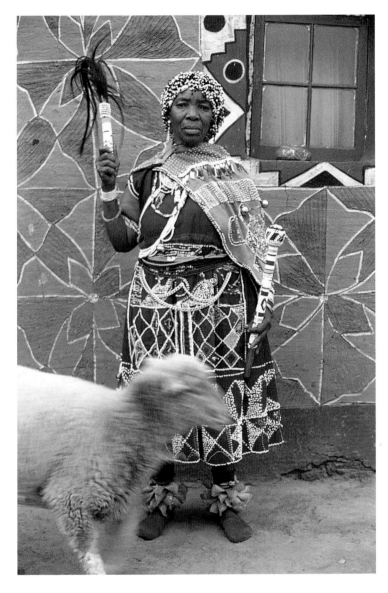

A guest at the Forest Creek graduation holds her whisk and beaded club as a sheep dashes between her and the camera. Around her ankles she wears rattles made from bladders filled with seeds.

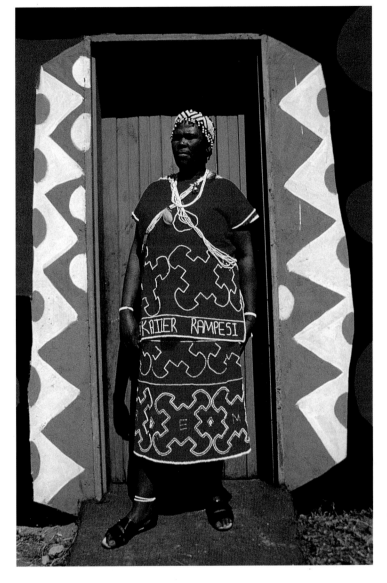

For her diviner's costume Elizabeth Rampesi has chosen a simple red and white color scheme. The bead embroidery defines a cross motif and spells out her husband's name. Her mural design is similarly minimalist.

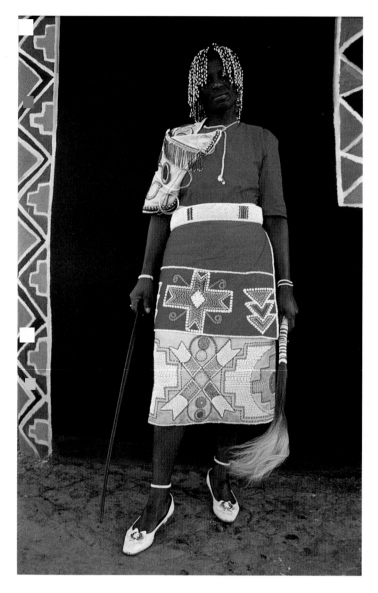

Anna Mofokeng's bead-embroidered skirt has a complex design and subtle colors. Her shoes must be removed whenever she is in contact with the spirits.

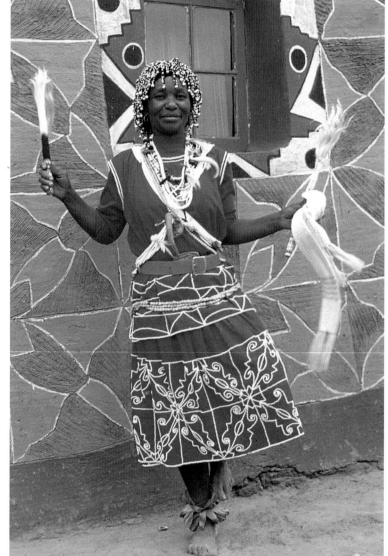

A visiting diviner at the Forest Creek graduation rests after a night of dancing.

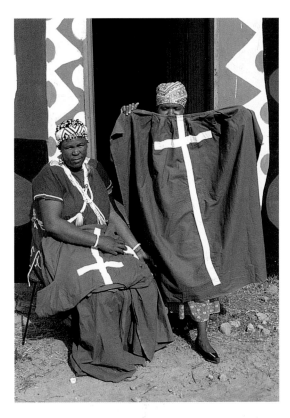

Elizabeth Rampesi, like many diviners, also belongs to an Africanist church that incorporates traditional African religion and a strong focus on the power of ancestral spirits. The owner of the farm on which she lives has contributed toward the building of a church on the property, seen in the background of the photograph below. Many of the workers' houses feature bold Christian motifs, such as the one in the foreground, painted by Emily Malakwane.

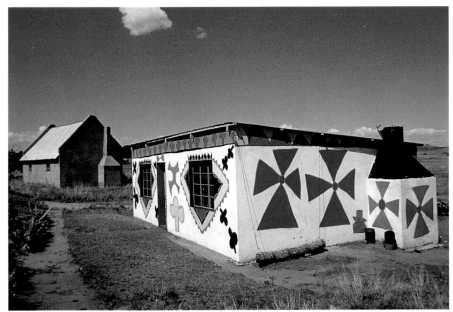

Moshoeshoe. In 1851 she informed him that the nation should prepare for a war against the British, Boers, and the Rolong—a Tswana group who, under the urging of their missionaries, had taken over Basotho land. She correctly predicted that the enemies would be easily defeated in a quick and decisive battle.

Like Moshoeshoe and many other Basotho, Mantsopa was strongly influenced by Christianity and fused the idea of the Christian God with the existing prophet tradition, which was based on receiving messages from ancestral spirits. She is reported to have observed in the 1860s that "the way to heaven is not a narrow road, that the missionaries are ridiculously mistaken in saying so, but that God is really the Supreme Chief, and of course the road to his town is very broad indeed and constantly full of crowds of people going to court."

While Basotho religious traditions were being reinterpreted in light of the Christian message, they were also strongly influenced by religious practices of coastal peoples, who received direct inspiration from God or the ancestors and could use this power to heal. This method of spiritual communication bypassed the more traditional practice of Basotho doctors or *linohe,* who had to undergo lengthy training in order to read messages from the fall of the "bones," or the use of a set of divination articles.

Called *mathuela* among Basotho, but more generally known throughout southern Africa as *izangoma* (singular: *sangoma*), these diviners frequently enter trances to commune with the ancestors and then prescribe cures for physical, psychological, and spiritual afflictions. They earn good incomes, particularly if they establish wide reputations. In the rural areas of the Free State, where women now have little work, the

mathuela profession has many attractions, but it is not to be taken lightly. Usually the first signs that the spirits are calling someone to become a *sangoma* are troubling dreams and strange physical afflictions. This is called *go twasa,* the onset, likened to a blooming of the spirit in a person, but it can be a very disturbing and upsetting process. The novice must enter training with an experienced *sangoma,* an apprenticeship that may last several months or even years for those who learn the full use of herbs and medicines.

In the 1870s a religious movement affecting mainly women sprang up among Basotho. It was based on direct communication with the spirits, and prophesied disaster unless Basotho rejected the ways of whites and returned to tradition. Whole villages were sometimes affected, the women becoming possessed and announcing messages from the ancestors. This gave women a spiritual voice, with which they articulated a definite political message. This was completely new to Basotho tradition. Christianity, especially its more charismatic strains, also holds out the possibility of an intimate connection with the Supreme Being. These changes had deep and lasting consequences.

The influential nineteenth-century diviner Mantsopa was baptized on the very date set for Moshoeshoe's own baptism, March 13, 1870. Moshoeshoe had brought his nation to the brink of a radical symbolic transformation by planning his own conversion after decades of doubt and debate. But Moshoeshoe died two days before the event, bringing to an end the era of first contact with whites without taking the leap of faith. Mantsopa, however, established herself in a tiny cave at Modderpoort, in view of the very mountain where the decisive battle she had predicted long before had taken

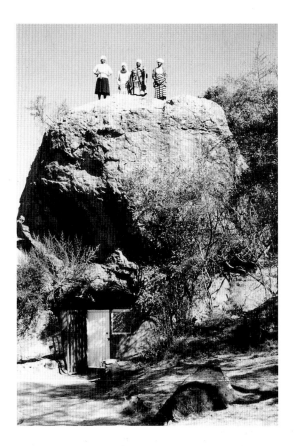

Mantsopa's chapel is a tiny cave that nestles beneath an enormous boulder. The women standing on top are (left to right) Selina Mothibi, Susan Plaatjes, Martha Noliqu Mathobisa, and Anna Mogoera.

place. There she practiced a fusion of the religious strands that had become current.

Lisa and I visited Mantsopa's cave, located on the grounds of an Anglican mission, where Archbishop Desmond Tutu, who was born in Modderpoort, must first have become attracted to the Anglican faith. To reach the cave we walked through a grove of phallic cacti toward sounds of singing and clapping, which we soon saw were produced by four women standing on top of an enormous boulder, below which were the door and the tiny window of Mantsopa's chapel. I realized immediately that one of the women was a *sangoma,* wearing the distinctive printed cloth of black, white, and red favored by

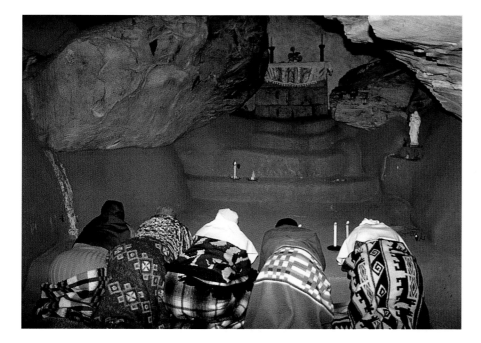

Women dressed in Basotho blankets praying on all fours inside the chapel. The altar at the rear is directly below the roof of the cave. A plastic Madonna rests on one of the mud stairs before the altar.

many diviners. All the women had their heads covered, a sign of respect. One wore part of a uniform that marked her as a senior member of an Africanist Christian church, one of many that blends worship of the ancestors with Christianity.

After we had received permission and filmed their prayers, we discovered that the church elder, Selina Mothibi, and the diviner, Martha Noliqu Mathobisa, had brought with them two patients: Anna Mogoera, suffering from a breast tumor, and Susan Plaatjes, who was mentally disturbed. They had traveled several hours from Bloemfontein to pray here for healing, and then intended to visit the holy spring in the valley far below to perform baptisms. They invited us to join them, but first we had to enter the cave to pray. Behind the closed door we could hear a prayer being offered, punctuated by a chorus of *siyavumas*.

We entered a dark, candlelit space. As our eyes adjusted, the space immediately inside the door was revealed to be a smoothed mud floor about three yards square. Beyond this area, the cave receded upward in a series of progressively narrow steps, made of packed earth, until the cave ended in a pointed niche slightly above eye level. The exaggerated perspective had a strangely illusionistic effect in such a small and embracing space. The entire surface was smeared in a skin of red earth, undulating over the rock surface on all sides and overhead. It reminded me of the biblical story of Jonah in the whale's belly, of a womb, and of a tiny cave high up in the Drakensberg Mountains in which Lisa and I had spent a night. We imagined it as a mouth waiting to devour us when we were dreaming. Right at the back of the chapel, where all the surfaces meet, a white plastic Madonna glowed on a little platform.

Candles melted, as if on a tiered cake, and soaked into the earth.

A group of women knelt on all fours in front of the first step. All that could be seen were their backs, covered in patterned Basotho blankets. Mrs. Mothibi's group lit candles to make it clear that they were waiting to take their turn.

Beside the door was a photocopied page, protected behind wrinkled plastic, headed "Modderpoort Cave Church." It stated that the chapel was "established by the Society of St. Augustine (after St. Augustine of Hippo, African 'saint') on a farm purchased by the Bishop of Bloemfontein. In 1902 it was taken over by the Society of the Sacred Mission. Anna Mantsopa Makhetha, a seer and rainbringer married to a chief of the area (so it is said) took up residence here in 1906. She was baptized by missionaries in Lesotho and was charismatic in prayer and healing. A belief in the power of the ancestors to aid those who still live on this earth is typified by the devotion that many express when they come to Modderpoort to seek help in their daily life."

Presently the praying group got up off their knees and shuffled out quietly, making it clear that they had been hastened away. While Lisa took light readings and I set up the video tripod, Selina Mothibi arranged the patients between herself and the diviner, and they all stood facing the altar. They began to pray and clap in a far more animated way than the previous group. The woman with the tumor became possessed and began to bounce up and down like a pogo stick. She crashed her head into the roof of the cave but appeared oblivious to the collision, continuing to stagger, lurch, and hop, unsettling the space. She smashed into the tripod and collapsed on the earth. I picked her up and asked if she was okay, but I could see from her

glazed expression that she was really elsewhere and could not answer. I steadied her with my hands and let her go, like releasing a bird, and she continued her frenetic trancing. Meanwhile, the prayers were calling *balimo* and Molimo to come and heal. When the prayers were over, we went outside. The light was blinding.

Now we began the walk to the river at the bottom of the valley, a few miles away. The path went through a series of erosion gullies and across the landscape. The *sangoma* stopped frequently to gather different kinds of earth and plants, telling us their various uses. She was delighted to discover a termite mound, and chopped off several large pieces, which she tied up in her *sangoma*'s cloth.

The healing spring was a little grotto in a muddy bank. Water trickled down from the mountain above and gathered in a pool, around which there was just enough space to stand. The water then ran off to the main stream, which was barely flowing in the drought. Stubs of candles and food offerings occupied shelves in the rock. There were offerings in the pool too, including the wink of silver coins as in a wishing well.

Selina Mothibi tied colored bandannas around the disturbed woman, Susan Plaatjes, each color for a specific application that was required to calm her mind. The healer had brought with her a plastic bowl and a Bible. She read a prayer, the others repeating after her. Then Susan Plaatjes knelt before her and Sebina Mothibi poured a bowl of freezing water over her head. It was a shock to her system, but the patient registered little reaction. Several more bowlfuls followed. Mud from the site was smeared on her face. Anna Mogoera was baptized next, and a poultice of healing mud was applied to her large tumor. The *sangoma* was

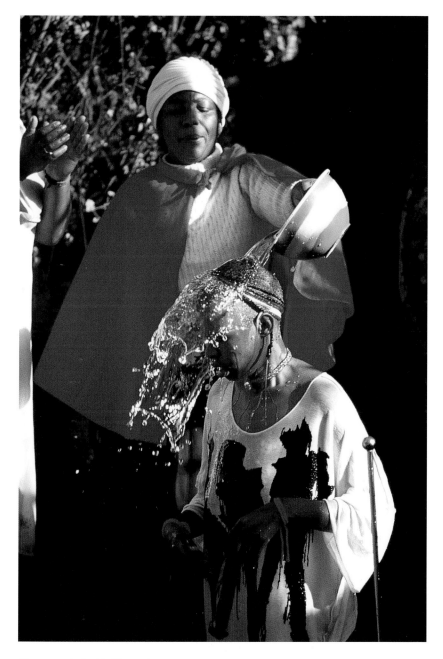

After prayers in the Modderpoort cave chapel, Selina Mothibi baptizes Susan Plaatjes at the holy spring in a nearby valley.

also baptized, not for any illness, but, she said, because it felt good and strengthened her. She gasped loudly as she was repeatedly doused. They changed into dry clothes. Everyone was invigorated and in high spirits. Even Susan smiled and seemed to interact normally now. Martha pointed out to me that Susan was healed already, and all were convinced that both Susan and Anna would recover completely.

Another Free State cave famous for spiritual power is Saltpeterskranz. I had tried unsuccessfully several times to find this cave, which is not marked on maps. Whites in the area generally do not know exactly where it is, though they have heard of it. Blacks know how to reach it by foot and point the direction as the crow flies. Finally, a few months before South Africa's first democratic election, I set out on a special mission to locate it with Lisa and my brother, Roger.

I asked for directions in the nearby town of Fouriesburg, one of the towns hastily established by Boers in the Conquered Territory to secure their possession of what was once Basotho land. I was given contacts to telephone in other towns, and received a few vague directions. While I was making telephone calls at the public phone outside the post office, I became surrounded by a political demonstration of workers waving ANC placards and dancing the *toyi-toyi,* a guerrilla dance accompanied with chant and song. White passersby looked alarmed at this presage of the New South Africa and were disgusted at the civil disorder, for which the crowd and we, as we filmed it and conducted interviews, would have been arrested if these events had occurred just three years earlier. Now, they were powerless to stop this expression of the people's will, and knew that it was a symptom of the great political changes that were just around the corner.

The town clerk came up to ask me what we were doing. He tried hard to appear completely unruffled by the riotous assembly, but was clearly very relieved to hear that we were not journalists and that his once orderly little town would not appear on television news. He said he knew Saltpeterskranz and kindly offered to take us there when we had finished filming. "It's a very famous place," he said. "People come to Saltpeterskranz from as far away as Malawi," in central Africa.

I kept him company in his car while Lisa and Roger followed behind in ours. Now it was my turn to feign tolerance as I was subjected to his interpretation of why such demonstrations achieved nothing, how apartheid was necessary "because blacks and whites are totally different—you only have to look over there on the other side of the Caledon River to see what a mess blacks have made of the land in Lesotho. This side of the Caledon it is all beautiful wheat, over there it is nothing but erosion. So they come over here and steal from us."

I had to remind him of the history of this Conquered Territory, which I had been studying—how the Boers seized this lush land from Basotho by force and squeezed them over the river into the shrunken territory of Lesotho, where, overcrowded, they could no longer survive on what little land was left to them. The political control that was once wrested away through the barrels of Boer guns was about to revert through the ballot box, but the ownership of the white farms would not return either to the Basotho farm workers or to Lesotho.

Since we were talking about the old wars in this region—and the pending elections that signaled the end of what really had been an extended civil war in our own time—he sped past the turnoff we needed to take to Saltpeters-kranz, saying he had something I had to see. A short distance down the road was a fenced off memorial to Boers who fell in war there. The place is called Skandevlek—Scar of Scandal. Here we conducted a video interview with him about the Conquered Territory and the New South Africa, the mountains of Lesotho rising behind him. Then we went down into the gorge of Saltpeterskranz.

Parking in the bottom of a valley, we followed a river upstream for about a mile. As we neared Saltpeterskranz we heard the deep bass boom of drums reverberating between the towering cliffs of the ravine. Rounding a bend in the river we saw an enormous dark gash high up in the sandstone strata, just below the surface of the plateau from which we had descended. A steep, narrow path up the rocks led to the far end of the cave. The drums stopped. We were met by a young man dressed in the colorful regalia of an African Christian sect who welcomed us—he was the drummer for the Church of God group, which was taking a rest.

The silence and utter calm of the cave provided a close embrace affected by the slightest movement or sound. The powdered dust of the floor was etched with naked footprints and the claw and hoof marks of animals that had been sacrificed and eaten here.

Inside the vast space, the clerk's patronizing attitude was instantly erased by the awe we all immediately felt. With a sense of amazement at himself, he volunteered that this truly was a very holy place. I knew then that he had never actually been here before. And I discovered that he was fluent in Sesotho. He fell quickly into conversation with a Mosotho man who was staying here on a meditative retreat. They climbed high up onto the rock pile and talked while we explored.

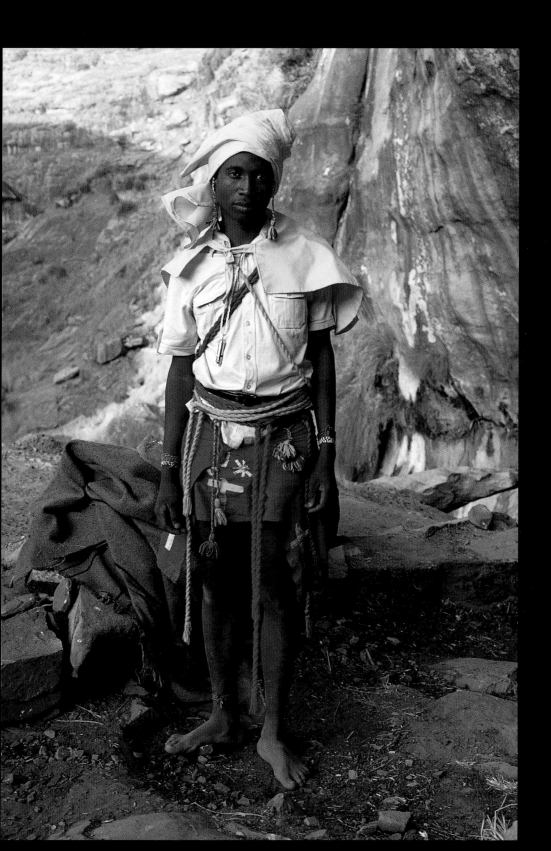

A deep natural tunnel in the rock wall was where visitors collected the cave's holy water and limestone-rich white powder. A young man sat there in the darkness, wrapped in a dull gray blanket. He said he was experiencing *go twasa* and answering the call to become a *sangoma*.

Farther along the rock face, a wall of piled stones defined the kitchen and laundry area. Women folded blankets and prepared food. A sheep was tethered here.

Under "Church of God," painted in blue on the rock face, stood a white, wrought-iron pulpit with a crucifix. The rock walls enclosing the space were also painted blue and covered in a fine gray dust. The celebrants returned and began to drum, call, and sing. Between the rock pile hill and the face, the music pulsated and echoed. An elderly man in a bright yellow cloak began to dance around in the blue corral, around and around in a tight circle, blurring. When he slowed, others took his place to whirl in the hypnotic circle.

All along the curving back wall of the cave, graffiti defined several such open "chapel" spaces. There could be a hundred gatherings at once here. Around the bend of the cave, on the other side of the hill of rocks, a diviner and a Christian priestess had set up an altar to pray for the patient they had brought to Saltpeters-kranz. It was a quiet day at Saltpeterskranz, just these two ceremonies in progress. I watched from a discreet distance, since, unlike the other ceremonies I had witnessed, I had not specifically been invited here, although it was clear that anyone was welcome. The women paused in their service for Bible readings, the laying on of hands, and to light candles. Many of their prayers were for peace in South Africa.

As the women danced around in a circle,

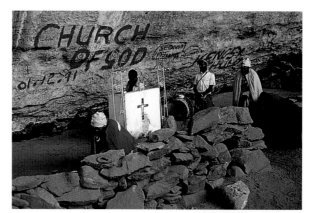

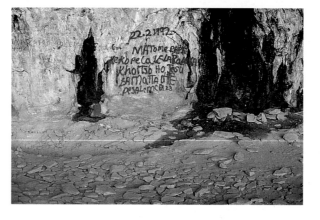

The Church of God has established a permanent pulpit in the cave. Their space of worship is defined by the rock walls that they have built. Beside the spring of holy water that flows from the wall of the cave (below) is a prayer for peace, *khotso.*

Opposite:
A drummer of the Church of God sect at the mouth of the Saltpeterskranz cave.

Overleaf:
A view of the enormous cave of Saltpeterskranz, renowned for the curative powers of its water and soil and as a spiritually powerful place. The fallen overhang has created a hill of rocks (left) that shuts off the mouth of the cave. The entrance to the cave is at far left, behind the rocks. All along the back wall of the cave, which continues in a 180-degree sweep, church sects and diviners conduct ceremonies and healing sessions.

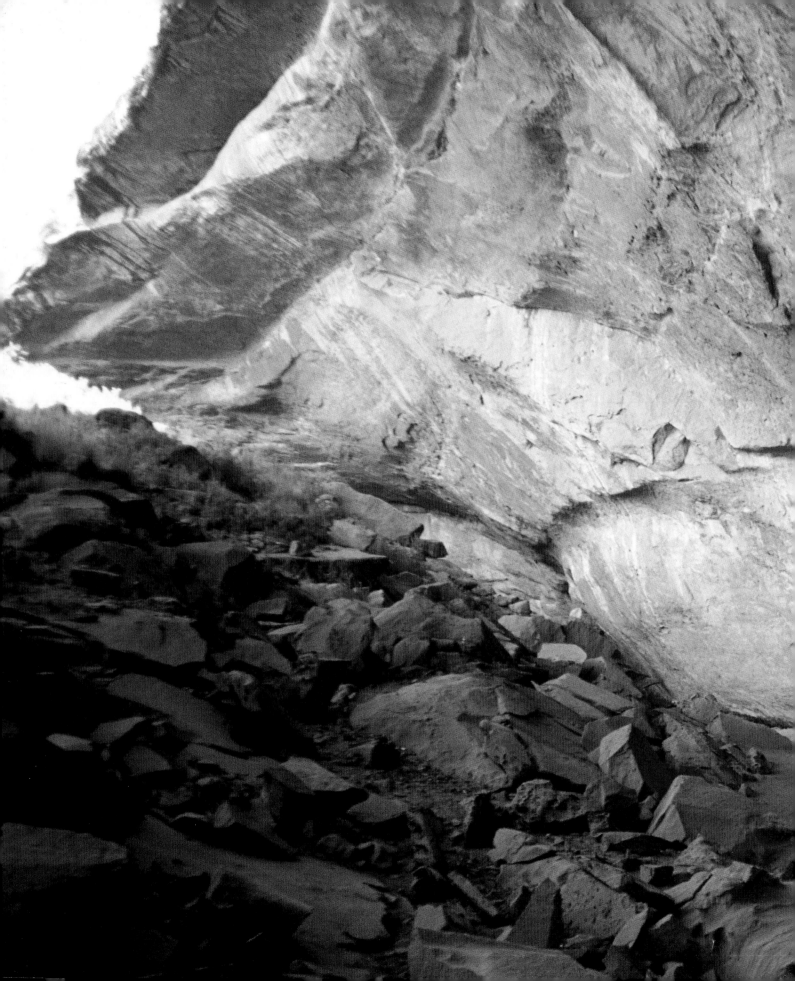

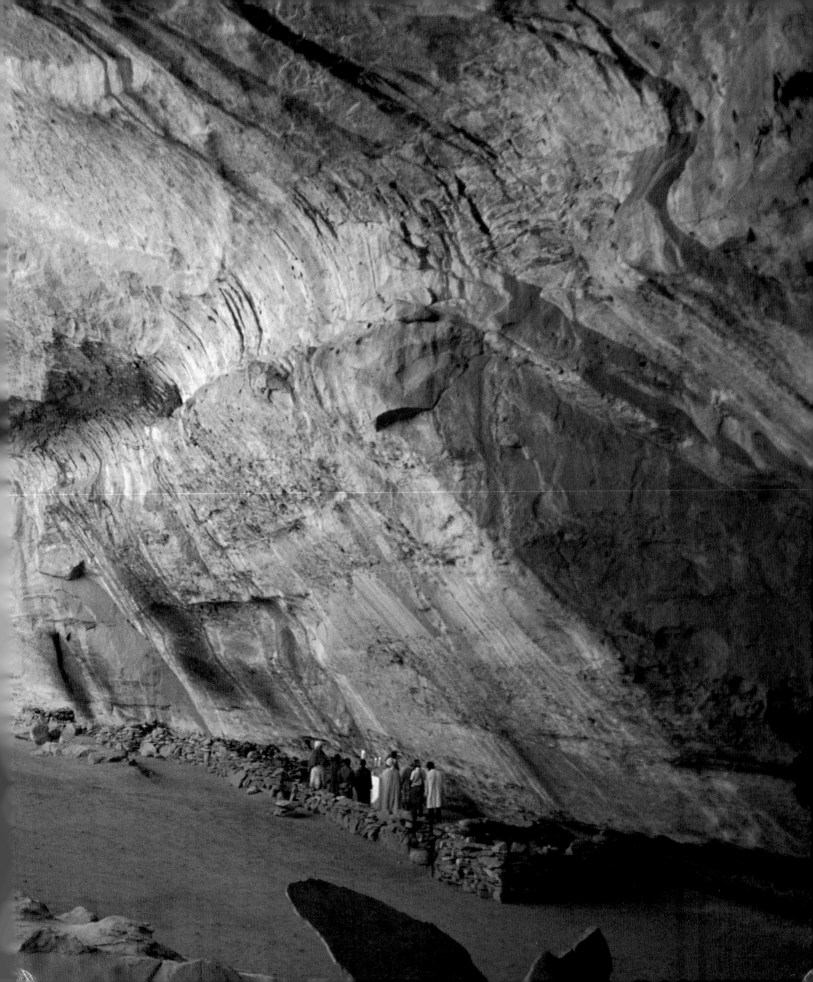

singing and clapping, performing the *hlope* healing dance, their feet kicking up puffs of powder, I wondered if such circles had been inscribed in the earth here by the feet of worshippers and healers for thousands of years, from the time of the San, whose paintings may lie below the layers of graffiti. Whether or not that is so, as I sat in Saltpeterskranz, I saw it as a cave cathedral, a holy place naturally carved out of the sacred earth, a monumental counterpart to the intimacy of the womblike Modderpoort chapel.

During all my investigations I was struck by how closely Basotho women are connected to earth in all of its manifestations: as home, as art, as altar, as medicine, and as manifold metaphor. The holy caves of the Free State clearly focus the symbolism that Basotho connection with the earth: as the womb of origin, as the resting place of the ancestors and the altar upon which they are addressed, and as the life-supporting surface that requires peace and sacrificial libation to provide plenty for all.

In southern Africa, the earth has been savagely contested terrain, soaked not only with the sacrificial blood of worship but also of strife. Even before the first whites arrived among Basotho, the Lifaqane had cut its bloody swathe across this landscape, forcing some of the population to hide in caves and survive by devouring passersby. On a visit to the cave of the cannibals who ate his grandfather, Moshoeshoe lectured them on the folly of war that had decimated the population, proclaiming "War, that is the great evil of this country!" He forgave them their crime, because he saw them as the "living sepulchers" of his grandfather, and said, "Did I speak the truth that time when I assured you that you could not die of hunger under my eyes, when in front of us grew magnificent fields of corn? Will you, with Moshoeshoe, thank the God of peace and abundance today?"

That wise king's humanity, his message of reconciliation and sharing, and his hopes for peace and prosperity for all had an urgent pertinence throughout the time I worked among Basotho, witnessing the death throes of the violent apartheid regime and the dawn of democracy. On the parched farms of the Free State, both the white farm owners and the Basotho farm workers prayed for rain and wondered how their lives would change under the New South Africa. Owners feared that their blessed workers, no longer meek, would inherit the earth. Farm workers hoped that they would be allowed to farm the land together with the owners. To date, these hopes and fears have not been met, and it remains to be seen if and how history might reverse the change in possession of the land.

Many farm workers have left the farms in search of new opportunities. Many workers' houses on the farms are now made of cement block. Their surfaces are not as easily painted, and often workers are forbidden to decorate the walls. It is not possible to say whether the art of *litema* will continue, but the values encoded in *litema* and the pride in Sesotho identity that the murals celebrate surely will.

The murals, however, continue to offer up the same prayer that Moshoeshoe invited the cannibals to join him in making, one that is also echoed in the quintessential Basotho benediction: *Khotso, Pula, Nala.* Peace, Rain, Plenty.

Opposite Right:
Teacher Selinah Mamoketi Mseu displays a pupil's painting of a Basotho house. Some Basotho regard Western-style houses as signs of status and as better homes, requiring little maintainance. Others think they are hot in summer and cold in winter. Farm owners favor rehousing their workers since they receive generous government incentives to do so.

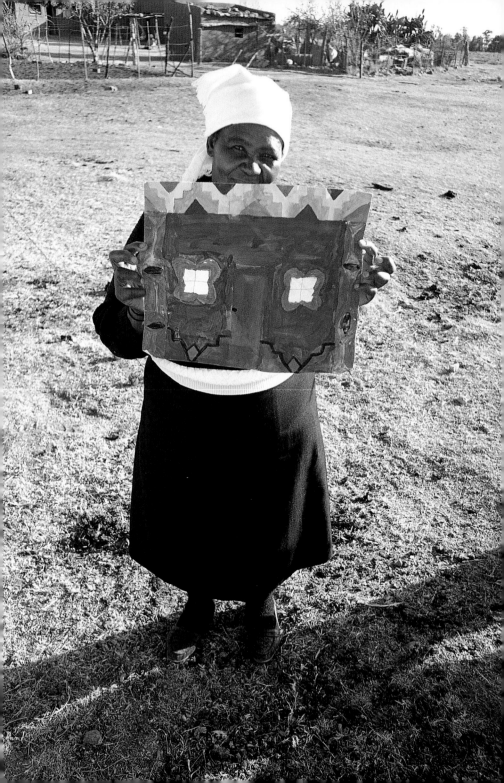

Index

Editor:
ROBERT MORTON

Editorial Assistant:
NOLA BUTLER

Designer:
E. NYGAARD FORD

Library of Congress Cataloging-in-
Publication Data
 Van Wyk, Gary.
 African painted houses : Basotho dwellings
 of Southern Africa/Gary van Wyk.
 p. cm.
 Includes bibliographical references and
 index.
 ISBN 0–8109–1990–7 (clothbound)
 1. Sotho (African people)—Dwellings.
 2. —Color in architecture—Lesotho.
 3. Architecture and society—Lesotho.
 I. Title.
 NA7468.6.L4V36 1998
 728' .096885—dc21 97–36230

All photographs by Gary N. van Wyk,
except page 54: Dr. Andrew Spiegel,
and page 118: Dennis Arden
Map execution by Christine Edwards

Printed and bound in Hong Kong

 Harry N. Abrams, Inc.
100 Fifth Avenue
New York, N.Y. 10011
www.abramsbooks.com

African

BASOTHO DWELLINGS OF

Painted

SOUTHERN AFRICA

Houses

GARY N. VAN WYK

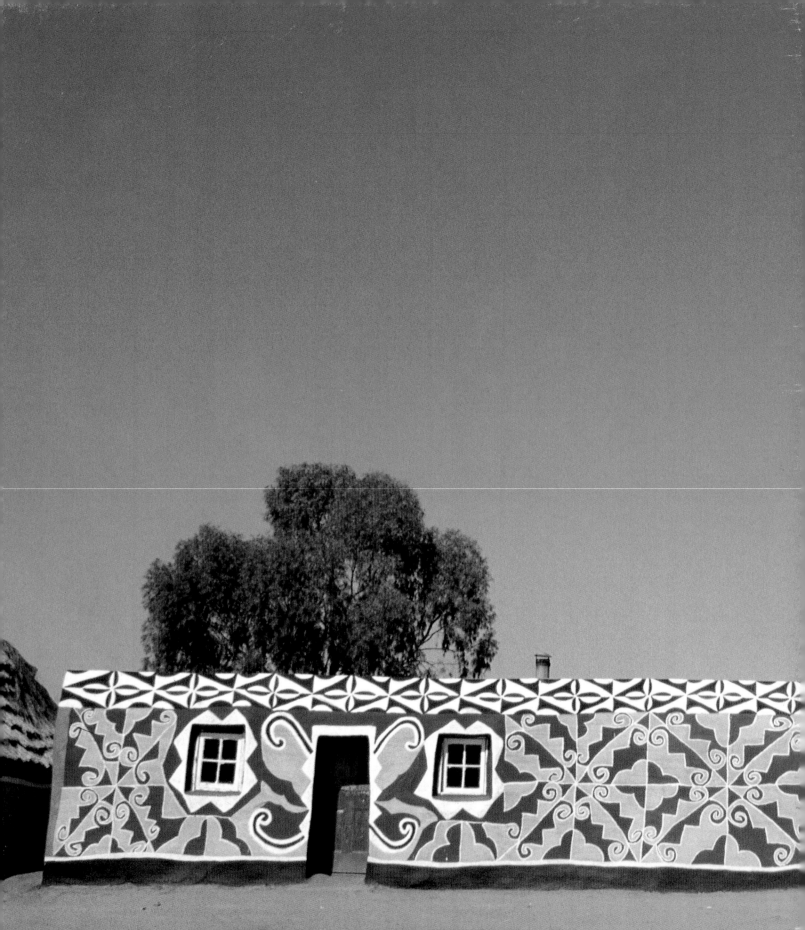

HARRY N. ABRAMS, INC., PUBLISHERS

African Painted Houses